3/01

D0819983

3/01

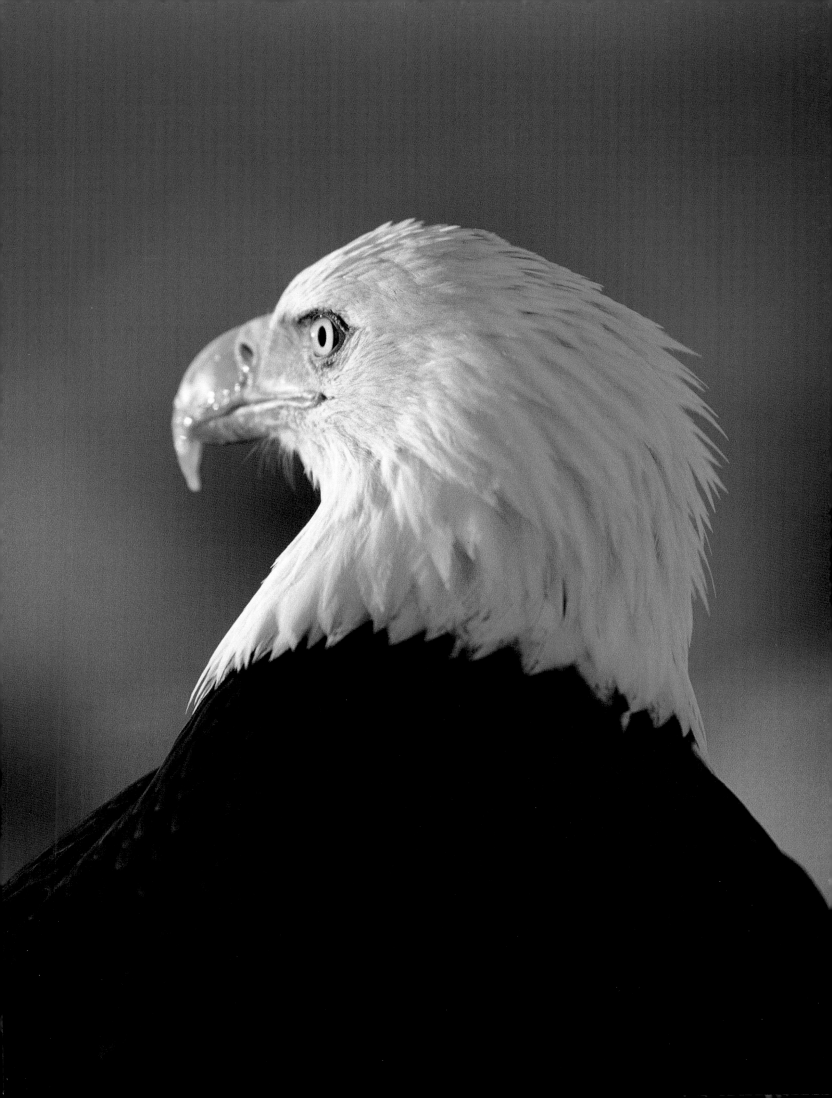

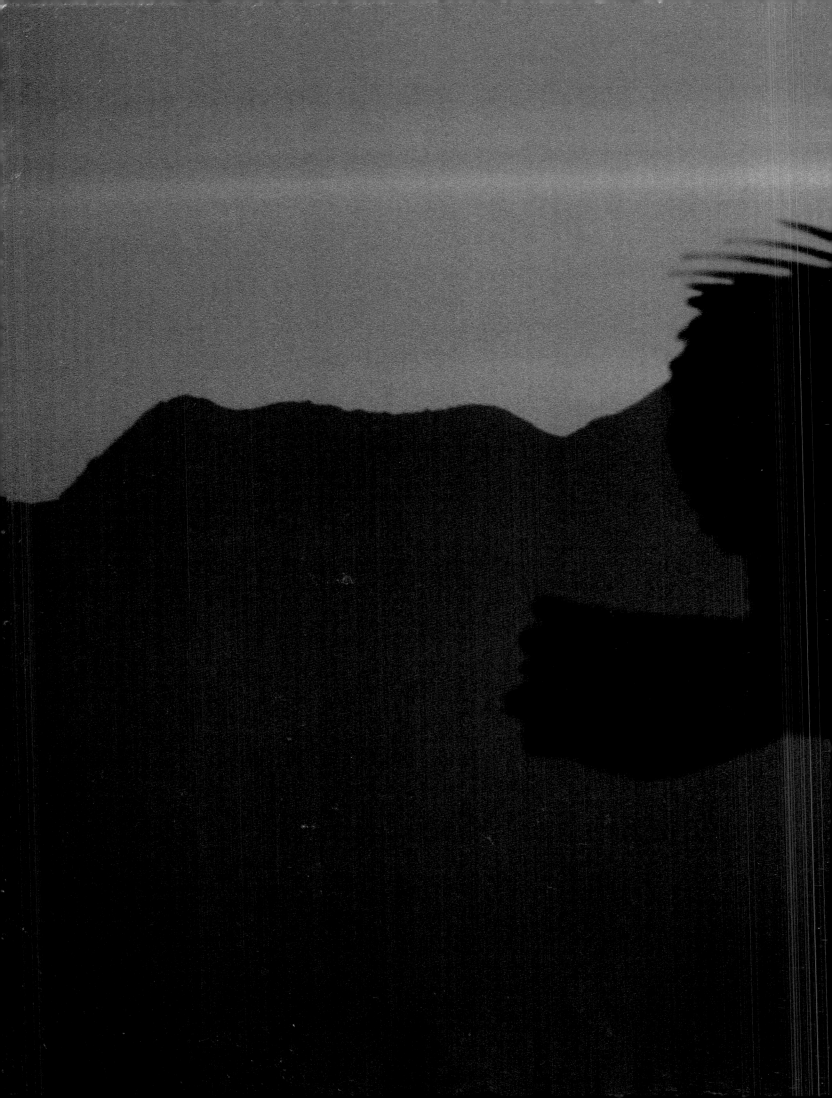

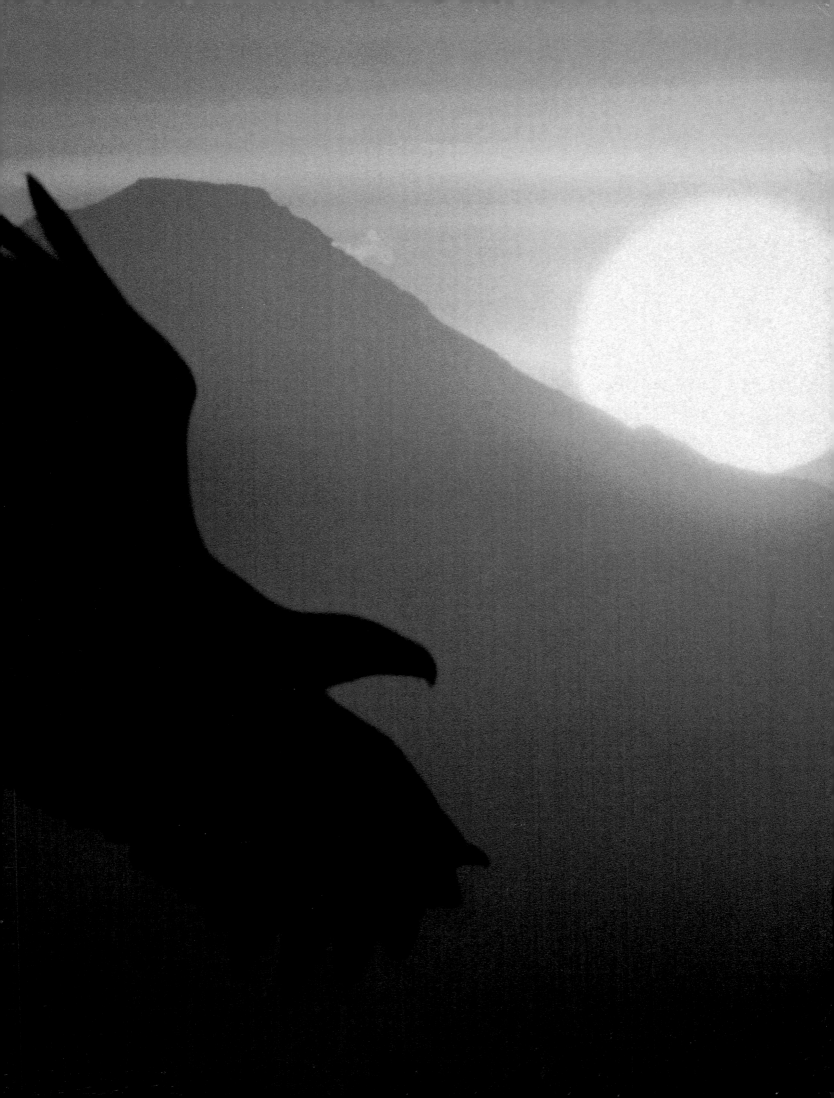

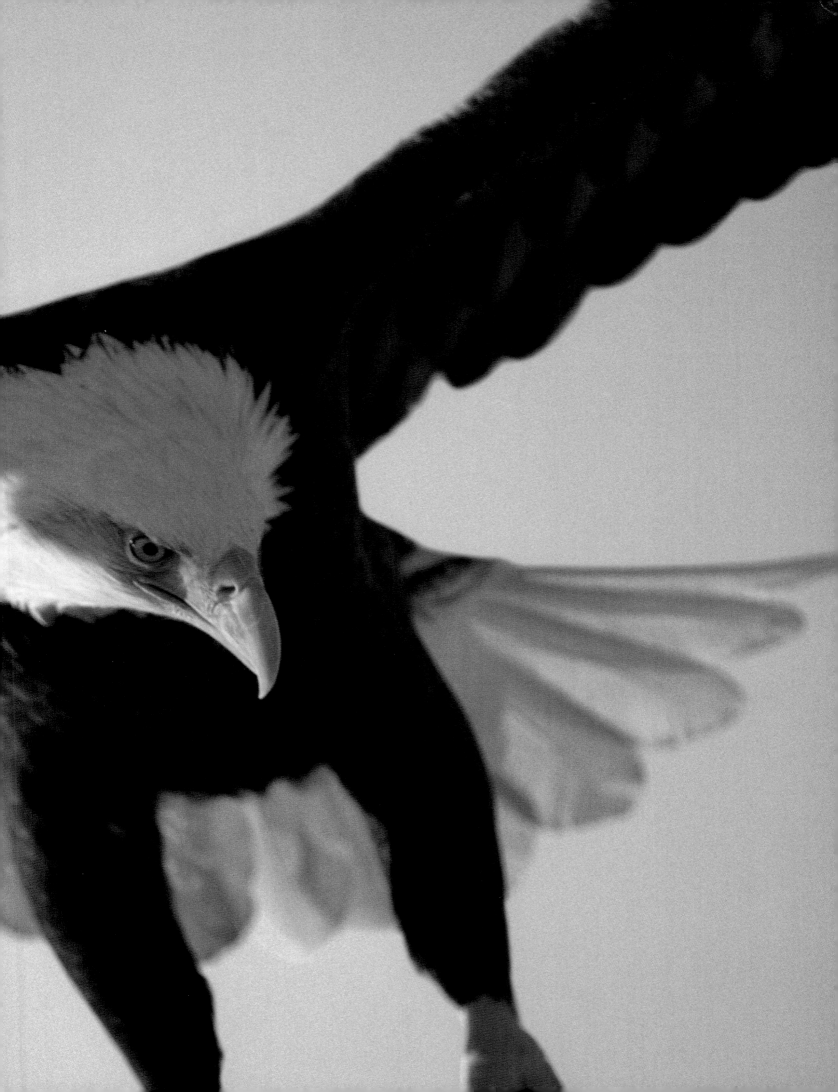

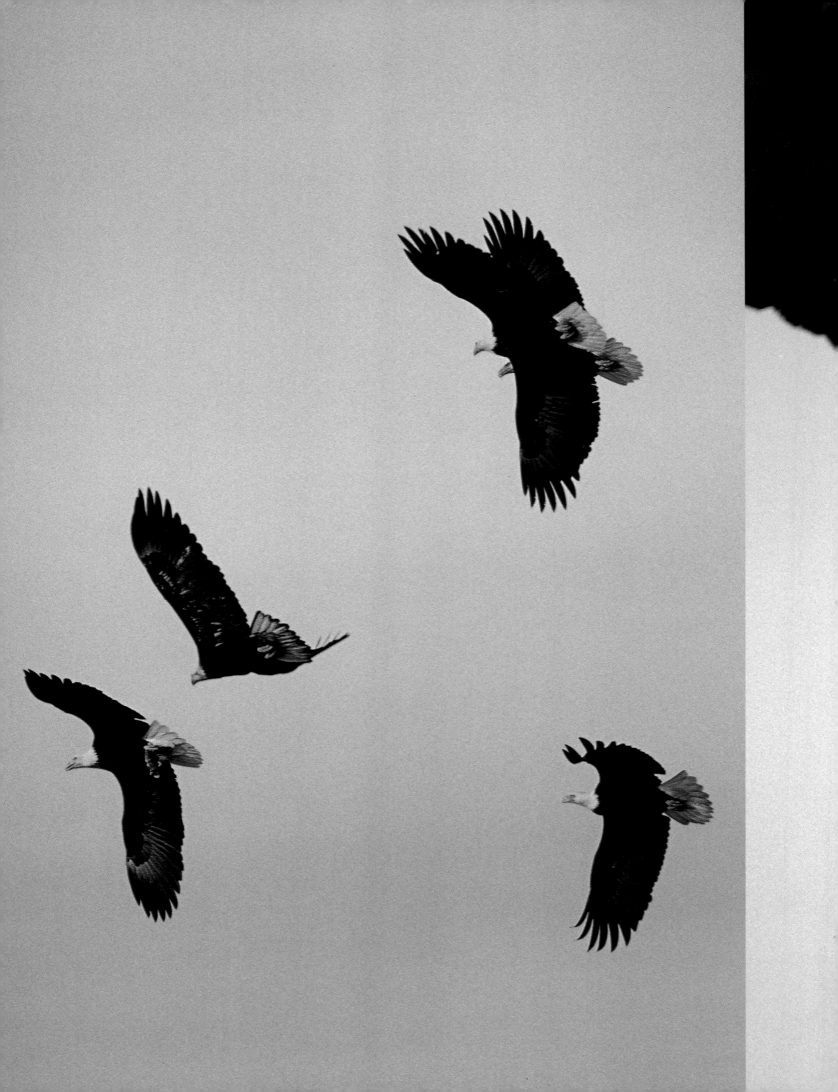

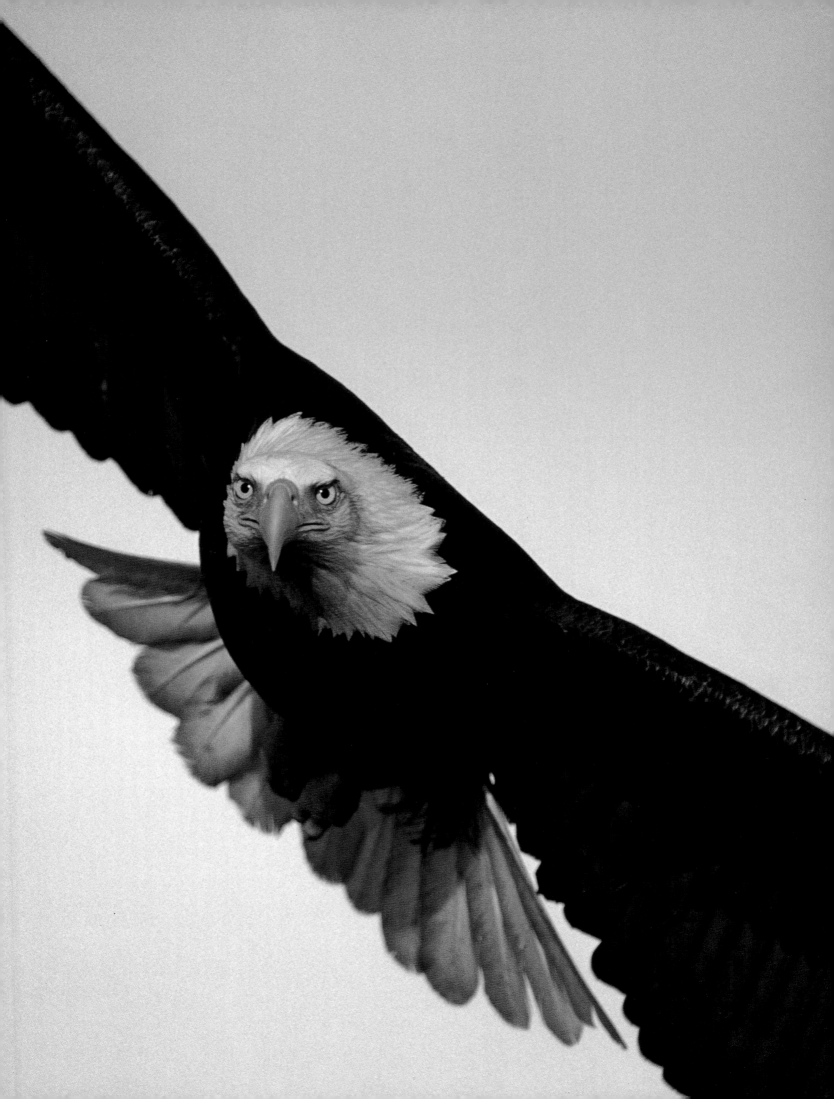

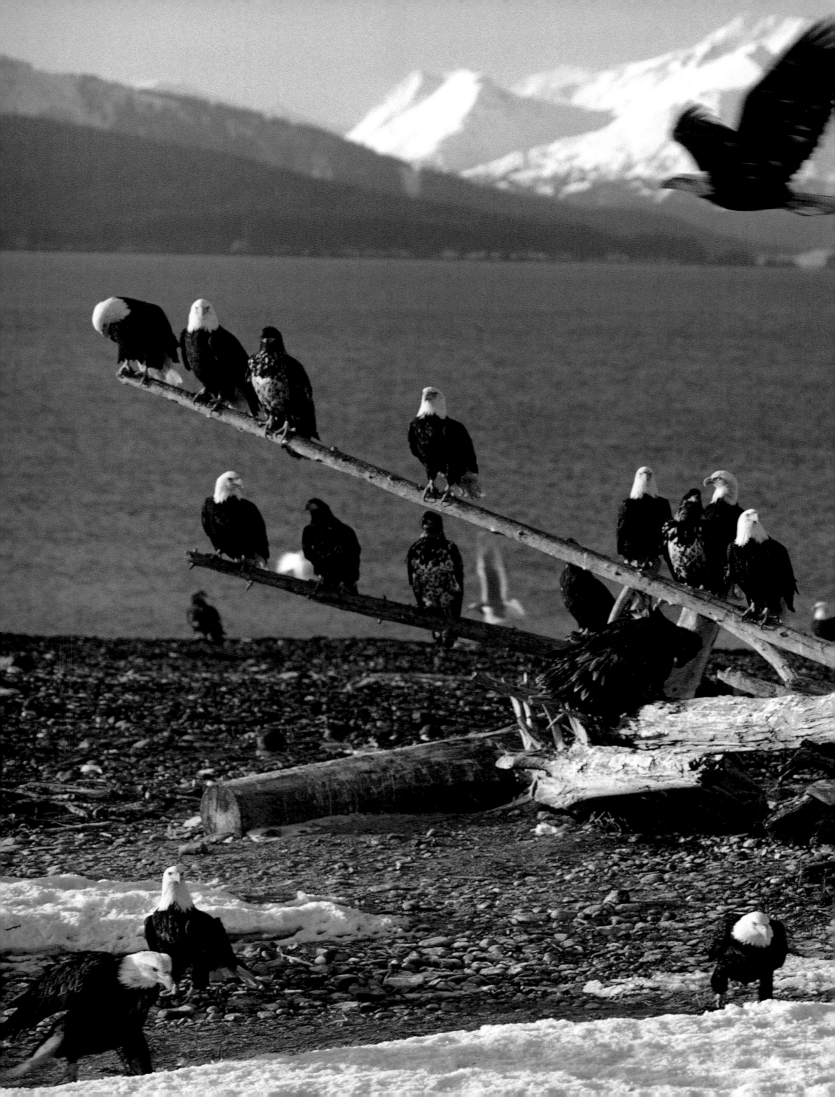

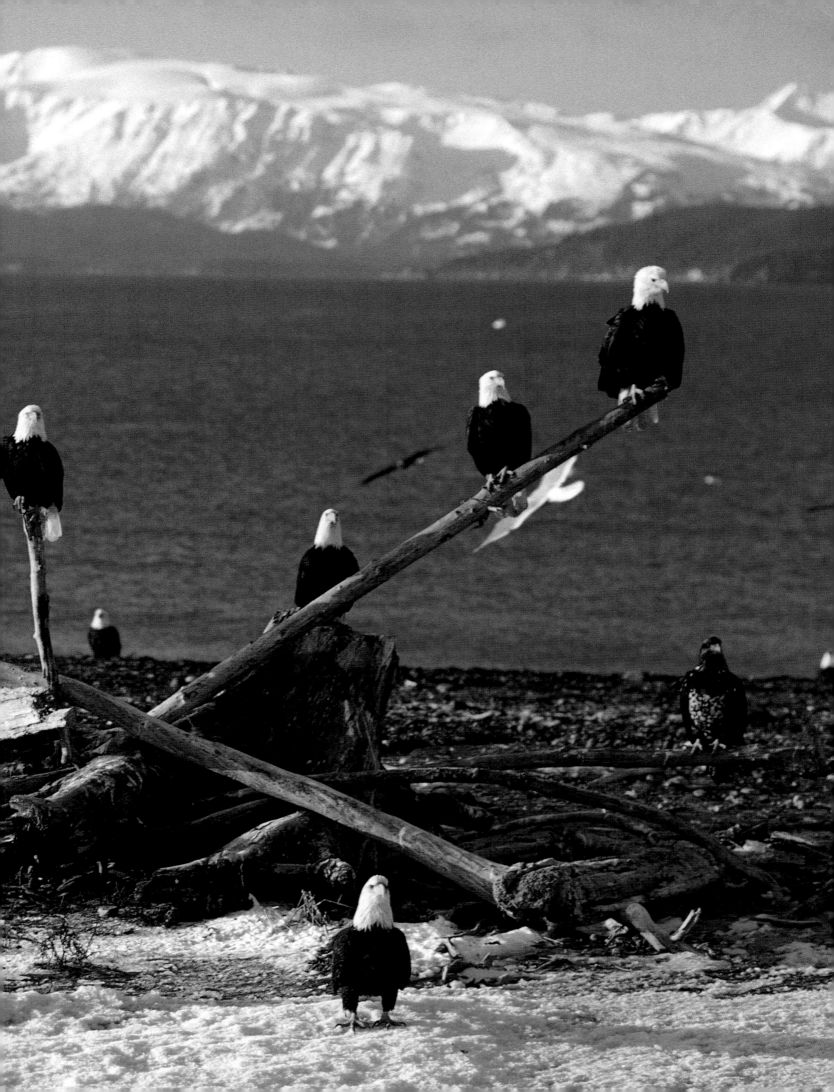

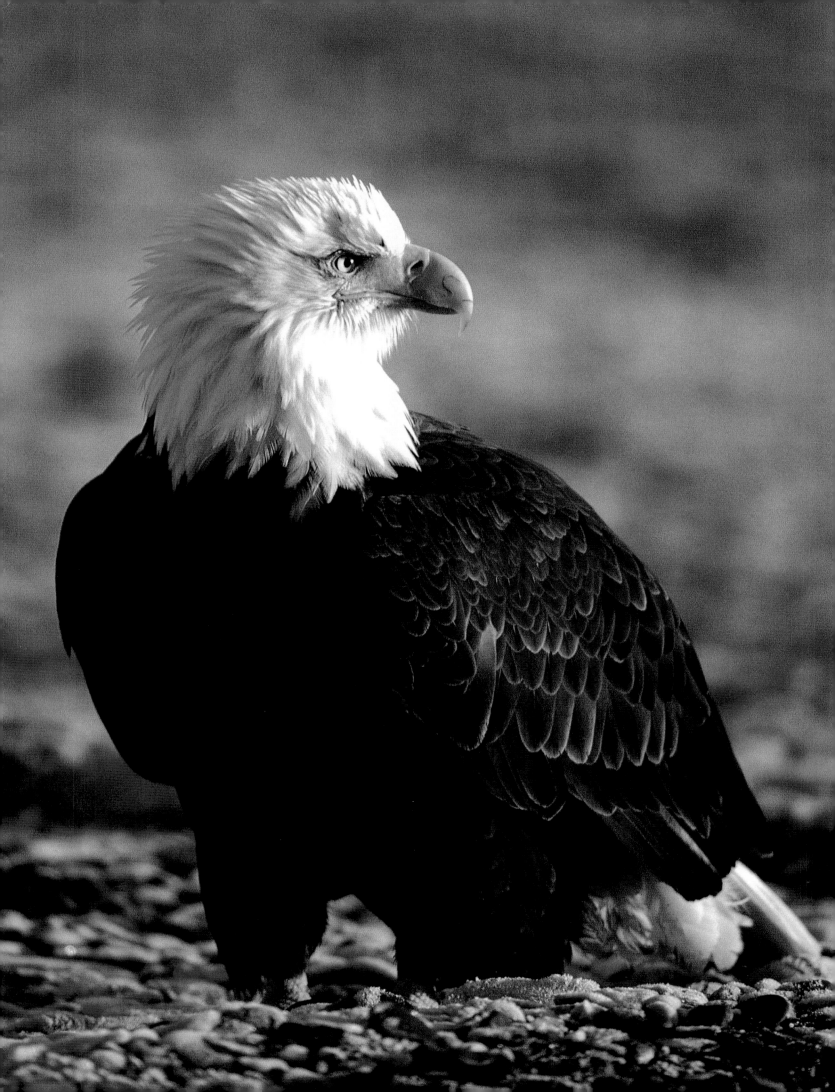

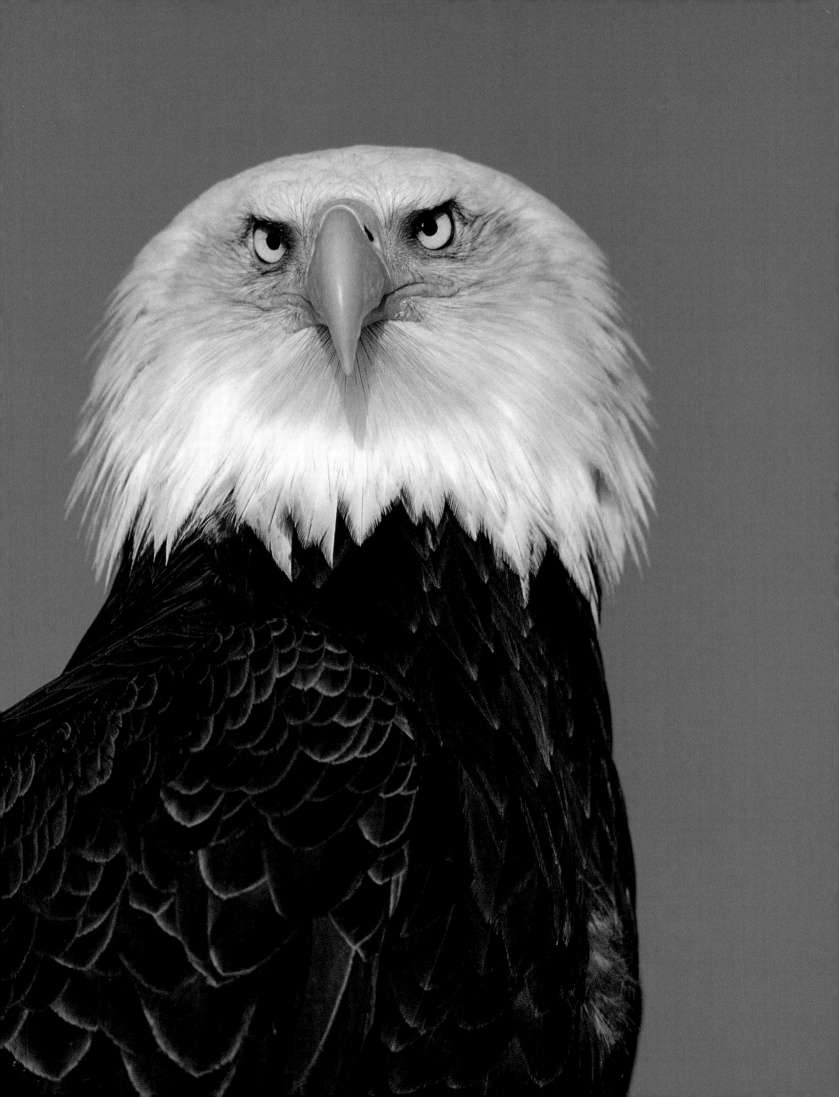

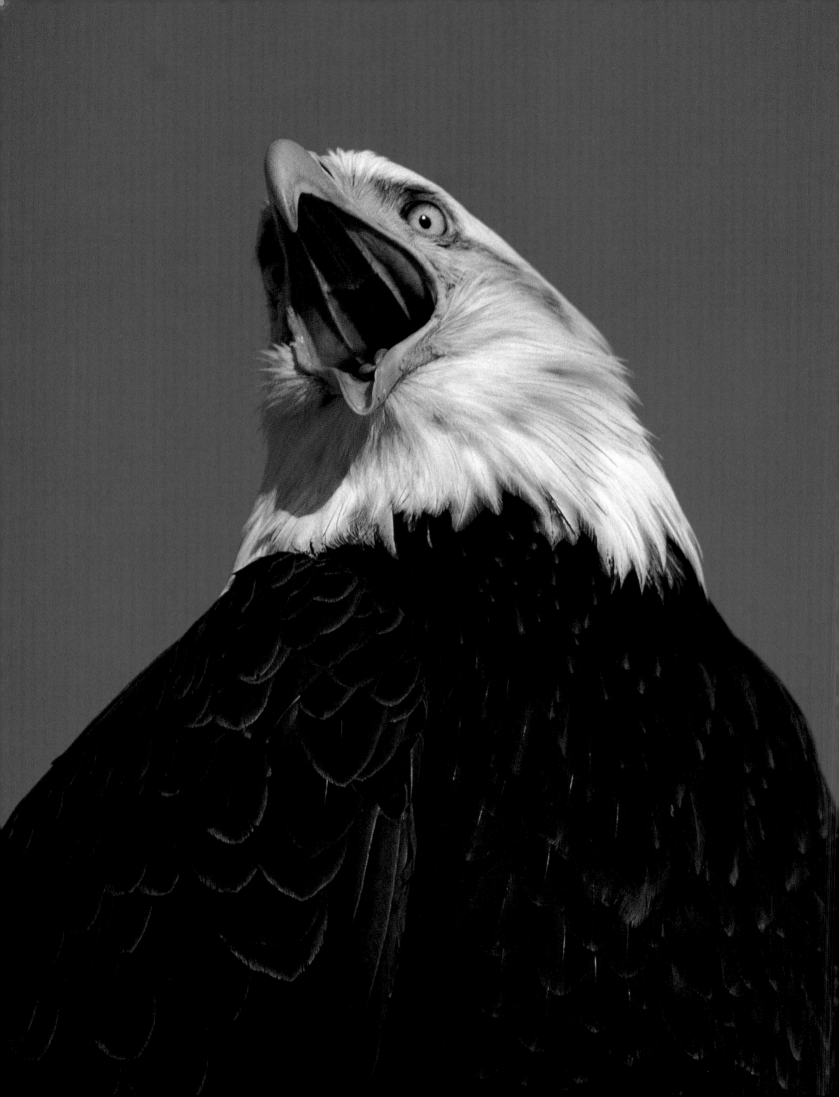

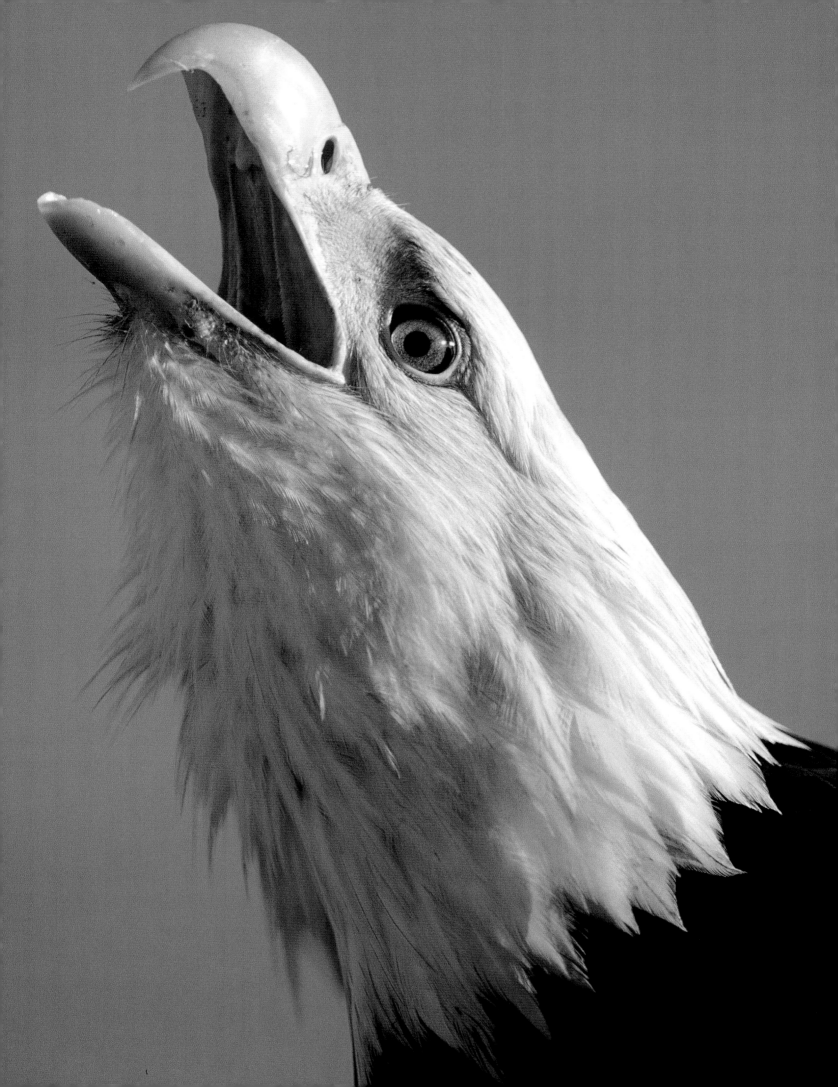

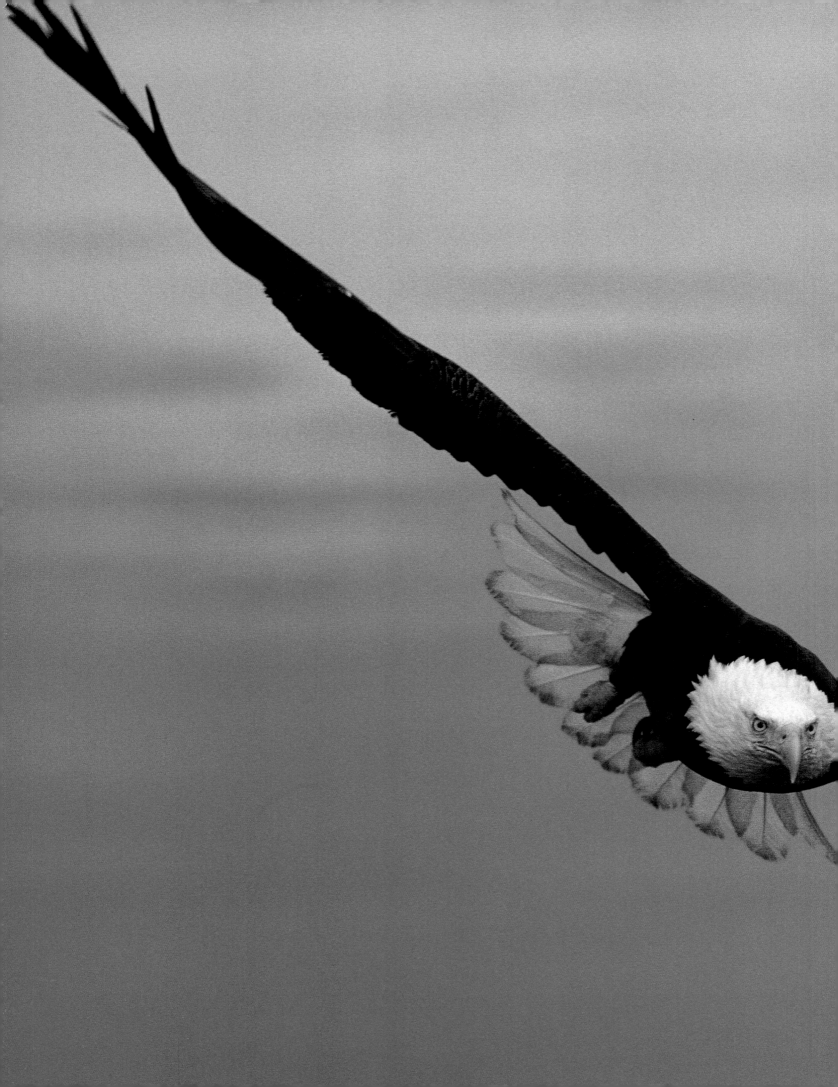

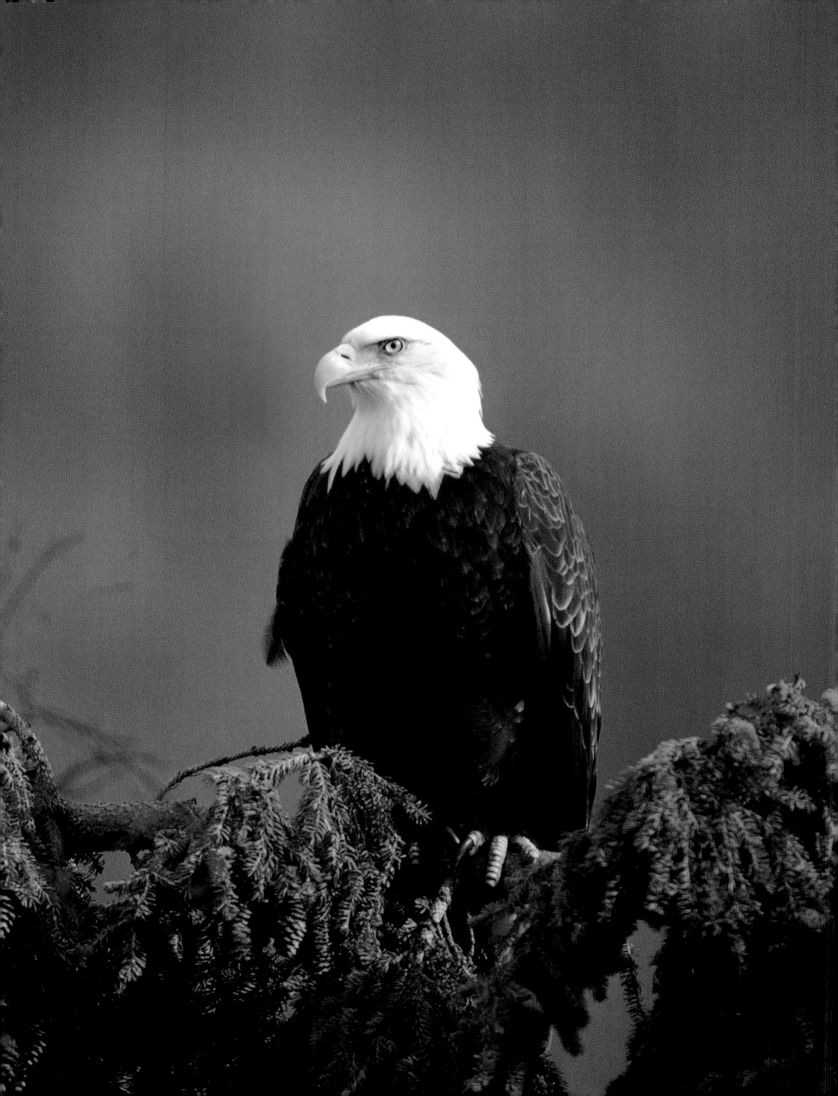

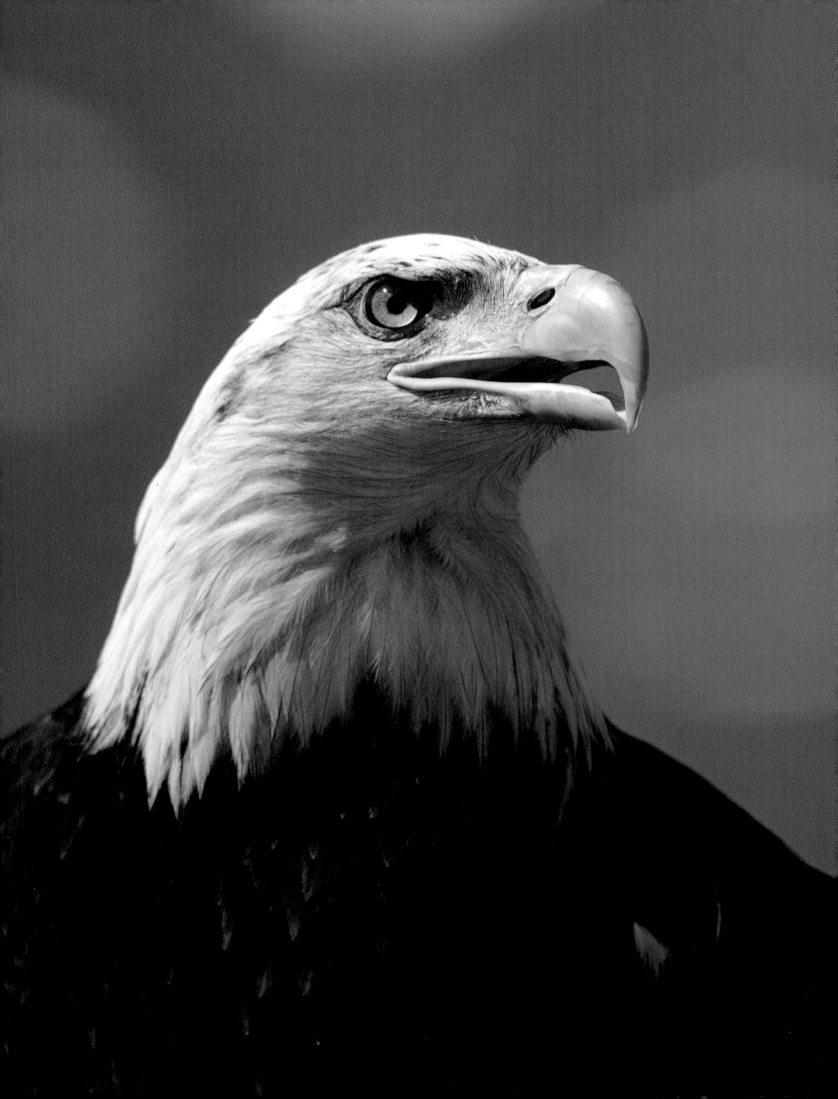

THE AMERICAN

A Photographic Portrait

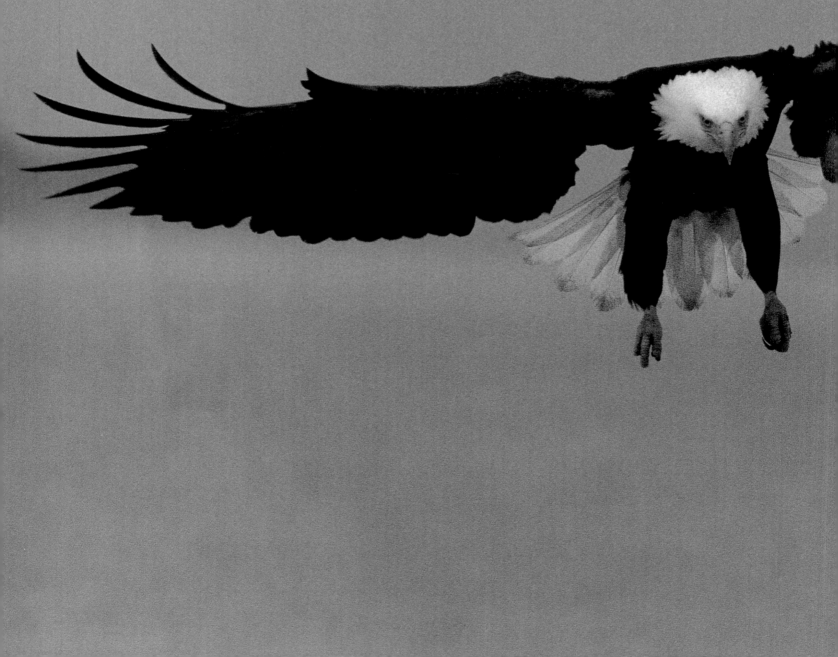

EAGLE

JOHN PEZZENTI, JR.

VIKING STUDIO

VIKING STUDIO
Published by the Penguin Group
Penguin Putnam Inc., 375 Hudson Street,
New York, New York 10014, U.S.A.
Penguin Books Ltd, 27 Wrights Lane, London W8 5TZ, England
Penguin Books Australia Ltd, Ringwood, Victoria, Australia
Penguin Books Canada Ltd, 10 Alcorn Avenue,
Toronto, Ontario, Canada M4V 3B2
Penguin Books (N.Z.) Ltd, 182–190 Wairau Road,
Auckland 10, New Zealand

Penguin Books Ltd, Registered Offices:
Harmondsworth, Middlesex, England

First published in 1999 by Viking Studio,
a member of Penguin Putnam Inc.

3 5 7 9 10 8 6 4 2

LIBRARY OF CONGRESS CATALOGING IN PUBLICATION DATA
Pezzenti, John.
The American eagle : a photographic portrait / John Pezzenti.
p. cm.
ISBN 0–670–88448–0
1. Bald eagle. 2. Bald eagle pictorial works. I. Title.
QL696.F32P485 1999
598.9'43'0222—dc21 99–25312

This book is printed on acid-free paper.
∞

Printed in Hong Kong
Set in Caslon 224
Designed by Kathryn Parise

Art prints and stock photography from the color plates
in this book are available through:
The American Eagle Images
John Pezzenti, Jr.
P.O. Box 111668
Anchorage, AK 99511
Tel: 907-345-8999
Fax: 907-345-0910

The larger part of the author's royalties from this book project goes to
the treatment for leprosy, through:
American Leprosy Missions
1 Alm Way
Greenville, SC 29601

CAPTIONS FOR PRECEDING PAGES:

PAGE I: *This handsome American eagle has the distinctive white head feathers of a mature eagle. Bald eagles are found only in North America, ranging from the northern parts of Alaska and Canada down to northern Mexico.*

PAGES II–III: *A soaring eagle en route to his daily fishing ground in south central Alaska. Eagles have massive wingspans of up to eight feet and can soar for very long distances on the right thermals.*

PAGES IV–V: *The white tail feathers of an adult bald eagle, such as this one in Calais, Maine, are as distinctive as its white head.*

PAGE VI: *Near the Columbia River gorge in Washington State, several eagles rise from the cliffs. The eagle nests in the area of the lower Columbia River are still in danger today and maintain low success rates. Commercial traffic on the river has polluted the water with many substances, including PCBs (polychlorinated biphenyl, a group of chemicals once widely used in industrial processes and later found to be toxic), and has tainted the food bald eagles consume.*

PAGE VII: *The airborne maneuverability of the American eagle has left me breathless for as long as I can remember. Truly the master of the skies in North America, the American eagle often resembles a falcon while diving on prey. This eagle flies over Bar Harbor, Maine.*

PAGES VIII–IX: *Eagles seem to tolerate each other's presence at wintering grounds (such as this one in Homer, Alaska) more than in the summer months. But even some eagles steer clear of gatherings and live their lives in solitude with only the company of their mate.*

PAGE X: *A beautiful mature eagle standing more than three feet tall balloons his feathers to absorb the early morning sun and to appear bigger in order to ward off any other eagles with hopes of edging in on his fishing locations on the Kenai River, Cooper Landing, Alaska.*

PAGE XI: *This large, healthy female found in Old Saybrook, Connecticut, probably weighs fourteen or fifteen pounds, making her as big as a golden eagle. Male bald eagles are about 30 percent smaller than females.*

PAGE XII: *A large female bald eagle screeches at my approach, a sure sign that I've foolishly tried to get too close. A moment later she flew from her roosting perch in Wethersfield Cove in Connecticut.*

PAGE XIII: *A scream is directed at a would-be airborne assailant to keep it away from this eagle's fishing location on the banks of the Quabbin Reservoir in Massachusetts.*

PAGES XIV–XV: *A bald eagle glides across Somes Sound in search of herring. This quiet area of Maine, much like Alaska, is now facing an ever-increasing influx of people to view eagles. This eagle has two bands on his leg so that biologists can study his movements or relocation.*

PAGE XVI: *See caption on page 35.*

PAGE XVII: *Deep in a Vermont forest this nearly mature bald eagle surveys the ground for rabbits or squirrels, as fishing is poor in the area.*

ACKNOWLEDGMENTS

This book is for the hundreds of dedicated folks who gave so much for so long in near silence and obscurity. Their tireless efforts to repopulate our winged icon have brought back the sense of freedom we feel when we behold an American eagle flying in the sky above, symbolizing the land of the free and the home of the brave. They are to be applauded one and all.

This book is also dedicated to the memory of Ken Kard.

It would take a volume of this size to explain how all those listed below helped to create this book project. Their devotion to it, in innumerable ways, often exceeded my own. Their names, as they grace the pages of this book, will forever be embedded in my heart.

Christopher Sweet
Rachel Tsutsumi
Roni Axelrod
Kathryn Parise
Dick Heffernan
Breene Farrington
John and Jane Pezzenti
Andreas Feininger
Tina Edge
Geneva Craig
John and Midge Garber
Tom Mahoney
Wayne Anthony Ross
Ken and Gerry Kard
Mjr. Tom Ricardi
Massachusetts Bird of Prey
 Facility
Wendyl Pedrone
Acadia National Park
Port in a Storm Bookstore
Kodak Professional Imaging
Jean Knoblock
Audrey Jonckheer
Claudia Schultz
Cathleen Fritsch
Dave Chipkin
Roger McAbe
Kodak Processing, Fair Lawn,
 New Jersey
Wimberley Tripod Heads
Clay and David Wimberley
Really Rite Stuff
Bryan Geyer

Kinesis Photo Gear
Richard Stum
Len Rue Enterprises
Applejack Licensing
 International
Bernard Fine Art
Michael Katz
Jack Appleman
Bar Harbor Chamber of
 Commerce
Lynda Z. Tyson
Atlantic Oaks
Sonny Cough
Everglades National Park
Dr. Bill Robertson
Richard Ring
Pat Toll
Flamingo Lodge and Outpost
Gary Sabbag
Julie Fondriest
Florida Auto Rentals
Todd Salzera
Big Cypress National Preserve
Debra Jensen
Rogue River Wilderness Area
Howie Tocher
Willie Cowie
Rick Robertson
Northeast Utilities
George B. Brosky, Jr.
Massachusetts Division of
 Fisheries and Wildlife
Tom French

Bill Davis
Sgt. Tony Brighenti
Janet Martin, D.V.M.
Paramount Pictures
Wild Things Television
Brady Connel
Michael Norton
Carla Jetton
Bertram Van Munster
Maria Baltazzi
Tompson Gun Works
Tim Tompson
L.A.R. Manufacturing, Utah
Skyline Sales
Bruce Friend
Great Alaskan Sportsman Show
Steve Shepherd
Tom Condon
Nick Fucci
Dennis Dolsby
Abear Photography
Arnie and Carlie Grisham
Kenai Lake Lodge
Joe Casassa and family
Wayne Carpenter
Bill and Marie Tracey
Brian McTeague, Castle Sedans
 and Limousines
Irvin Campbell, I.R.B.I.
Dr. John Gerster
Ardith Hunt
Bob Barclay
Lisa Marrett

Bayside Inn
Jim Hamilton and family
Tom Walters
Katmai Wilderness Lodge
Kenai National Wildlife Refuge
Dr. Theodore Bailey
Mary Portner
Joni Stephon and Walt Stephon
Sharon Lebowitz, Nikon
Robert Sabin, Katmai Bob
Lee Raiter
Tito's Discovery Cafe
Henry D
Skip Dent
Nikki and Loren Stewart
Gary King's Sporting Goods
The Nolan family
Lowell Thomas, Jr.
Yvonne Evans
Lew Freedman
The Anchorage Daily News
Ludwig Laab
Terry Marlett
Tim Davis
Chapel by the Sea
Eldy and Walter Covich
Castleton Custom Processing
Alaskan Marine Highways
Frank Zazarek
Bill Hysom
Ben Benedictson
Jan Van Den Top
John Botkin
Photo Craft Labs
Betty Fuller
Larry Casey
United States Air Force
Russ King
Wolf Color Chrome Lab
Myles Wolf

Chevrolet trucks
Cleaning World I and II
Obeidi's Fine Art and Framing
Said Obeidi
John Carrol (Bodine)
Ted Miller
Kenai Air
Vern Hocstetter
Dr. Horst Niesters
Dr. Fredric Van Grough
Nova River Runners
Jim Galbrith
Jay Dole
United States Coast Guard
Former President Ronald Reagan
Homer News
The Willard family
Rick Johnston
Carl High
Tangle River Inn
Nadine Johnson
Tom Cooper
Alaska Horn and Antler
Tony Pezzenti
Harold James
Kip Dougherty
Captain Chuck Girard
Jules Roinnel
World Trade Center
Barnes and Noble Booksellers
Ed Bailey
Mikel Dickenson
Barbara Bolton
Donning Publishers
Turnagain Chevron
Joe's Body, Paint and Frame
Dr. Steven Meneker
Dr. Hans Hager
Providence Hospital
Linda Shogren

The North Face
Mike and Monique Prozeralik
Alaska Airlines
Alaska State Troopers
Dr. Ron Martinelli
Philip Garbowski
Innovations
Governor Walter Hickel
Kachemak Air Service
Bill and Barbara de Creeft
Jeff Schultz, Alaska Stock
Sandy Wilbur
Dr. Barth Richards
Kenai Peninsula Clarion
Commander James T. Bankhead
Fred and Heidi Koster
Tom Fogerty
Fran Hut
Bob Reardon
Willis Schroeder and family
Max Lowe
Regal Alaskan Hotel
Fire Department, Marco, Florida
Ed McKoy
Dr. James Scott
Dr. David Spencer
Lori Stevens
Shutterbug magazine
Bonnie Paulk
Barry Tanenbaum
Petersen's Photographic
Roy S. Leach
Outdoor Photographer
Rob Sheppard
Mark Edward Harris
Sourdough Productions
Kim Jones
My sisters: Jean, Jane, Jeanine,
 and Joyce
Michael Fragnito

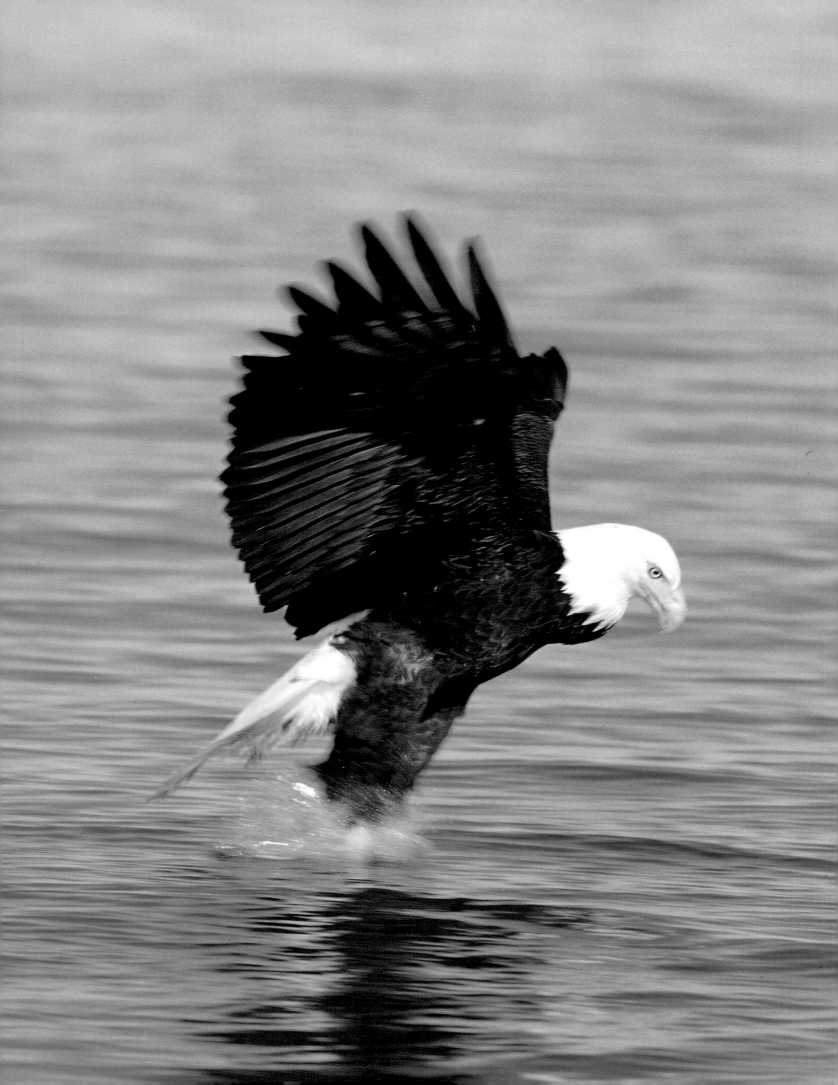

INTRODUCTION

It was as beautiful a day as the heavens could possibly allow. I slipped cautiously over the bow of the boat and into the muddy, unforgiving waters of the Florida Bay. Moments before, I had checked my thermometer, which was knotted to the zipper of my photo vest. It was 102 degrees, and the water, although putrid, was a relief to this nearly sunstruck Alaskan.

For days on end, my father and I had cruised the brackish waters of the Everglades and Florida Bay looking for young bald eagles, but with no luck at all. The expedition was carefully planned around the cycles of Florida's nesting eagles; finding immature bald eagles to photograph was our main mission. The only thing we had not taken into account was a hurricane, and Andrew more than rearranged our plans.

We arrived in February 1993, six months after Hurricane Andrew hit, and the evidence of mass destruction was still all around us as we drove through Homestead, Florida, heading toward the headquarters of Everglades National Park. As we passed mountains of wreckage and millions of pieces of scattered debris, the thing that touched me the most amid the total chaos was the haunting look of sorrow on the faces of hundreds of misplaced people lining the roadsides. Never again would I feel so removed from an act of devastation portrayed on the nightly news.

Park headquarters were a little worse for wear, and although several buildings sustained heavy damage, they were still open for business. After a few hours of presenting credentials and explanations of purpose, I was issued a permit to work in the park and was told where I could find Dr. Bill Robertson, the head scientist of biology for the Everglades for nearly fifty years.

After several hours of searching endless park buildings and being pointed in a multitude of directions by several biologists who all told me that he was too busy to meet me, I finally found him. As predicted, he was hesitant at first to give up any of his time. The storm had ripped open a building that housed decades' worth of his scientific studies and had scattered the majority of them to the four corners of the world. He was in the process of organizing a great loss, a loss that affected us all.

"So, you're from Alaska?" he asked quietly as he gestured to a seat at an old military conference table, a relic of World War II, no doubt, all metal and massive. His sun-bleached face was a battle map of conflict and nobility. He had dedicated his life to saving the Everglades. To me, it was like meeting John Muir or John James Audubon. I told him that I was hoping to photograph some immature eagles on this trip and asked him for his help in locating nests that had not been destroyed by the hurricane. He flipped through my eagle portfolio and remarked on the many unique shots that I had captured over the years. He understood that I had spent much time in the wilderness and he finally said, "Go ahead, you can work the Everglade Keys, but remember, nobody's been on several of them for forty-five years. Be careful, be gentle, and don't disturb anything." He abruptly but politely took his leave and I was still at the massive conference table when he tossed me a smile on his way out the door. As I gathered my portfolio, a sense of awe and reverence overtook me at the realization of what I was about to experience.

Nearly all of my youth I dreamed of going to the Everglades, the last great wilderness of the Eastern Seaboard where I grew up. Now, after nearly twenty-five years of living in the wilds of Alaska, I would perhaps comprehend and appreciate the Glades even more. My father and I drove south to the Flamingo Outpost.

Standing on the rocks at Flamingo, gazing out over a seemingly endless watery horizon dotted with mangrove islands, was as inspiring to me as seeing the polychromatic mountains teeming with wildlife in Alaska's Denali National Park for the first time. As always, however, man is altering the environment and the results are devastating. The great swamps of the Everglades are slowly being strangled by our need for an endless supply of water. The fresh water supply at the top of the Everglades is being cut off by thousands of pipeline irrigation ditches and various crop-watering apparatuses. Without an optimum flow of water flushing the swamps, the sediment never reaches the ocean, as Mother Earth so perfectly designed. Thousands and thousands of miles of Florida Bay have neither enough saltwater influx nor freshwater outpour due to the sludge deposits. The saltwater simply can't get in to purify, and the fresh water can't get out to cleanse. Because of this, everything is slowing dying in a world of stagnating water and nutrient-deficient sludge.

Despite the current environmental problems, the Everglades is still one of the strongholds of the bald eagle and Florida has consistently served as a barometer for America's eagle population. The population of Florida's eagles has always been the highest in the lower forty-eight states. Prior to World War II, there were more than five hundred active nests in Florida, with about four hundred nesting pairs and some fifteen hundred to two thousand bald eagles statewide. Due to the use of the pesticide dichlorodiphenyltrichloroethane (DDT) during and after the war, that number plummeted to less than fifty nests by 1960. Today, two decades after the banning of DDT, Florida's eagles are on the rebound, with populations almost reaching the same levels as before the war. Our American eagle is a fishing hawk that almost always lives by a body of water, and Florida and the Glades are the perfect environment.

The irony of Hurricane Andrew and the devastation it brought upon civilization would come to me weeks later when I realized that humans bore the brunt of the storm and that the natural world, although battered, continued on. Undoubtedly, the storm had taken its toll on the eagles of the Everglades, but in all, that was nothing compared with *our* destruction of this magnificent, noble winged creature. In the history of the world, including the Ice Age, natural and cataclysmic events would not cause even a fraction of the deaths of flora and fauna as one animal alone—humans!

I steadied myself on the gunwale of the boat and for an instant felt as if I were slipping into a warm, muddy abyss with no bottom. As I started to reach for the bow of the boat, I finally felt firm ground below three feet of water and a foot of sludge. There was simply no other way to approach this island, and the only immature eagles we could find after weeks of laboriously searching the Glades were roosting alongside their nest in a tree above the only affordable landing site on the entire key. We certainly wouldn't take the chance of scaring them into shock by landing on their front doorstep, as eight-to-twelve-week-old eagles are in a stage of rapid development and are extremely susceptible to any outside or human contact. In fact, the eagle survival rate for the first years is staggeringly low, even without the effects of DDT. I figured if these two had survived Andrew, then far be it from me to disrupt the ebb and flow of their life on this mangrove paradise along the farthest outskirts of Florida Bay.

Shifting my sludge-entombed feet caused a stir along the precariously uneven mud bar, releasing an incredible, ungodly odor. My gag reflex left me a millisecond away from vomiting as I grasped my mouth and nose to ward off the hideous smell. Even here (as close to Cuba as to Miami) where the tide still affects the bay, the silt and sludge don't make it to the ocean anymore because of the weak water flow at the top of the Glades.

The bow of the boat was now at my chest level—it had dropped a foot since my decision to go ashore. This, as well as the falling waterline on my body, made me realize that the tide was moving more quickly here than at the dozens of other keys we had approached farther in. A moment later the skipper of the boat motioned for me to get back into the boat. I waved him off, grabbed my cameras and tripod off the bow, and with the same fluid motion, gave the swamp boat a solid push back.

At that moment, with that swift and deliberate push, I sealed my fate for the next eighteen hours. It

would be an experience of horrifying magnitude for this northern woodsman, one that would knock me down to size and teach me that Alaska isn't the only place you can die in a millisecond in the wilderness.

My father, who had remained silent all this time near the back of the boat, shouted a loud and concerned, "What the hell are you doing?" With my left hand I put my fingers up to my lips and he realized at once the need for silence. With my other hand I jockeyed my cameras while trying to maintain my balance. "Tomorrow, high tide, I'll be right here," I whispered. "Now get gone before you're here all night as well."

It was almost too late—the rear of the boat was in mud—but after nearly ten minutes of wresting and dragging the boat, my father and the skipper hit water deep enough to start the engine. My father tossed me a last glance of disapproval as the boat rounded the northern tip of the island. In a few moments the roar of the supercharged engine faded away, and I was left alone in the mud with only the sounds of water lapping at my waist. It was now 105 degrees.

Focusing all of my attention on balancing, I started closing the watery gap between myself and the island. The mangrove roots that engulfed the island had a menacing appearance as I approached them at eye level. The ten-foot distance between the mud bar and the island was a trough of indiscernible depth. It felt as though the island was warning me to keep out as I grabbed for the first mangrove root while neck-deep in the water. My grasp was firm enough on these slick roots that live half their lives below the tide to pull myself closer to the island where roots shot up nearly four feet above my head.

Taking a moment to relax, to calm myself from going through the shark-infested slough, I got my first real look at the entangled black roots that formed the substructure of the island. There was no question in my mind that I was flirting with disaster as I balanced my cameras and tripod above me on the dry roots. Still in water up to my neck, I pulled my way through roots that now resembled a million foreboding black spiderwebs in the afternoon shadows. I felt like I was breaking into the island of Dr. Moreau.

Using the water to float my body up, I forced my legs onto a level of roots that I could maneuver from. One handful of roots and two pushes promptly left me lying on the top of the eerie spiderweb formation. The only sound I could hear was the water running off my body and dripping into the ocean below my precarious perch.

I was easily able to discern how this prehistoric island devoid of humans was created. The innermost part of the island was naked at first glance. Struggling to maintain balance, I caught views of the growth around me and realized that this mass of roots completely encircled the island, extending from the water's edge to nearly thirty feet inland. The outer mangrove roots actually formed the island, as there were only a few trees visible in the interior and they appeared dead. As I walked toward the center, my feet soon tired from continually searching out footholds. Finally I found a way down from the roots and onto the island floor.

A wave of bushes and growth resided just inside the mangrove roots and circled the island much in the same fashion, albeit inland, and out of the water. As I jumped down a foot, I landed with an audible thud and the bushes and grass engulfed me. Suddenly, I heard the sound that I fear most of all, and I froze instantly.

When I was very young my parents struggled gallantly to move our family from the inner city. My hobbies changed from jumping roofs to catching turtles, snakes, frogs, and a variety of animals that would fit in my pocket until their relocation to our back field. Within the first few months of my newly found explorer talents, I would get stung by twenty-eight bees at one time, grabbed by a snapping turtle (I still have the scars), have to remove hundreds of leeches from various swamp ordeals, break my arm in four places and—most horrifying of all—get attacked and bitten through the hand by a five-foot-long snake. It had taken fifteen minutes for me to pry the snake's jaws from my hand. Since then, a fear of snakes has never left me.

I struggled to decipher how many rattlesnakes were around me. Six . . . ten . . . twenty rattlers. My whole world turned to slow motion. I flung myself backward, up onto the entangled mangrove roots, with a giant eastern diamondback rattler attached to the heel of my water-soaked boot. My body went down entangled in the roots as my feet flung high in the air, flailing around, trying to shake off the rattler. My ears were inundated with the sounds of hundreds and even thousands of rattlesnakes all signing protests from the commotion. It was a horrifyingly orchestrated alarm as I realized the entire bed of the island was diamondback rattlers. The poisonous rep-

tiles sounded in waves back and forth across the floor. With one last swing of my leg, the one on my boot went hurtling toward the island center. A few weeks earlier, someone at the Big Cypress National Preserve in southern Florida had told me of such a gathering of snakes, but I just shuddered and dismissed it. I even once read that an eagle biologist went ashore on an island farther north to count eagles and encountered thousands of rattlesnakes. He fled from the island in his boat, never to return. These thoughts, plus a thousand others, ran through my mind at a million miles an hour.

What to do next? How to survive the night? Certainly my mission of photographing the young eagles would now have to be abandoned. *Eagles eat snakes* flashed into my mind as I grabbed my cameras and headed for the eagle nest. Not five minutes had passed since I shook the diamondback from my boot.

A breeze drifted in, slow and cool, from the open ocean and was a relief to my sweat-drenched body. It was easy to see why the parenting eagles had built their nest here. The approach and view forward was totally unhindered and left easy fishing strikes to the north end of the slough I had crossed. More important to me, however, was the rear pathway to the nest, which looked like a dirt landing strip, nearly vacant of foliage save one bush. They had chosen wisely; food, easy flight paths, and the best light were all in their well-laid plans. The nest was vacant, and I began to climb toward it.

Eagle nests vary in size and structure; the eagle's engineering abilities are second only to that of the beaver. The largest eagle nest in the world is in St. Petersburg, Florida, and measures some ten feet wide by twenty feet high. This small but functional nest in front of me was a far cry from that. It was about three feet wide and firmly woven into the fork of the tree with intertwined braces about two feet deep. I was quite sure that both the eagle parents and their two offspring would become greatly agitated as I attempted to access the safety of their nest.

The parenting eagles had followed my progress north along the roots, stopping to hiss above my head from the treetops. I welcomed their company as each wing beat and radical scream of objection to my presence caused a cherished moment of silence among the snake colony.

The air rushed from my lungs as I struck the ground with my chest. It was my sixth jump at the branches that would give me access to the eagle nest. I gasped for breath while staring at ground level at the leftover body parts of the varied eagle cuisine. The floor beneath the nest had an amazing array of discarded and unwanted remains: rosy spoonbills, egrets, flatfish, bonefish, barracudas, small sharks, feathers of various birds, and, most pleasing of all, snake parts.

Dread once again overcame me as I realized that it was impossible to reach the nest and spend a safer night there than on the island floor, regardless of what the eagles might do. The long shadows of sunset became apparent as I climbed several more trees that refused to bear my weight. From the last fall through the branches, I knew that I was fated to sleep on the ground among the rattlesnakes. Gathering the courage to leave the safety of the nest area, I imitated the *whoosh, whoosh, whoosh* sounds of eagle wings and the familiar "kii-kii, kii-kii" scream as I walked along the dirt floor landing approach toward an ominous-looking bush one hundred feet from the nest.

"What do rattlers do at night?" I said aloud to nobody as I surveyed the dome-shaped bush. "Kii-kii, kii-kii," I cried aloud, and for the first time the eagles answered. I turned around just as the two offspring landed in their nest. All four eagles cried and hissed and looked at me as though I was an idiot as I began to whack the bush with my tripod to see if anyone was home. Nobody answered, so I crawled inside.

My life would be measured in a matter of hours unless I turned the bush into a defense barrier of some kind. The eagles' presence as well as their commotion afforded me a little time. But how long before one snake found me in the oncoming darkness that was not more than thirty minutes away? *This is perfect,* I thought as I surveyed the hollow interior of the bush that resembled a dome tent. First things first, and I went back outside to urinate around and on the outside of the bush, hoping the scent would keep all animals away. Once

inside, I removed my tripod head and started digging in the center of my leaf-and-vine cave. My plan was to dig the center of the bush down about a foot and some eighteen inches wide and pile and pack the dirt up along the inside perimeter of the ditch to form a wall, thus preventing the diamondbacks from slithering onto me in the night.

The diamondbacks became more active as sunset drew near. As the lowering sun shot a thousand light beams through my defense barrier, it was obvious that a snake could fit in a multitude of places above my dirt barricade. The two garbage bags that I always carry in the rear pocket of my photo vest to protect my cameras from the elements instantly came out and were cut in half lengthwise. Weaving the eight one-foot-by-four-foot cut pieces through the bush atop the dirt mounds left me feeling more protected than ever as my dirt-and-plastic wall now nearly reached the bush's inner roof. Wiping the many unearthed bugs from my face, I laid back into my coffin of dirt and plastic and stared straight up to see the first stars of the night peeking at me through the last remaining holes of my fortress.

Pushing the side button on my watch revealed that it was 9:45 P.M.

"Self-control is strength, right thought is mastery, calmness is power," I began to recite over and over in my mind. That passage from *As a Man Thinketh* by James Allen had helped me through quite a few tough scenarios in my life, but now it didn't even make a dent in my current state of despair. I switched over to "Though I walk through the valley of the shadow of death, I fear no evil."

Each time a diamondback skirted the edge of the bush or banged its head into the plastic, I would scream "kii-kii, kii-kii," and everything would go silent for a moment. Only once in the night did the eagles ever answer my ridiculous imitation. But that answer made me feel not so terribly alone.

Twelve long hours after crawling into that bush, the first few rays of light illuminated the skies. It was hard to distinguish the light at first, as I struggled to adjust my eyes and examine the structure for diamondbacks. Without knowing it, I had collapsed in exhaustion and had managed to get a little sleep. The guide boat approached the small beach below the nest with a brown pelican sitting atop the stern drying its wings. In the morning heat, the pelican resembled a pterodactyl and the scene seemed apropos to the night's events. After deconstructing

my horror chamber, I washed in the slough and patiently awaited my father's return. There are no words to express my relief as I stepped aboard the craft and my father handed me a sandwich.

We spent the next few weeks crisscrossing south Florida looking for eagles. I managed to take a handful of photographs, and for that entire time I never got out of the truck or off the boat. We were scheduled to explore islands off the coast of New England next, but I postponed that trip and went home to Alaska to regroup. Yet even my harrowing experience with the rattlers would not long deter me from pursuing my photographic project of eagles in the wild.

◆

"Run, Artumus Gordon! Run!" I shouted to my cat as he broke out of the forest and ran across the tundra with a diving eagle in rapid pursuit. The grace and agility of the mature bald eagle in a foiled attempt to seal the fate of my cat was a sight to behold. Good fortune had been mine as we set up our remote camp not far from a magnificent pair of nesting eagles, although I'm sure my cat would have preferred another location. Each day brought untold adventures. It was here on the clam-filled beaches of Polycreek, on the west side of south central Alaska's Cook Inlet, that I would begin to study our American eagle. I was a young man of twenty-four at the time.

I had taken a position with a wily old cuss named Bob Barclay to construct a camp and operate a remote-site clam dredge in the wilds of Alaska as a means to reaching bald eagles on some of the most godforsaken coasts in North America. Barclay, a long-time wilderness inhabitant and an expert on eagles, proved to be a wonderful teacher. During his early years in Alaska he had fought to stop the eagle bounty, in which one hundred fifty thousand American eagles were killed because people ignorantly believed that eagles were carrying off livestock and killing off fish populations. The bounty finally ended in 1952, when Alaska was no longer exempt from the 1940 Bald Eagle Protection Act.

Over the course of the next two and a half years, Barclay would explain how road construction and land development claimed countless bald eagle lives, nest sites, and habitat areas. He would spend days and weeks showing me wing structure and how eagles maneuvered in the air. He was virtually an encyclopedia of bald eagle information at a time when no one

was paying much attention to our American icon. The information he gave me has lasted with me to this day, more than twenty years later.

The clam dredge was constantly breaking down (I call the entire episode a "clamtastrophy"), leaving me with plenty of time to study the thirty or so eagles in the area. Slowly it became clear that it would be impossible to approach these eagles in any fashion. It was during this time that I would find the inner determination and learn the skills needed to carry my bald eagle work to all corners of our nation. One thing was certain and constantly reaffirmed over the years: All the photographs would be of wild eagles. There would be no zoo photos or computer-generated images, no fake trees planted with fish tied to their limbs as lures. The birds would all have to be wild and free as America once was. I knew it would be an extremely difficult undertaking. Each day another Polycreek eagle flew away at my appearance, and Barclay would laugh and tell me, "More patience next time, John, and put the cameras away until they accept you."

The eagles in this area were stately birds whose behavior contradicted a great deal of the literature I had read. Benjamin Franklin loudly protested naming the bald eagle as our national symbol, calling it a lazy bird that would rather steal than catch an honest meal. The exact opposite is true. I became fascinated above all else with the intelligence and beauty of these noble winged creatures.

On a day that Barclay was free he showed me a place where a magnificent and very large mated pair roosted. "They're just passin' through," Barclay explained. "But they always stop in these trees this late in the fall. They stay here nearly all winter feeding on the clam beds in front of them, but mostly they'll roost in their protective tree cover for about ninety percent of the day conserving energy. Eagles are massive birds living in this harsh environment; they must conserve their energy roosting or perched motionless to remain warm and to be able to muster the strength to feed. Let's not approach too close, as we'll make them fly. They need all the energy they can save for this winter."

The only communal hunting ground the eagles had in the area was a five-mile hike down a rocky

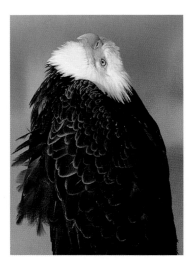

beach to the mouth of the Grecian River. Here several eagles would gather atop massive pine trees to scan the water for fish. I would make the long and arduous hike no less than fifty times the first season to observe their behavior. Several serious incidents would befall me on various walks to the river. Getting trapped by the tide and forced into the cliffs or being surprised by giant brown bears became common occurrences. Yet, the chance to observe eagles in their natural habitat was more than worth the dangerous encounters.

Often adventure pales in comparison to a new observation, and my small outposts along the walk afforded me a quiet and peaceful life among the great birds. Several large, very powerful mature eagles had fishing sites along my oceanside trek and I witnessed many wonderful and amazing forms of behavior. The most notable back then, and still today after years of observing our national icon, started with the appearance of a small and comical porcupine.

As I watched the slow-moving, lumbering little creature some two hundred yards down the beach, the largest eagle in the area dropped from his perch and dove on him. Calmly, and without much adieu, the basketball-sized porcupine raised its quills at the sound of the airborne assault and froze. The eagle's first pass seemed like a playful antic and I paid it no attention until the eagle flipped in midair, turned, and dove to grab the unfortunate porcupine's head, flipping the animal a few feet in the air.

In my life that I have been so blessed to spend among wild animals, I have witnessed innumerable and extremely dramatic battles for survival. I have watched giant bears kill cubs and moose calves, and seagulls and hawks kill baby loons and terns. However, this small porcupine's fight for life displayed an amazing and unprecedented will to survive. Several more aerial assaults left the little guy dazed and confused as he waddled around at the quickest pace a porcupine could muster. In his confused circular motion, he ran into a large rock and quickly attempted to bury his head in the sand in front of it. The eagle perched on the rock directly above him, rested a few moments, and began to pull

quills from its massive feet with its beak. After a few more minutes of preening, the giant bird simply fell from the rock with outstretched wings and caught the porcupine tail to once again send him hurtling through the air.

Close to his demise, although far from giving up, the porcupine gallantly and defiantly squared off face-to-face with his assailant, who had now landed on the beach opposite him. With everything the comical and adorable little porcupine possessed, he waddled and charged the towering eagle. The giant raptor, obviously finding this turn of events puzzling, if not amusing, simply hopped in the air and landed a few feet away. The nearly dead porcupine repeated the charge over and over until the eagle simply locked its talons around the brave little guy's head, and it was over. If ever there was a wilderness analogy to David and Goliath, this would be it, except for the ill-fated outcome.

Saddened by the dramatic struggle for life, I watched the eagle attempt to flip the dead porcupine onto his back. It no sooner accomplished this than its great wings filled the air, and with a great deal of effort, he lifted off to carry his prize out to a sandbar to dine on it until the tide forced him out. In the strange irony of the wilderness world, a few weeks later I would watch this same eagle lock its talons onto a monstrous king salmon and be whisked underwater in a deadly second, never to soar the skies again. I said to myself, while watching the eagle go under with only enough time for a partial frantic scream, "Bad karma."

Artumus, my cat, survived the eagle's aerial attacks all that year, only to be killed by a great horned owl the following winter. The clam project was doomed. High tides and monstrous waves carried off food, fuel, and even our refrigerator. We had several near plane crashes, a crew mutiny, and two of our dogs met a horrible demise in the blades of a mail plane. A group of ragtag hand clammers and drunk fishermen who worked the few remote nets was more than a handful to deal with. Often I would stand guard on the bluff above the camp, rifle in hand, and fire a volley of shots across the bows of their dories to keep them out.

In spite of everything, Barclay never faltered or complained. Even when all hope was lost for his dredge, he would spend countless days with me showing me vital components of the eagles' habitat or the aerodynamics of their wings. Together we'd find various eagle feathers in an attempt to reconstruct a wing and he'd explain what each single feather did. Today, at the age of ninety-two, Barclay is still teaching me, and I have yet to meet anyone with more firsthand field knowledge of eagles.

Following my eagle education with Barclay, I would live the next ten years among the eagles of Alaska's Kenai Peninsula and in Haines on the Chilkat River, an area that is host to the largest gathering of American eagles in the world. In those years I would spend more time with bald eagles than with humans, continuing my studies of eagle life and behavior.

◆

"Possessing exalted moral or mental character or excellence; very impressive or imposing in appearance; stately; magnificent. Of an admirably high quality, notable superiority." These were the definitions of *noble* that I discovered the first time I ever looked up the word in *Webster's Dictionary*.

At the inquisitive age of twelve I saw my first bald eagle above the sleepy back roads and forests of Mansfield Hollow Dam in Connecticut. My father and I were driving back home from a night of fishing when this incredibly monstrous winged creature appeared before us, filling our entire field of vision. With reverence and an awe-filled voice, my father, who had been as struck by the sight as I was, simply said, "What a noble creature!" At the time, I didn't fully understand what noble meant. I just sat in silence, watching as the eagle soared above us. That initial feeling of awe at the great bird's presence has never left me. And the word *noble* in my mind is forever linked to the bald eagle.

The close friends I have are as diverse as the contents of a chef salad. There are a few doctors and psychiatrists, three or four university professors, a couple of mechanics and accountants, many photographers, a few multimillionaires, governors, statesmen, ditch diggers, and several cops. Combine them with the dozens of equally diverse folks I meet each year in my travels and that creates a fairly broad base of life experiences. But, for all of these people, one of their most powerful memories is the first time their eyes transfixed an American eagle. From the Atlantic to the Pacific and from Mexico to Alaska, the eagle stories told to me countless times are really more than stories. I believe they are a multitude of inner reflections of pride and nobility

that are released when one stands in the great bird's presence. These tales of eagle encounters are as varied as the personalities explaining them, and I have learned to remain silent so that I might understand more about the encounter as well as the person.

What the hundreds of stories ultimately tell is the pride that Americans have in their country—a reflection of the past when dignity and freedom were our most cherished possessions. Visions of the American Revolution, the Constitution, George Washington, and Abraham Lincoln soar through our mind's eye as we observe our national bird. The American eagle may very well be the only living monument that can ennoble the human spirit and help us to regain our pride in this great country.

◆

My many trips throughout the country to photograph bald eagles were almost all complete failures. Injuries, failed or lost camera equipment, and the weather were all contributing factors. However, the main reason was that there weren't many eagles in 90 percent of the country when I started working to depict them more than twenty years ago. The effects of habitat destruction, illegal shooting, and DDT had reduced the eagle population in the lower forty-eight states to fewer than 450 nesting pairs by the early 1960s.

It is still ludicrous to me that Swiss chemist Paul Müller won the 1948 Nobel Prize in Physiology or Medicine for the discovery of DDT's insecticidal properties. The deadly potion was used to kill insects that fed on crops and malaria-carrying mosquitoes during World War II. I'm quite sure many veterans are glad he did make the discovery, but more tests should have been performed on the environment before releasing such a horrendous poison on a global scale.

In Florida during World War II, amateur ornithologist Charles Broley began eagle nesting and reproduction counts. His study of failed nests and the drop in the number of immature eagles went on for nearly twenty years and would ultimately tie in DDT as the killer of all things great and small. Joseph Howell, a professor of zoology also working on eagle reproduction in Florida, confirmed Broley's findings. Years of crop spraying and coastal spraying to eliminate mosquitoes had allowed DDT to find its way into anything and everything that eagles ate. It didn't kill our great bird outright, but it destroyed the eagle's ability to procreate. By the late 1960s and early 1970s it was determined that a principal breakdown product of DDT was accumulating in the fatty tissues of females and preventing the calcium release needed to create strong egg shells. Clear across the country DDT was the primary reason for thousands of failed eagle nests. If Charles Broley and Joseph Howell hadn't performed their dedicated studies in Florida, our skies would be devoid of the great American icon.

After Broley's findings, the National Audubon Society launched a nationwide eagle survey in 1961 to determine the devastation. This study, along with a growing concern from dozens of states in the nation, finally brought attention to our rapidly dwindling eagle populations. In 1967, the bald eagle was officially declared an endangered species in all areas south of the fortieth parallel. Following the Endangered Species Act of 1973, the bald eagle was listed as endangered throughout the lower forty-eight states, except in Michigan, Minnesota, Oregon, Washington, and Wisconsin, where it was listed as threatened.

Nearly thirty years passed before the full-scale use of DDT was banned in this country, in 1972. It was yet another decade before anyone would attempt to reverse the deadly effects of DDT on a large scale. In 1982, the United States Fish and Wildlife Service launched a program called "The Year of the Eagle," and finally, notice was paid to the wingless skies over America. Today the population stands at more than five thousand nesting pairs in the contiguous states, with an estimated forty thousand eagles in Alaska.

My photo exploits during the 1970s and 1980s were faring only a fraction better than the great birds. Along the Big Sur coast in California I spent weeks climbing cliffs, struggling for even one photo of a Big Sur bald eagle. I soon discovered that I had been hiking through poison sumac, and ultimately I ended up hospitalized with infected and swollen-shut eyes and throat. From Arizona to Oklahoma, things went better until a lodge I was staying at in Colorado caught fire in the middle of the night. After traveling through Montana and Washington, my group nearly drowned on a flooded Rogue River in Oregon. Our dory is still there, crushed at the bottom of Devil's Staircase. We were airlifted out, as two of my crew were in serious shock.

All of these mishaps pale in comparison, however, to the loss of my best friend, Ken Kard. Ken, one of Alaska's top photographers for twenty years, died in a car accident while counting eagles for me on the Kenai Peninsula one year. He had been stopping at designated locations checking eagle populations en route to picking me up for a week of work on eagles for this book. When Ken passed away I feared that I would never be able to finish this project. When someone loses his life helping you, no matter what the circumstances, it is hard to justify or in any way rationalize the importance of the project. Weeks turned into months and months into a year, and my sorrow at Ken's passing still shrouded all my work on eagles. Eventually, I once again left Alaska and traveled to Maine in an attempt to work on eagles far from the area that claimed my friend's life.

◆

After being inundated with facts and statistics all morning at the headquarters of the Acadia National Park in Bar Harbor, Maine, my father and I decided to check on the eagle nests we'd found ourselves on our previous trips. I was greatly disappointed by all the statistics and reports I'd been examining on my many trips to the rocky coasts, woodlands, and mountains of Maine. With each trip through New England, it became painfully apparent that Maine residents were not actively working to bring the eagles back to their state.

During the year of the eagle in 1982, Maine never really joined in, according to some park officials. The reasoning was simply that they had plenty of eagles everywhere. So while all the states around them were diligently working to replace the birds, Maine continued losing them. I have always felt that Massachusetts had the most dedicated team in the country working on eagles. Teams in New York had already been importing and transplanting eagles from Alaska since the 1960s. It was actually sad to make my regular trips from Massachusetts to Maine. So many eagles were dying and nests were failing in Maine while Massachusetts was experiencing a rebound. The mercury levels in the water, and subsequently the fish Maine eagles ate, were poisoning this great state's eagle population. This combined with the harmful forces of tourism and development finally reduced the eagle numbers so greatly that Maine took notice and followed the lead of its neighboring states. In the 1990s, through the

hard work of many dedicated wildlife folks, the situation improved dramatically.

Out on the Somes Sound I rowed the last two miles to shore with aching hands and arthritic shoulders. The mass of foreboding clouds above our heads released a torrent of water, and in seconds we were soaked to the core and petrified of the lightning strikes that were touching down all around us. I couldn't help thinking what an idiot I had been for wanting to check one nest that no one else knew about—but I had to do it. The nest was there and I, by the grace of God, managed to capture a forest flight photo before the downpour. It wasn't much of a photo, but to me it represented thousands of hours of searching for nests that only I knew existed.

The rowboat struck the dock of Wendyl Pedrone's house, and my father and I received a quick greeting from Wendyl, who was shielding his eyes from the rain. We had met Wendyl some years before when we discovered an enchanting place to work on eagles. At the head of Somes Sound, standing on the great white granite rocks at the edge of Wendyl's property, it is easy to comprehend the Viking folklore of centuries past. The locals in Somesville are protective of the beautiful surroundings and bald eagles and take pride in the fact that the Norwegian explorer Leif Eriksson is buried somewhere in the area. They hope to keep their little coastal paradise from turning into a great tourist frenzy like Bar Harbor, which is only a few miles away. My father and I first met Wendyl and his mom several years ago in the parking lot of the Port in a Storm Bookstore that adjoins their beautiful home. At the time, not many folks knew about the few eagles that often flew behind their home while fishing for herring.

After our first meeting in 1991, Wendyl would call me every year and I would make the journey from Alaska to pick up my father in Connecticut and drive the final thousand miles north, while checking eagle locations around New England all along the way. Over the five years that I made the annual pilgrimage, Wendyl's back parking lot of the bookstore went from a quiet, serene sanctuary to a crowded site with scores of people cramming in for just a glimmer of a chance to see the American eagle.

It was the evening following the horrendous rainstorm, and we had waited all day for the clouds to lift in order to see a mature bald eagle flying from one side of the cove into Wendyl's backyard and,

hopefully, into my camera's field of view. This night, however, I would lose my concentration, and experience being with eagles again as though for the first time through the eyes of the visitors.

People trickled in at first, until the group of twenty or so became thirty. Folks from all over the country stood quietly. In whispers they asked what everyone was doing there and they pointed at me standing behind my camera. Within a few moments the first eagle soared in from an unseen roost two hundred feet up in a pine tree. This great bird could not have entered more deliberately or dramatically as he soared just twenty feet above the crowd. All at once the whooshing sound of the eagle's wings reached the crowd as the great bird swooped right before our eyes and dove for a herring a few yards from our faces.

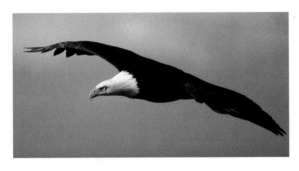

Everyone was ecstatic. The eagle was actually performing on cue as the crowd got splashed from the eagle entering and exiting the water. The cries of jubilation from the elated onlookers could never be duplicated, not even on a roller coaster at Coney Island. This was Mother Nature's wild ride on the wings of eagles, and everyone, including myself, was touched to the depths of their forgotten wilderness souls by the bird's awesome beauty.

In the midst of the eagle's swooping and circling, a small but notable thing happened. It began with the appearance of a Chevrolet van that proudly displayed the words BANGOR NEWS on its side. A tall man emerged in a haphazard, Mr. Magoo–like manner, comically dragging a lens the size of his lower body. In a frantic run he broke into the crowd, propped the well-worn lens on a rock and attempted to photograph the soaring eagle ten feet from his face. This, of course, was impossible, given the close distance of the eagle and the length of the telephoto lens. With a frustrated look he turned around and asked the crowd a question I'll never forget. "What kind of bird is that?" he bellowed out. The crowd stood and looked in amazement at the reporter with this magnificent bald eagle flying about his head. Everyone was so stupefied at his question that we just stared at him in a rather awkward manner. The few seconds of silence were broken by an adorable girl of about ten who simply said, "Why, that's a bald

eagle. Everyone knows that, mister." The reporter looked at the little girl, then with a bewildered and embarrassed look said, "That's a bald eagle? I've never seen one before. Thanks, folks." With that, he was on his way in the same ragtag, confused manner in which he had first entered.

Once he was gone, our attention was immediately drawn back to the water as a second eagle now joined in with his fantastic aerial maneuvers. During the last few hours of the evening some of us shared eagle stories while continuing to marvel over the eagles fishing in front of us. The one thing that I would remember about that evening was that comical reporter who didn't know what a bald eagle was. His appearance started a dialogue, and slowly, as the night played on, nearly two-thirds of the group admitted that they had never seen a bald eagle in the wild. All in the group were Americans.

In all of my trips to Somes Sound I would produce only two or three photographs for this book project. But I would do everything over again to spend that one evening with all those strangers and watch the bald eagles dance in the twilight and affirm what seeing this winged creature means to so many Americans. It was their first look at a living representation of the icon of freedom.

❧

"Eagle Mission in the Quabbin Reservoir: Injured Bald Eagle Nursed Back to Health" and "Fledgling Eagle Soars to Freedom" are a few of the newspaper headlines from the early 1990s that I've kept in my files concerning environmental police major and master falconer Tom Ricardi.

Sitting in a little diner that was completely enshrouded by giant oaks in Bartlett Cove in central Massachusetts, I awaited the legendary eagle team from the Massachusetts Division of Fisheries and Wildlife. This band of environmental police, veterinarians, biologists, and scientists was, and still is, the most dedicated group in the country working to restore our bald eagles to the American skies. They are all my heroes.

A few months earlier, I had been invited along by Bill Davis, the eagle project leader, to document for

this book the work of the eagle team. Two baby eagles Tom Ricardi had raised from eggs were to be carefully placed into nests in the area that day. Over the past six years, Ricardi has raised about a dozen eaglets and relocated them to nests both in the New England area and in western states. The eaglets were produced by captive eagles that suffered from chronic injuries and could not be returned to the wild.

After meeting the group over breakfast, I was finally introduced to Major Ricardi, who had been caring for a twenty-day-old baby bald eagle outside the diner. Tom is a rather stately man who immediately reminded me of Kirk Douglas in the movie *Lonely Are the Brave*. When we shook hands his eyes met mine for only a fraction of a second before they focused on the will spear peregrine falcon pin fixed to the top of my photo vest.

We then all boarded an environmental police boat piloted by a hard-assed, but lovable, officer, Tony Brighenti, who escorted us across the cove on the Connecticut River. Tony had been labeled as tough cop years ago by my friends as well as my father, who all tried to work on the Bartlett Cove eagle nests. But Tony's smile and good sense of humor are fond memories for me even today. I truly believe that if not for the diligent and gallant efforts of Officer Brighenti to keep would-be intruders and photographers from eagle nests in his area, many nests would have been abandoned.

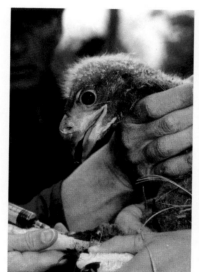

Tom French, the assistant director of the Nongame and Endangered Species Program in Massachusetts and climber extraordinaire, started the day off by ascending the giant dead oak tree that contained a nest with one surviving eaglet. The goal was to place one of Tom Ricardi's twenty-day-old eaglets into the nest to replace one that had died. We all watched as French climbed more than one hundred feet above the ground.

With a system of pulleys and ropes, the young eagle was lowered to the ground in a bag. Tom French stayed aloft as the parent eagle flew overhead. Ricardi, Brighenti, and Janet Martin, a veterinarian from Tufts University, performed a variety of tests and took blood samples to gauge the eaglet's health.

I have been involved in many an eagle program such as this, but never witnessed such proficiency in the task or such caring for the patient. All in all, the eaglet was back in the nest in less than twenty minutes—a fraction of the time it takes other teams. The solo eaglet was raised into the arms of Tom French, who at once removed him from the bag and placed him exactly where he had found him. I noticed a look of concern on Ricardi's face as he tenderly balanced his eaglet in his arms. It was easy to guess at the thoughts that ran through Ricardi's mind as his eaglet was placed in the bag for its ride to the top of the dead oak. Would the eaglet adjust to the transition? Would it fall from the nest in a startled moment? Would it be rejected by its stepbrother and/or be neglected by the parents? We quickly and quietly left the area after French placed Ricardi's eaglet in the nest and descended the tree.

Our subdued group gathered at the cars after debarking Brighenti's skiff. It was obvious that everyone was concerned. We left in various vehicles for Bill Davis's headquarters in order to regroup before placing yet another of Ricardi's eaglets into a nest near Holyoke, another town near the Connecticut River. As soon as we all arrived at headquarters, Bill Davis made a beeline for the telephone to call the couple back at Bartlett Cove who were watching the nest with spotting scopes.

Major Ricardi was still preoccupied when we started talking. His eyes again glanced at my peregrine falcon pin. I wanted to hear the story of how on earth he actually hatches and raises our American eagles. There has never been more than a handful of people worldwide who have ever accomplished this. My good friend Dr. Horst Niesters, of Wildlife Hellenthal in Germany, once raised a pair for President Reagan at the request of the chancellor of Germany. The pressure was enormous. He told me that the job left him with high blood pressure and ulcers. In Maryland, the United States Fish and Wildlife Service started a program in the late 1980s to raise bald eagles from eggs to release into the wild, but this proved so difficult that it was soon dissolved.

"No word yet," Bill Davis said, as he emerged from the backdoor of his headquarters. "Just got off

the phone and the parenting eagles are still circling high above the nest." Ricardi's worried look intensified as he watched me unfasten the falcon pin from my vest and hand it to him. "It's a will spear," I said as he reluctantly opened his hand to accept the gift. Later, downriver, he replied, "Thanks, ever so."

"John, come with me to my rehab facility to get the other baby eagle for the failed Holyoke nest," he said. I was delighted and flattered by the invitation and I gratefully accepted.

As in the days of old, an eagle was tethered in front of Ricardi's mountaintop facility. From before the Romans and up to Genghis Khan, eagles have been perched in front of houses of nobility and their images have graced ancient art and carvings. This eagle looked particularly stately against the picturesque New England setting of Conway, Massachusetts, located in the western part of the state. Although several of my friends are master falconers and I have visited many bird rehab centers, the Massachusetts Bird of Prey Facility is the most impressive center I have ever seen. "No one, anywhere, does this," I thought to myself as Ricardi led me through rows and rows of spacious cages. Golden eagles, barn owls, red-tailed hawks, kestrels, and falcons all sounded a note of jubilation at his approach as he guided me back to his greatest accomplishment of all, his breeding pair of American eagles.

"Wait here, John. I don't think it's appropriate for you to go closer. These eagles need as little human contact as possible to breed." The open wire structure that housed the mating pair of American eagles was huge, some fourteen to eighteen feet high and three times that in length. It was located far in the back of Ricardi's compound to deter unnecessary contact and had trees and branches growing inside as well as out. The entire enclosure looked like a scene from southeastern Alaska.

The raptor facility is much more than just a place to rehabilitate injured birds of prey for release back into the wild or to raise bald eagles from parenting eagles that are too injured to release. Major Ricardi's facility is a national treasure by anyone's standards. In addition, his educational programs have reached more than fifty thousand school children as well as countless clubs, organizations, nursing homes, and even prisons.

Ricardi talks gently to the parenting eagles as he scoops up the eaglet that is destined to fly wild and free. Nary a stir is heard from the parents. I can't help but wonder if they know what's going on. They definitely know that anything that Ricardi does is with his heart and in their best interests. The phone rings as we load the baby eagle into the back of the major's game warden truck. He goes to answer it and I wait next to the tethered eagle in the front yard—I have goose bumps of excitement all over. Ricardi comes back out moments later with a broad smile. "That was Bill Davis. The eagles have landed in the Bartlett nest and by all accounts have accepted the new one. They're feeding him, the spotters say. Now let's get back to the rest of the crew and hope for the same with this little guy." And we did just that. Ricardi and the team in Massachusetts are truly one of the main reasons there are eagle wings over America once again.

◆

The pain in my broken forearm increased tenfold as the Beaver DeHavilan I was flying in banked a turn to position for a radical beach landing. At that moment, with the G-force nearly plastering my face to the downside window of the airplane, I got my first look at the remote compound where I would be staying to complete the photographic work for this book. What I was looking at was nothing short of a scene out of *Swiss Family Robinson*. But it would turn out to be so much more, and this island, two unique people, and their eagles will be forever embedded in my heart.

My last major eagle expedition had started two weeks prior on a neighboring island in the northern Pacific that had a cattle ranch. In 1960, a thousand head of cattle were left to fend for themselves on this grass-filled, treeless, snowless island. The thousand head turned into three thousand head of the most ornery, massive wild cattle I've ever seen or heard of. It was here that I was charged by a four-thousand-pound bull and in a cowardly panic flipped a six-hundred-pound four-wheeler over a small bank, breaking my left forearm and two cameras in an attempt to get away from the bull's bluff charge. The cameras represented two months' wages. Not only had I severely broken my arm and lost my cameras, but all but one of the eagle ground nests I had come to work on had failed, leaving me in quite a horrible situation indeed.

A large number of foxes inhabited the island, and in a never-before-documented feat they were managing to eat eagle eggs in teams of two. One fox

would tease the parenting eagles, making them both take chase, while a second hidden fox would run up and gobble up as much of the two or three eggs as he could eat. I saw this happen on two of the nine island nests so I cannot be sure exactly why the other ones failed, but all had cracked eggs within.

My friends (a father and son team) had won the contract to round up the wild-hoofed cattle demons. Every few days a coast guard helicopter would land for various reasons but mostly so the crew could stretch their legs. The day I broke my arm the coast guard onboard medic set it and offered to take me to a hospital some two hundred miles away. I declined because of a sweet voice I had heard on the ship-to-shore radio. The voice beckoned me to stay with her and her husband on an island not ten miles away where there were no foxes and several ground eagle nests. Because I had no chance of getting any eaglet photographs on this island, I begged the coast guard for a hop over to the next island. They declined, saying the only place I should go or they'd take me was a hospital. As the island was so remote, it cost me nearly $2,000 to fly the ten miles.

It was June 12, 1993, when that Beaver made a perfect landing on a radical sloped beach. I was in pain and had a high fever when I stepped onto the beach, but at once I knew that I was in a magical land that far surpassed anything I could have imagined. Tom, a tall, lanky man with wild red-and-gray hair, welcomed me as we loaded up my gear and his summer supplies that had been picked up from another island. We packed the four-wheeler trailer, and Tom darted up a log ramp to the beach bluff that Tom and his wife called home. As the four-wheeler crested the bluff, the trailer came free, sailing back down the ramp and ending up in the surf. I made a mad dash into the surf and held on to the trailer with one arm until Tom could come down and assist me, lest we lose everything in the back. Visions of my past eagle exploits and disasters raced through my mind as I stood waist-deep in the water. Hell, I felt as if I fit right in on this island.

After securing the trailer, we crested the bluff and I was taken aback by the beauty, style, and configuration of the unique island compound. Solar panels and wildflowers decorated the roofs of all the buildings, while whale bones of all shapes and sizes were placed about in the most appropriate manner. The compound was built to last a lifetime far from the reaches of civilization. Tom and his wife were the only two folks on the island and hadn't left for nearly ten years.

Mary, Tom's wife, stood gracing the top of the bluff. With gray hair past her waist, she appeared angel-like in the evening sun. As I stepped down off the trailer, she greeted me with a gentle hug and a happy birthday (she had caught on the radio that I would arrive on my birthday). They treated me to an unbelievable full-course turkey dinner followed by a birthday cake. She at once noticed my condition and put me to bed to break my fever and mend my arm. For two days she cared for me while I slept.

The following weeks I learned how Mary and Tom live among the waves, the sand dunes, and the eagles. Each day I spent photographing some of the rarest moments in the bald eagle's life cycle. Some moments that I had waited ten years to document were made possible through Tom's help and my remote control cameras. The island, with waters rich in fish, was an oasis for ground nesting eagles. I was able to work on the many phases of a young eagle's life for one reason: no predators.

One afternoon with Tom's help I was actually able to observe three nests from a single vantage point. As luck would have it, I arrived at one of the nests to change film while both parents were away fishing and was able to capture on camera the miraculous event of an eaglet hatching. Although everything was going better than planned, I had a vision of how I wanted to portray these eagles in their prehistoric-like setting. I explained my idea to Tom and he told me about a place he knew where I could get the image.

The next morning brought a beautiful sixty-degree day as we started out on a fifteen-mile trek. Tom drove as I kept gauging the sun. "Will that do?" Tom asked, while pointing to a thirty-foot raised sand dune with two thirty-day-old eagles sitting on the pointed top of it. "Perfect," I replied. In a matter of moments, I quietly crested the dune and set up a wide-angle camera and three flashes, all the while keeping a safe distance from the young birds. Eagles have a poor sense of smell, so my intrusion at the far end of the dune was nearly unnoticed.

Now a few hundred feet away, I held my finger on the remote control and prayed for the eagles to make their way over to inspect the cameras. Instead, the mom came home to check on her kids and drop off dinner of a baby halibut. After she had left again and the eaglets devoured their fresh fish, they began

roaming around the nest. Eagle ground nests are not at all like the massive and lofty tree nests found in the rest of the country. I'm quite sure that if there had been one tree on this island, all ten pairs of nesting eagles would have tried to build in it. The sand dune nest was nothing more than a small impression scraped out of the sand with an enormous amount of dead swamp grass lining the inside.

Baby eagles of this age are very amusing to watch. Their feet and talons are massive, and watching them trying to maneuver is nothing short of comedy. After an hour or so they made it the several yards over to the remote camera and sat down as if to pose for me. With the sun at their back and talons filling the foreground awash in swamp grass, I pressed the remote and got the photo I had been hoping for. As an added bonus I could never have planned, at the last second a large ground hornet flew through the air and one of the eaglets contemplated grabbing it.

I quickly and quietly retrieved my gear and stood looking over at the next island where I had broken my arm. It seemed large and forbidding, looming up at me with a three-thousand-foot peak right in the middle. Out of the nine nests I observed there, eight had failed for a variety of reasons. But here, a stone's throw away, out of ten nests, only one failed. It is still amazing to me that our giant American bald eagle is more delicate in its first cycle of life than a newborn baby. Tom came back to pick me up and that night I once again sat and listened to the stories of the couple's incredible lives.

Mary and Tom lived on this remote island in the northern Pacific in a much-needed self-banishment. Mary had suffered unspeakable cruelties at the hands of the dictator in her previous country, and Tom had a similar story concerning a foreign government. Although I cannot reveal their true names or island location, those details are not important. Together they live in happiness guarding bald eagles in a place far from the reaches of brutal governments.

On another day during my month-long stay, I looked down the nearly white sand beach and noticed a pair of eagles in a bluff-top nest. Their screams of anxiety immediately caught my attention

as I assessed the bluff a safe three hundred feet away. It took a few moments for me to realize what was happening in the nest, but when I did, I was overcome with sadness.

As the male eagle repeatedly beckoned the female off the nest, she would cry screams of great anguish. He wanted her to leave her two dead babies. For some unknown reason, both ten-day-old eaglets had not survived. She constantly nudged their bodies and cried to them. I have never seen such a display of grief by a wild animal. As humans, we think that we are the only ones to have these feelings. But this eagle mother was nothing short of hysterical at the loss of her children.

As I turned to leave them to their suffering, I witnessed an amazing thing that I had never seen or read about previously. The mother eagle lifted off the nest with both dead babies in her talons. She soared to several hundred feet, where she released their frail bodies. As they plummeted to earth, she screamed at them to fly. As they neared the ground, she dove like a falcon and with the grace of an angel caught them by turning upside down as they landed in her outstretched talons. Tears flowed down my cheeks at the sight of this mother eagle's grief as she did this over and over again. My stay on the island was drawing to a close, and yet every day I managed to observe the mother eagle still on the nest. Her mate had left her after four days of unsuccessful attempts to get her to abandon her dead babies. As far as I know, she died there with them on this remote coast.

When our forefathers signed the Constitution, there were an estimated two hundred fifty thousand bald eagles in the area that is now the contiguous United States; the number jumps to approximately half a million when the land that is now Alaska is included. By the 1930s, there were less than five hundred active nests in all of America, and Alaska lost thousands of birds to an insane bounty. How, then, did the American eagle rebound so that by 1995 it was reclassified as threatened and no longer endangered?

The recovery was long and slow and relied on the

dedication of thousands of folks over five decades with the will and determination to bring our icon back to the skies. It is our nation's greatest wildlife success story. Without question, it began in Florida with Charles Broley and his work to band more than a thousand eagles, track their falling population numbers, and then sound the alarm about DDT. The National Audubon Society followed up with the first nationwide survey, and as its results started to come in, individual states, such as New York, California, and, later, Oklahoma, began importing eagles.

Raptor centers were formed in many states throughout the country and conservation organizations started acquiring critical habitats to protect our vanishing wetlands. Air and water acts were passed to clean up the life-sustaining habitats for many species of birds and wildlife. Toxic dumping in the ocean, where about 60 percent of all eagles feed, decreased.

Tom Ricardi's Massachusetts rehab center put eagles in the skies that are now bearing offspring of their own. In Alaska, Dr. Theodore Bailey brought to light the second-largest gathering of wintering eagles in the world on the Kenai Peninsula and helped stop the habitat destruction. Veterinar-

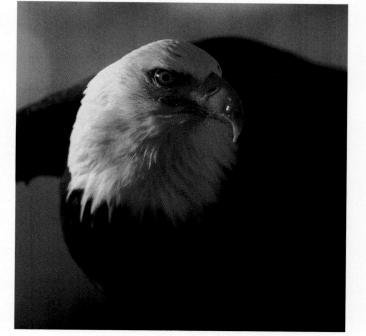

ians across the country have nursed injured eagles back to health, while countless people donated money to the cause.

Workers build aviaries and hacking towers and clean cages. Still others across the country donate rats and fish to feed injured eagles. People like Bob Barclay and Tom and Mary watch over our beloved birds in places so remote no one will ever know of their heroic deeds, while Wendyl Pedrone stops crowds from harassing the bald eagles in Bar Harbor. Debra Jensen builds nest sites after storms in Big Cypress, while Dr. Bill Robertson continues to protect the Everglades. My friend Ken Kard gave his life while counting eagles for this book. It was providence that this many people, and a thousand more, came together, and in most cases, hardly knew what the other was doing. They all just knew that something had to be done and did it.

To me, in my heart, these dedicated folks represent the notes in a magnificent song, and the programs and rehab centers are the bars and stanzas. Individually they are all the true heroes of the return of the American eagle and combined they are a symphony of freedom.

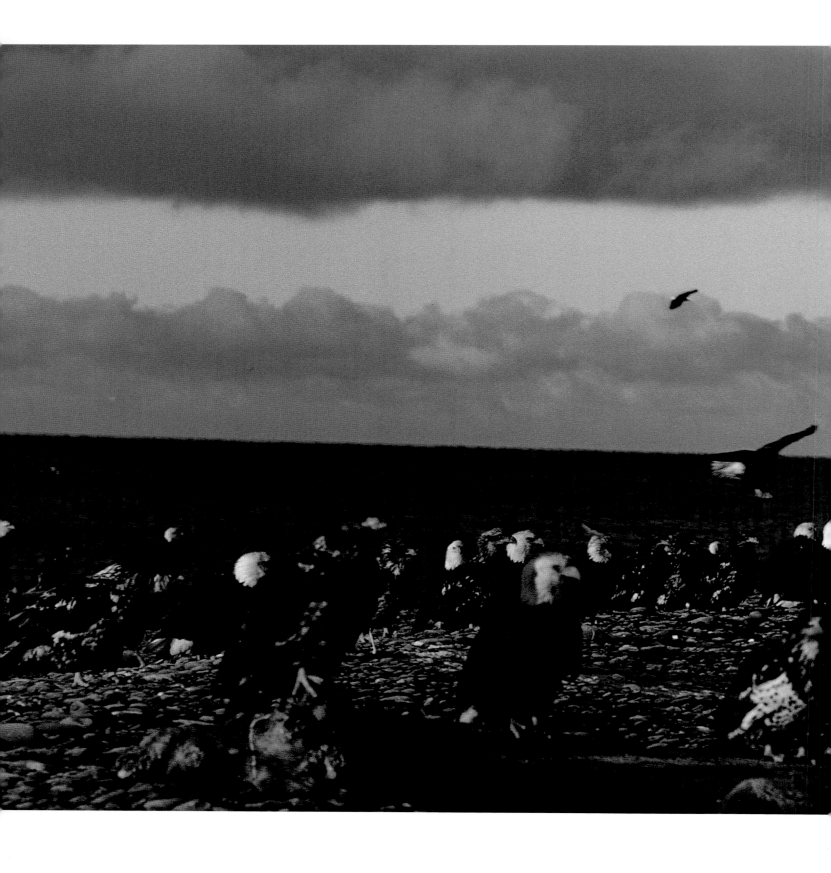

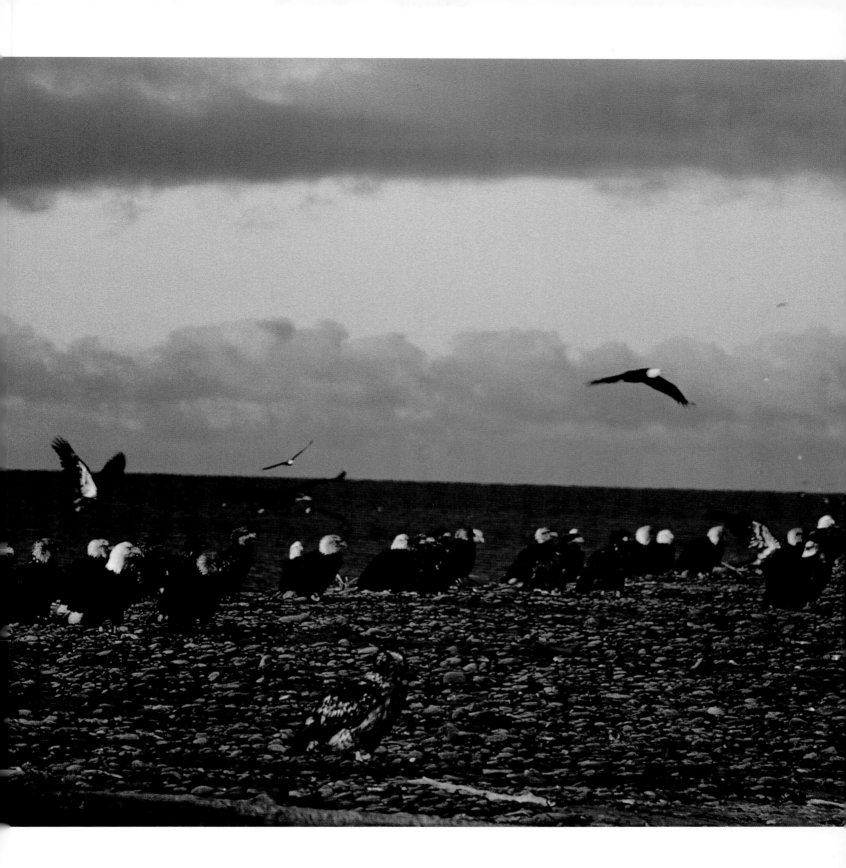

ABOVE: *Alaska has the largest number of bald eagles in the world with some twenty thousand nesting pairs. Many states, such as New York, have imported bald eagles from Alaska since 1960 in an effort to return them to their skies. This gathering is in Kachemak Bay, Alaska.*

FOLLOWING PAGES: *On the right morning along the windswept beaches of Cook Inlet at Deep Creek, Alaska, one can count as many as a hundred bald eagles. They come here either to clam or to fish. Their airborne antics are rarely serious. Here, however, one mature bald eagle is intimidated by the other's size and attempts, in vain, to knock him from the sky.*

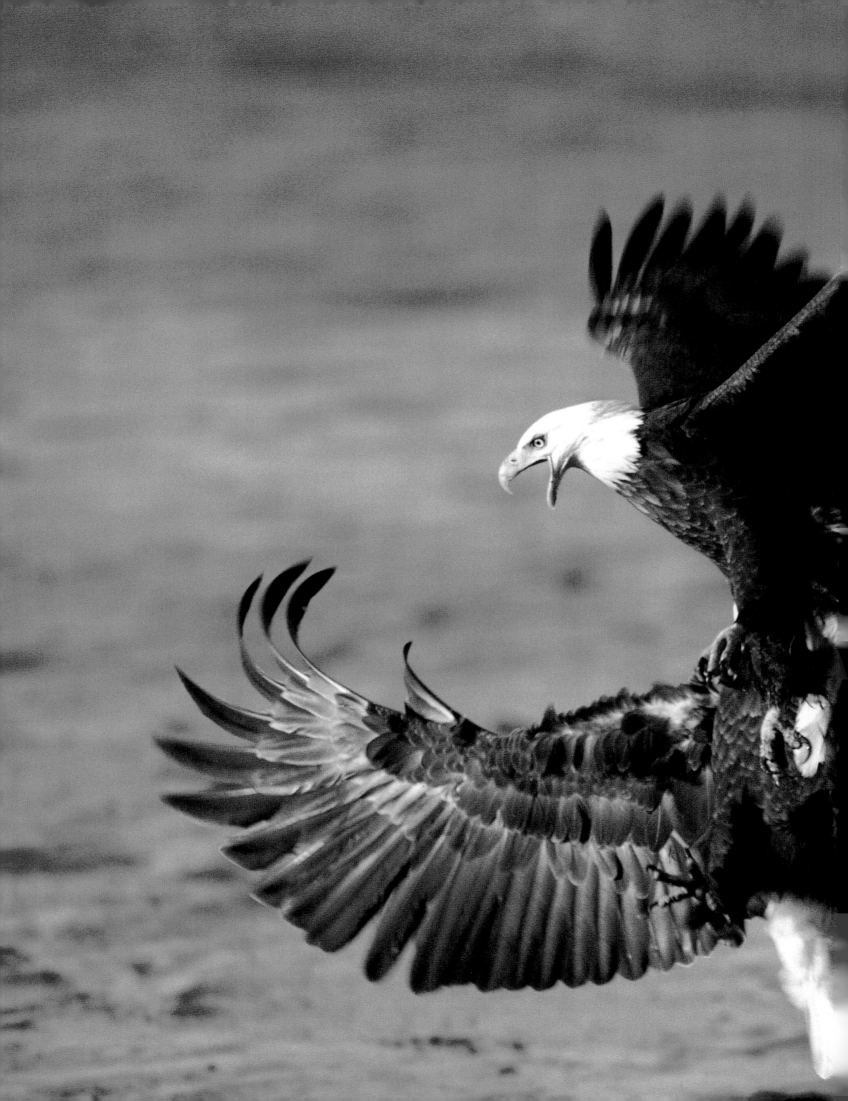

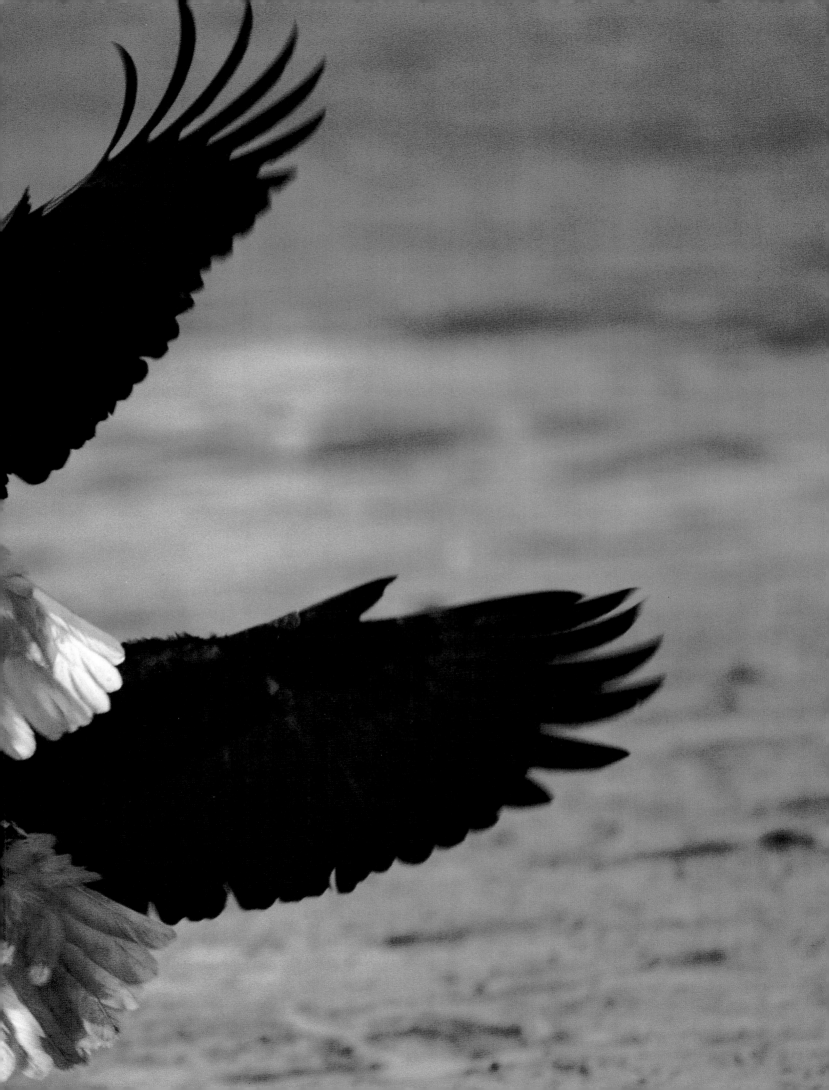

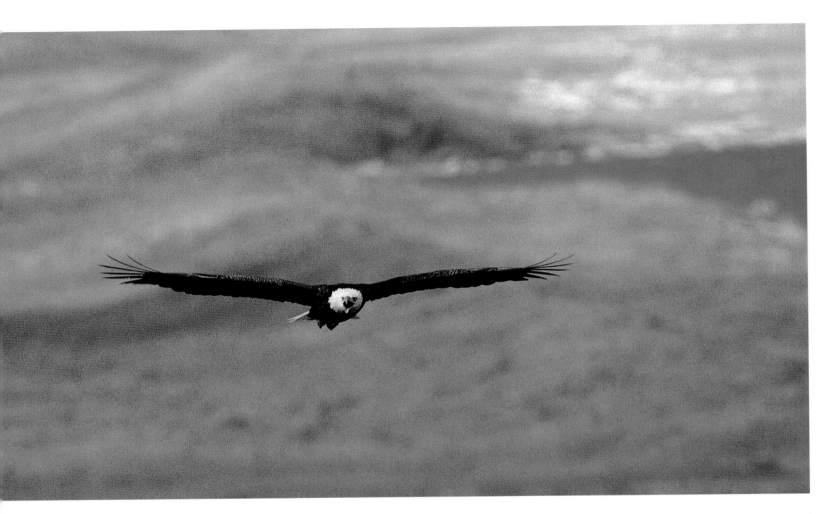

ABOVE: *Alaska's Aleutian Islands are a treeless, mystical land of water and fish. Here, as in only a few other places, bald eagles build ground nests along the cliffs.*

OPPOSITE: *A lone immature roosts on a cliff in the Aleutian Islands, far from the reaches of humans. One would think that eagles would flourish here without the intrusions of civilization. Not so. Out of the six ground nests I studied in July 1992, five failed for various reasons, including predators, starvation, and lead shot poisoning, which is the result of eagles' consuming migrating ducks that have been wounded by hunters' lead bullets.*

FOLLOWING PAGES: *On a sandy beach at the end of the Kenai Peninsula on the Homer spit in Alaska is the sad but amazing spectacle of an artificial feeding site. For more than a dozen years the local residents have battled with the issue of feeding eagles to promote winter tourism. According to local naturalists, it's a travesty that has gone unchecked for too long. Several generations of eagles have grown up, matured, and had offspring that do not know how to survive in the winter because they never had to fend for themselves. The sad reality is that nearly half the eagles pictured here may perish when the unnatural feeding program eventually stops.*

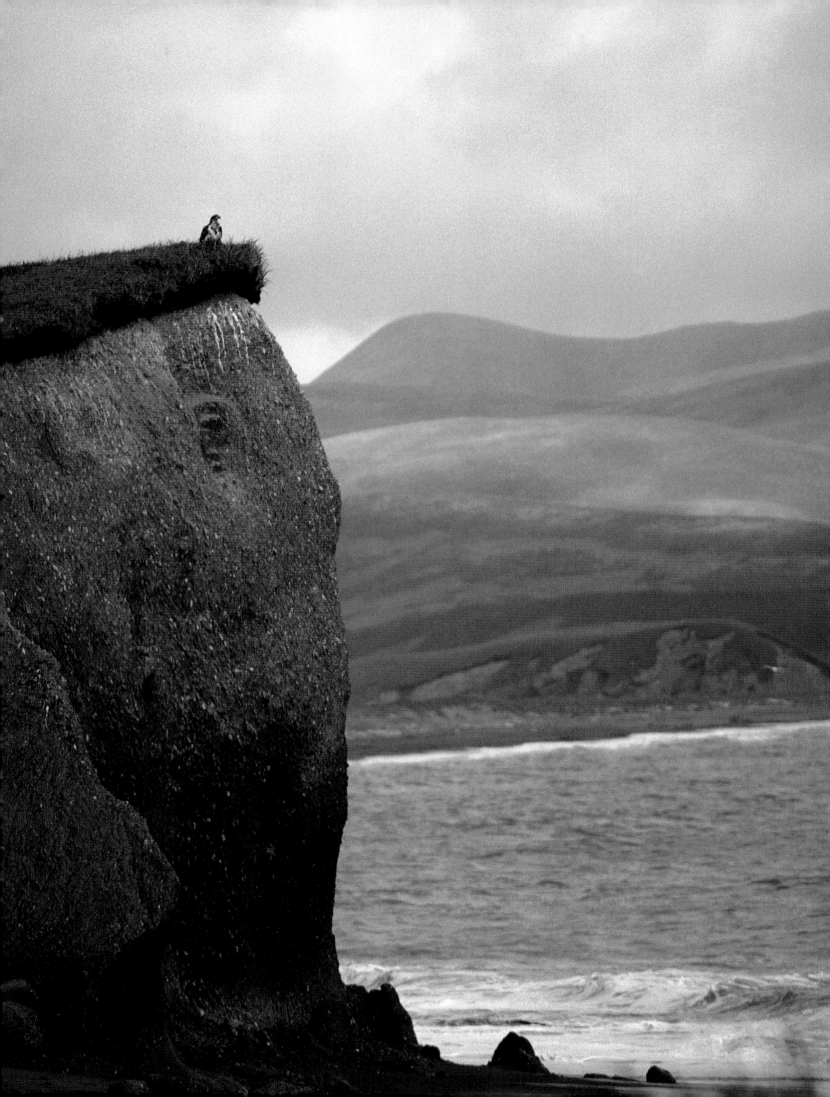

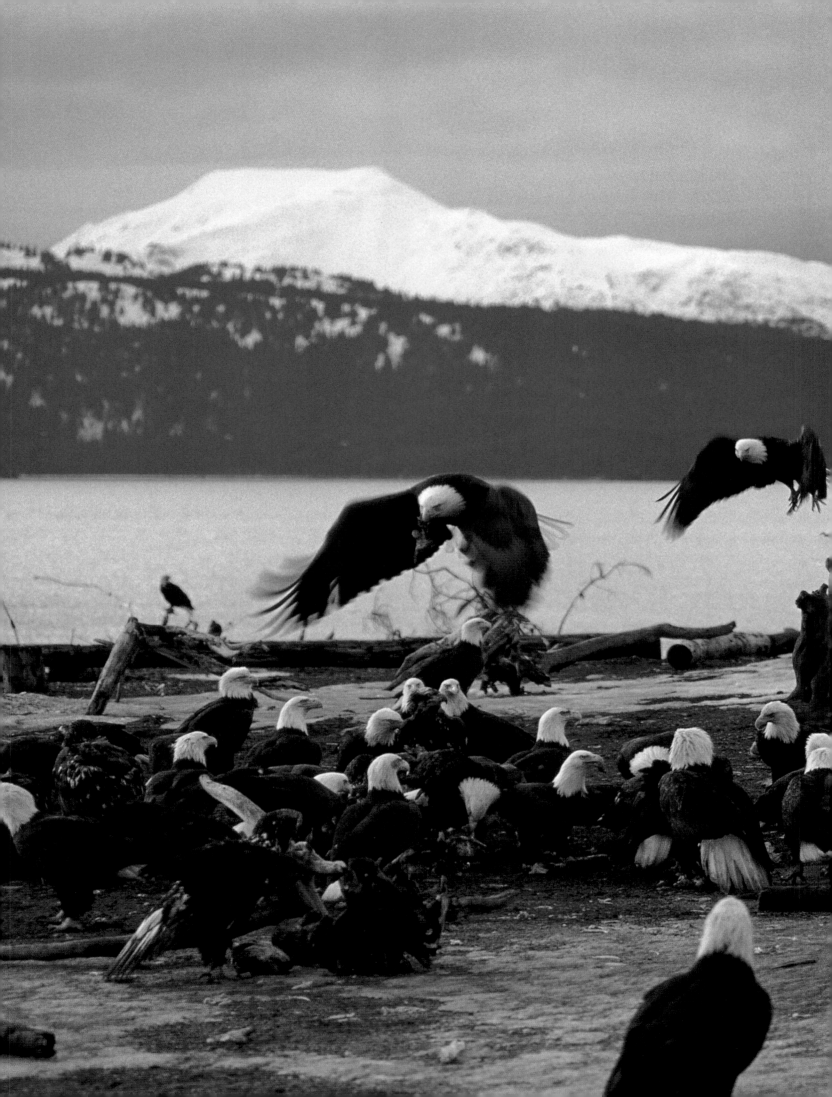

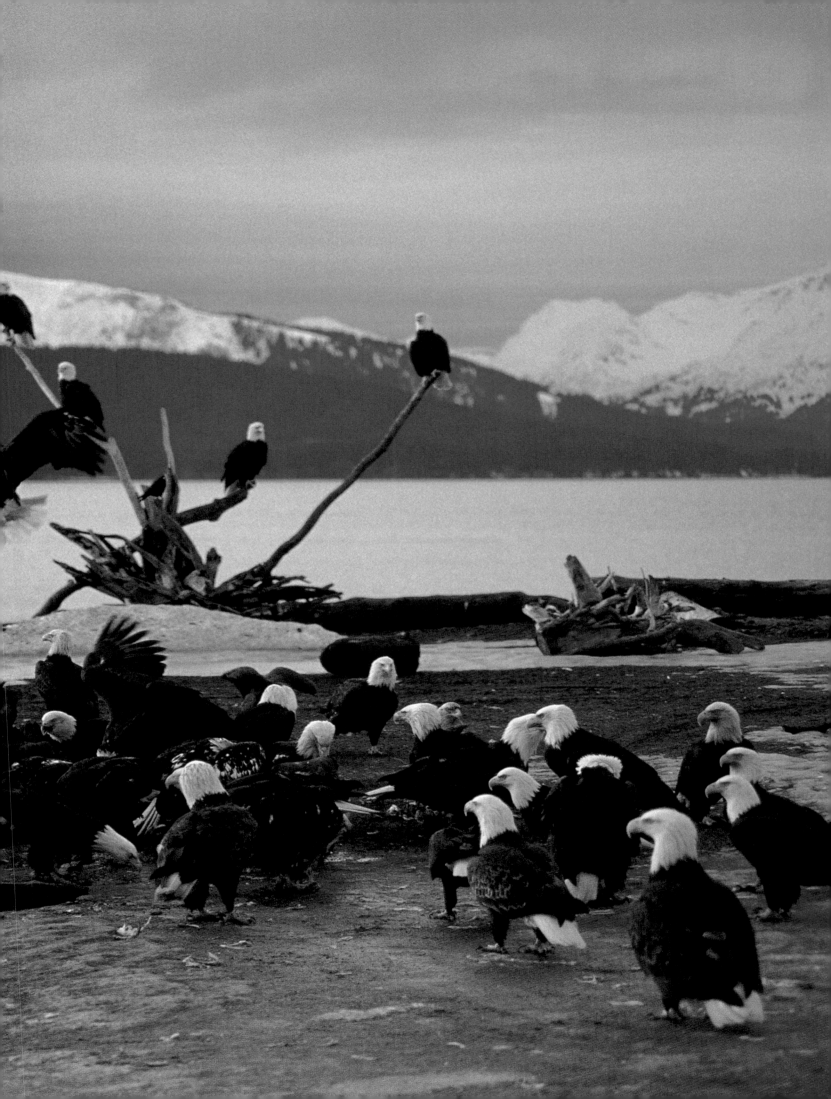

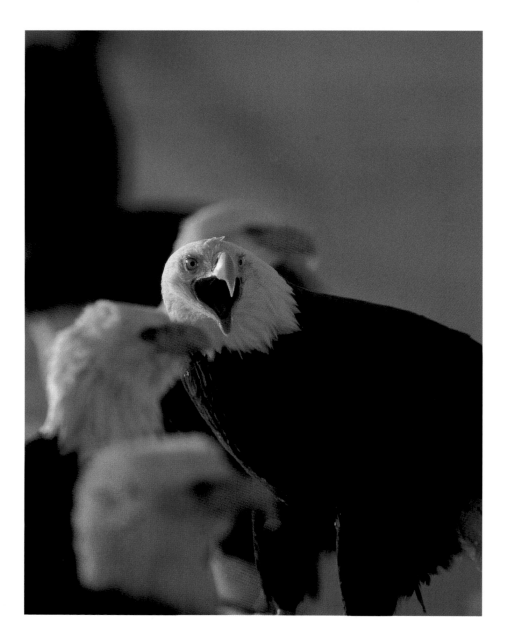

ABOVE: A Homer spit eagle cries for a handout.

OPPOSITE: A solitary eagle on Alaska's Kenai Peninsula.

FOLLOWING PAGES: Sunlight brings life to a group of wintering eagles in south central Alaska. Cold nights take their toll on American eagles that winter in frigid areas, but these eagles have migrated from even colder regions of the state. The migration patterns of bald eagles vary all over the country. Southern eagles migrate very short distances if at all. A northern migration route may run two hundred to eight hundred miles south, depending on availability of food and the climate. Some northern eagles, however, may actually migrate farther north to catch a late winter fish run. Those eagles trade colder climates for a more stable food source.

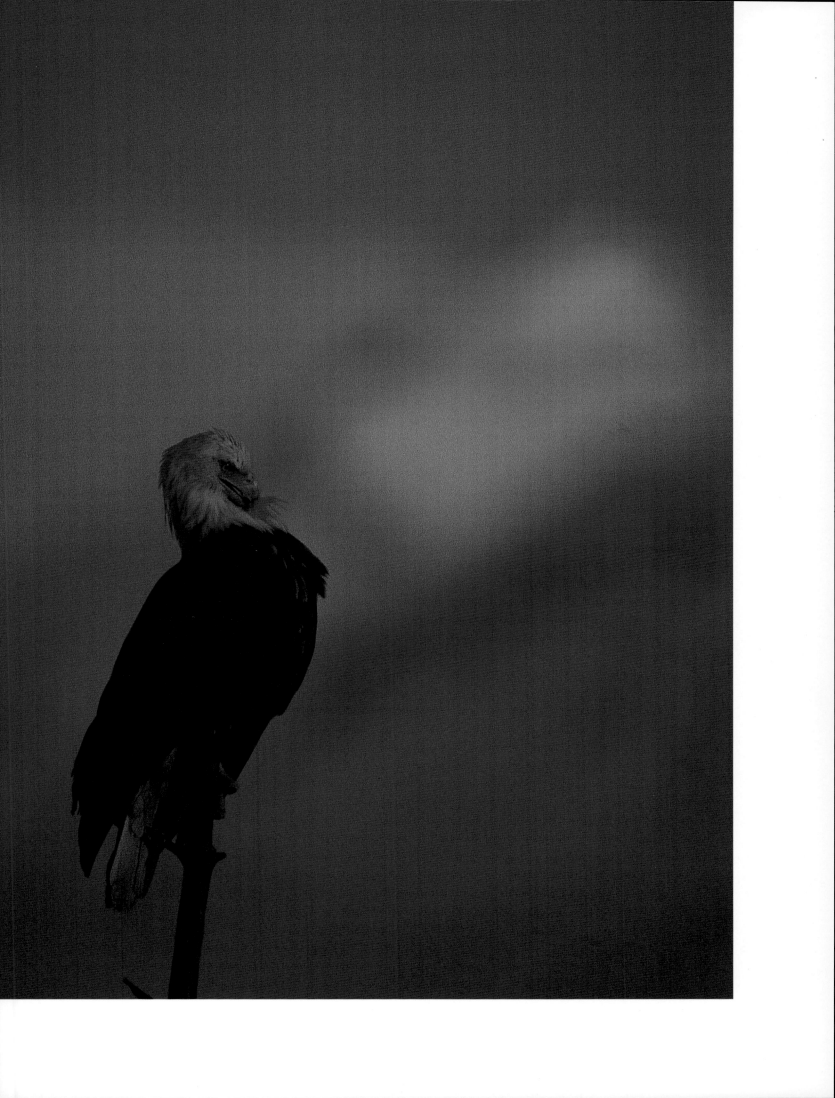

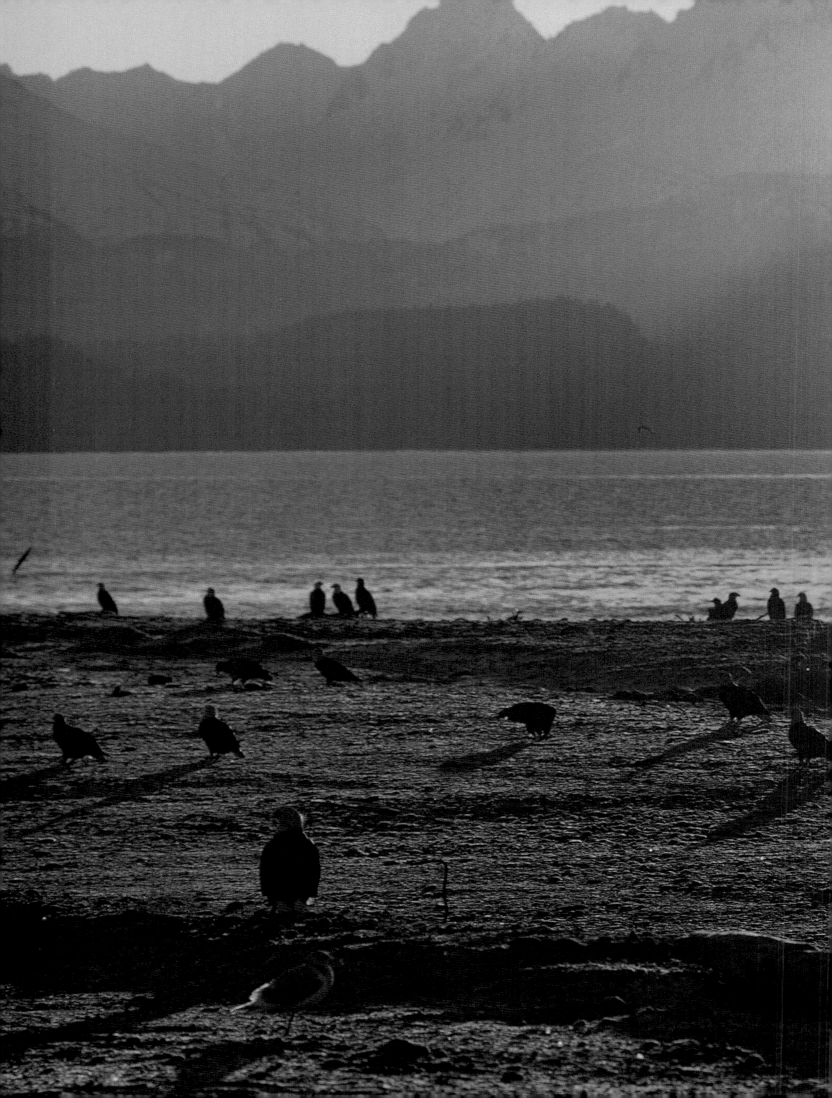

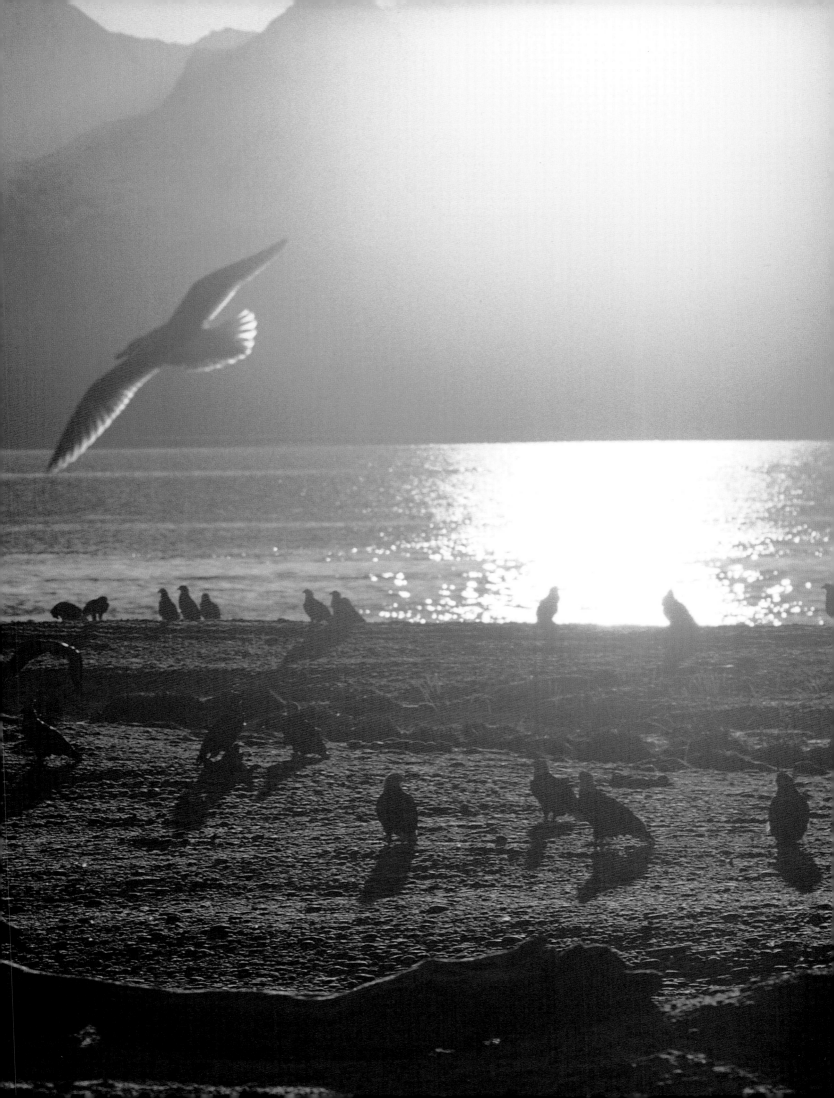

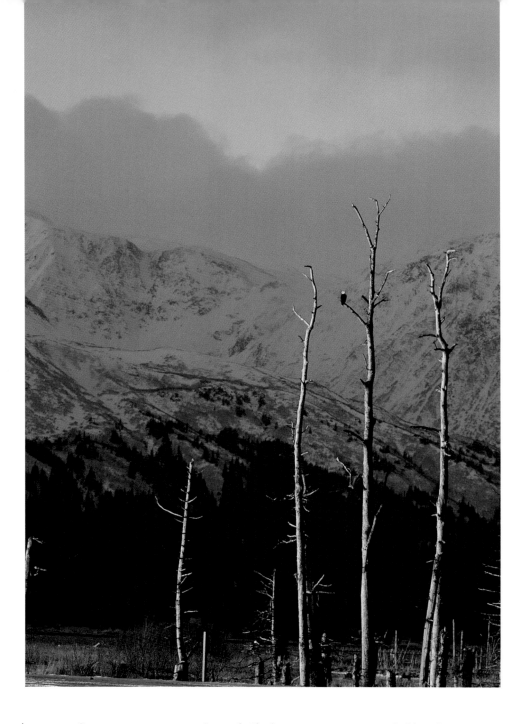

ABOVE: *On a remote coast near Seward, Alaska, it is common to see bald eagles roosting high in beautiful cottonwood trees. Nationwide, cottonwoods seem to be a favorite eagle perch.*

OPPOSITE: *The Chilkat Bald Eagle Preserve near Haines in southeast Alaska has the largest gathering of wintering bald eagles in the world. Countless scientific and biological studies have been performed on the eagles that winter here, including injecting them with DDT in the early 1960s in order to study the effects on reproduction. The sanctuary was finally formed in 1982 thanks to the dedicated work of many people. Several local residents, however, opposed the sanctuary, fearing that it would hinder the timber and fishing industries—two main sources of income in the very rural Alaskan community. Now, a decade and a half later, the sanctuary has become a main tourist attraction to eagle lovers across America.*

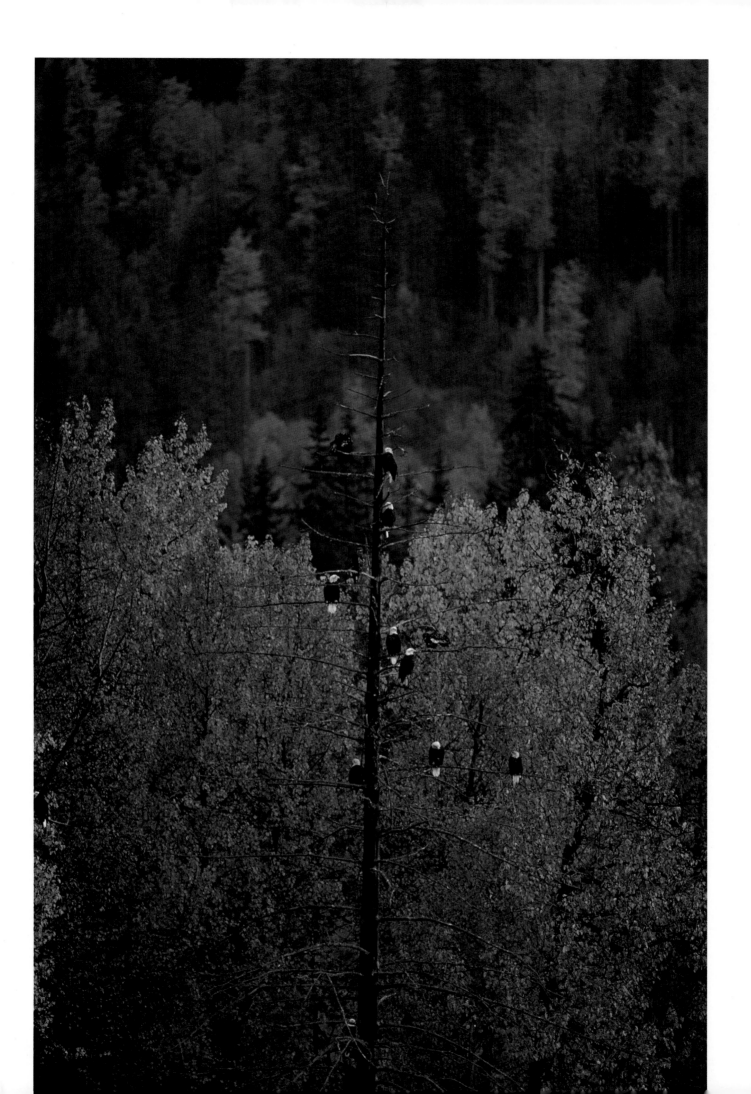

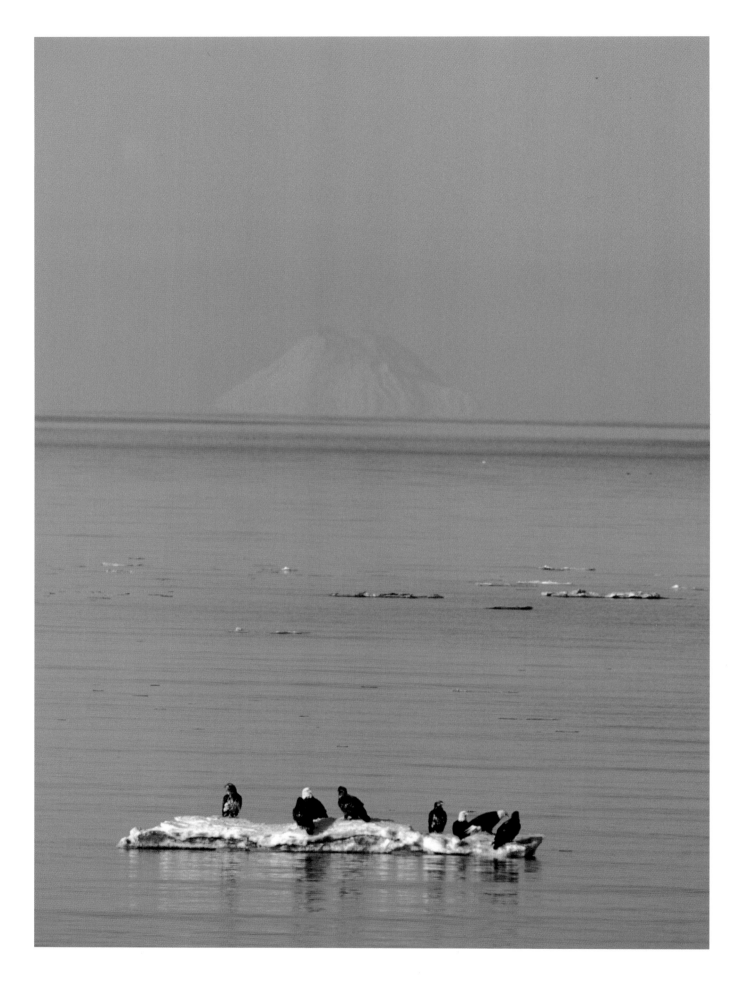

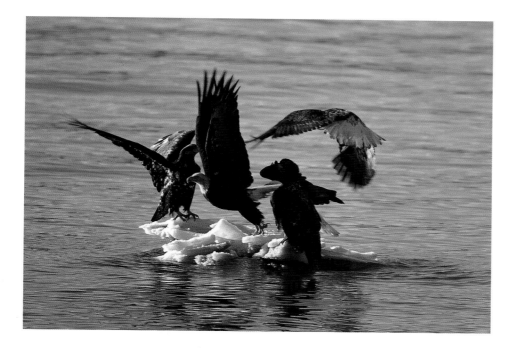

LEFT: Four eagles struggle for a foothold on an iceberg, trying to rest from the efforts of fishing at sea at Anchor Point on Cook Inlet, south central Alaska.

FOLLOWING PAGES: A winter scene on the Trail River in Moose Pass, south central Alaska, gives one an indication of the harsh weather encountered by eagles that winter here. In a dozen or more years that I visited the site, I found four dead eagles. They starved to death because the only opening in the ice couldn't provide enough fish to support even the small wintering population.

OPPOSITE: Eagles are by no means Arctic hunters, as long bouts of severely cold weather would easily kill an eagle. In Alaska, most of the forty thousand bald eagles live in the southern half of the state and none are found above the Arctic Circle. The eagles pictured here rest on a piece of ice with the Augustine volcano in the background.

RIGHT: A nearly mature bald eagle that has become quite proficient at fishing has managed to catch and drag ashore a silver salmon that weighs more than he does. This late run of silver salmon in March on Alaska's famed Kenai River attracts enough eagles to make this the second largest gathering of wintering bald eagles in the world.

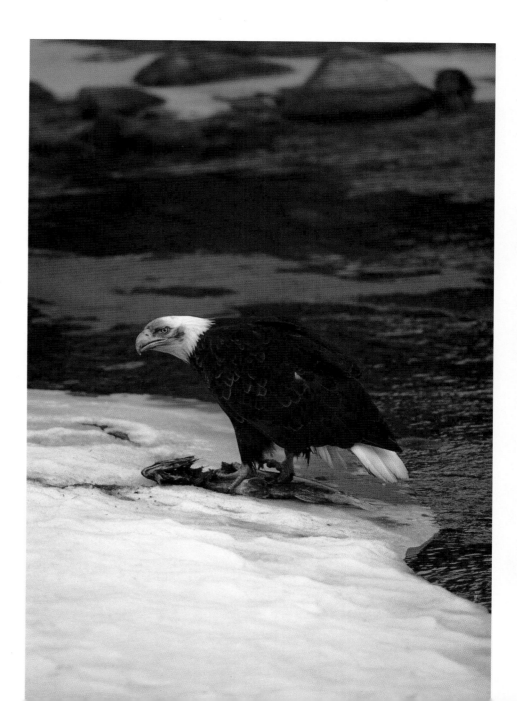

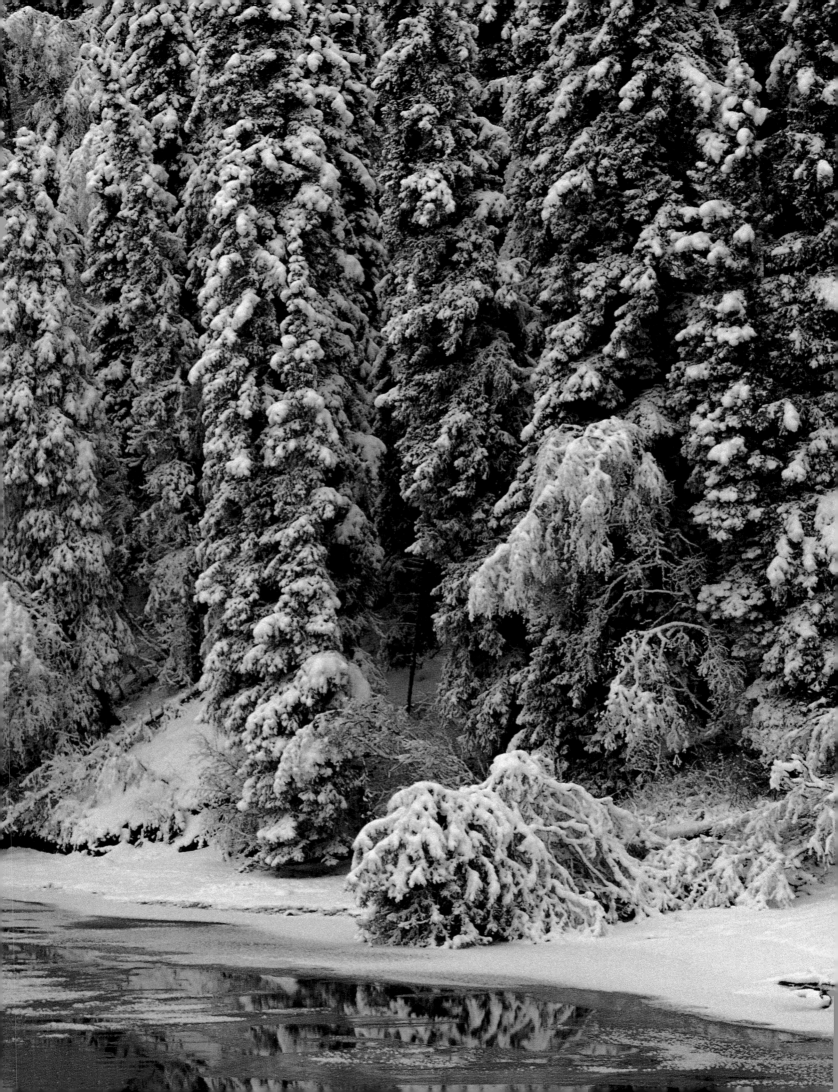

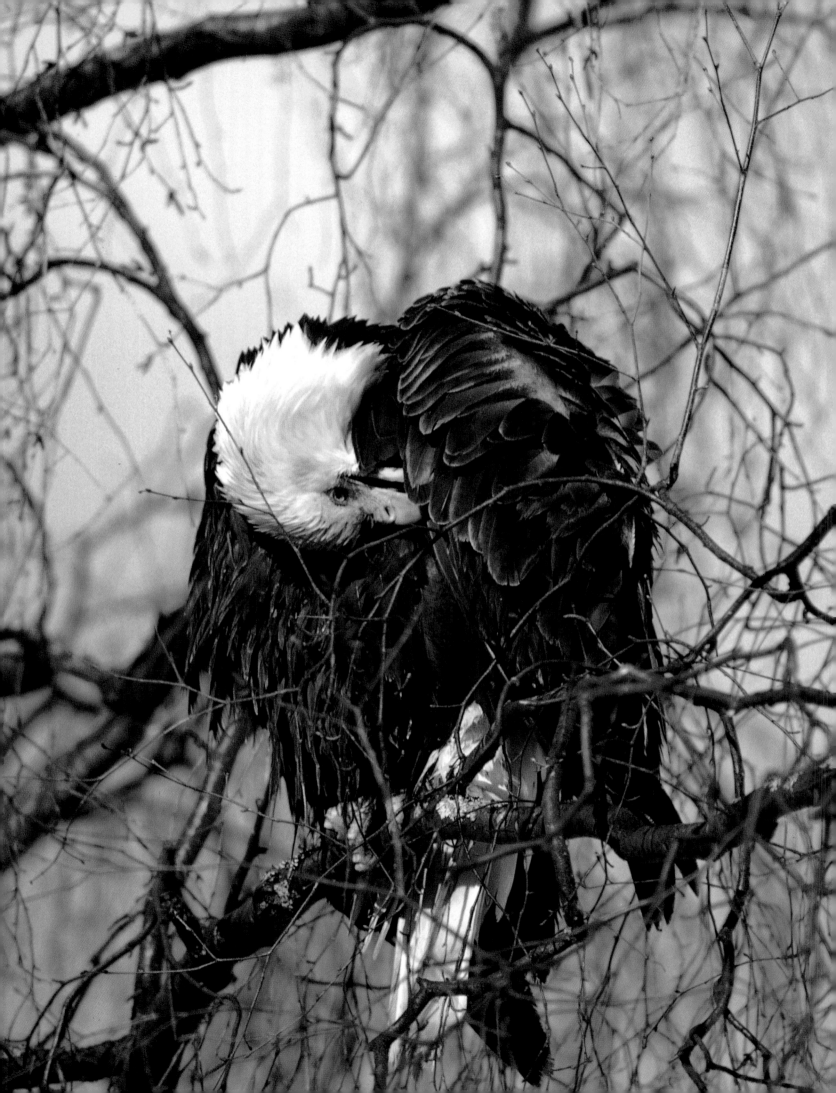

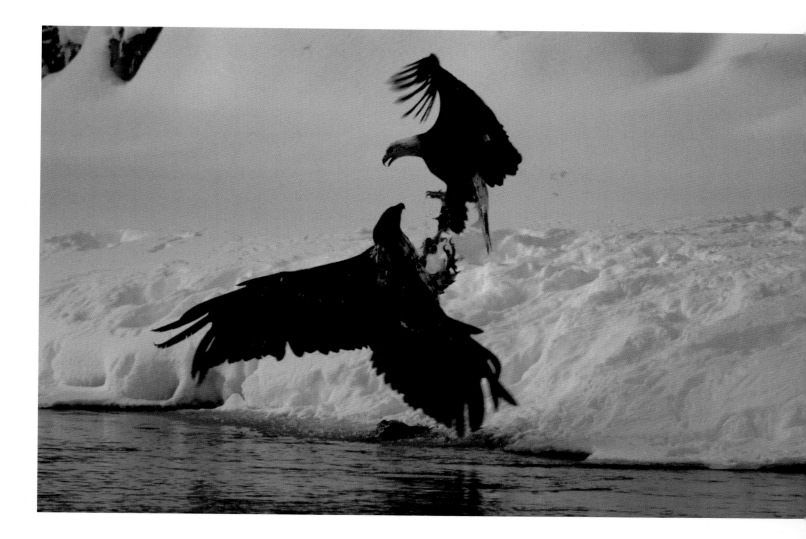

OPPOSITE: *A small pond in southern Vermont has weekly visits from a large adult male bald eagle. Here he is cleaning his innermost breast feathers to ensure they are able to retain warmth for the oncoming winter.*

ABOVE AND FOLLOWING PAGES: *This is a rare and dramatic portrayal of a battle over a fishing site. A cunning mature bald eagle first watches the two immatures fight over his site (following pages), thus creating an exhausted winner. The mature eagle then quickly and effectively disposes of the winner by pushing him backward into the frigid waters (above). The mature eagle expended the least energy in the cold weather to obtain his goal—the immatures have to learn this skill or will freeze to death.*

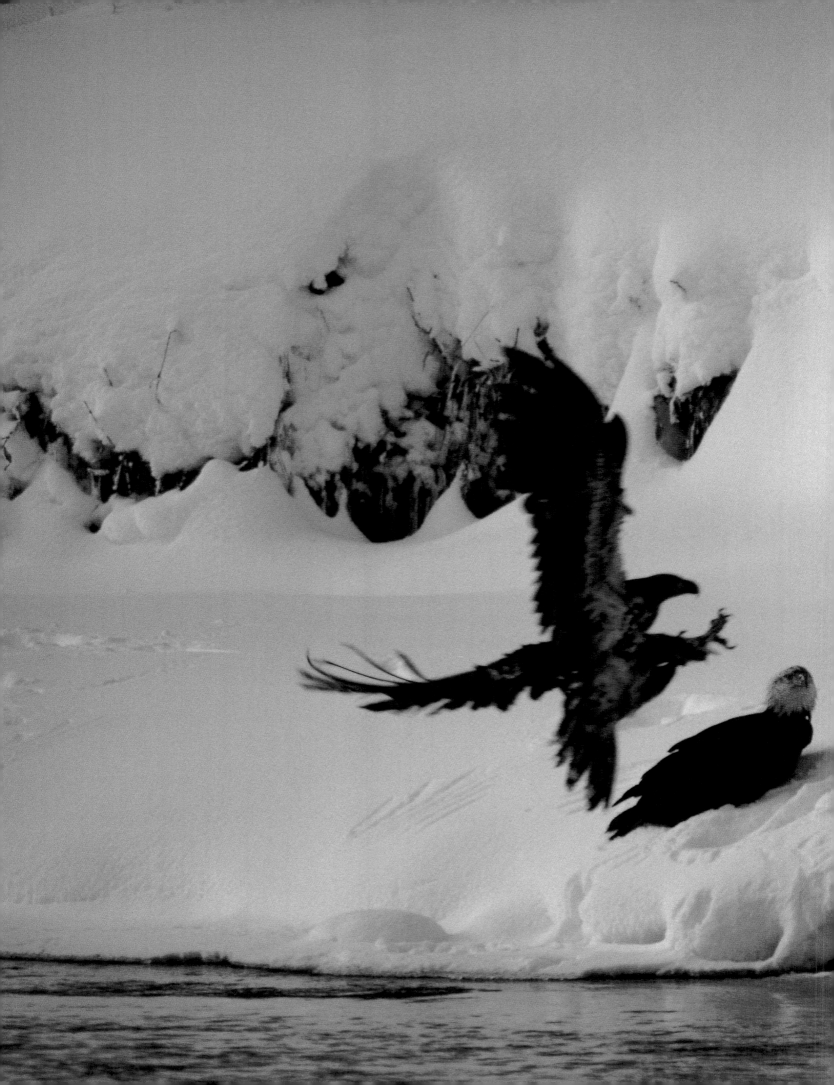

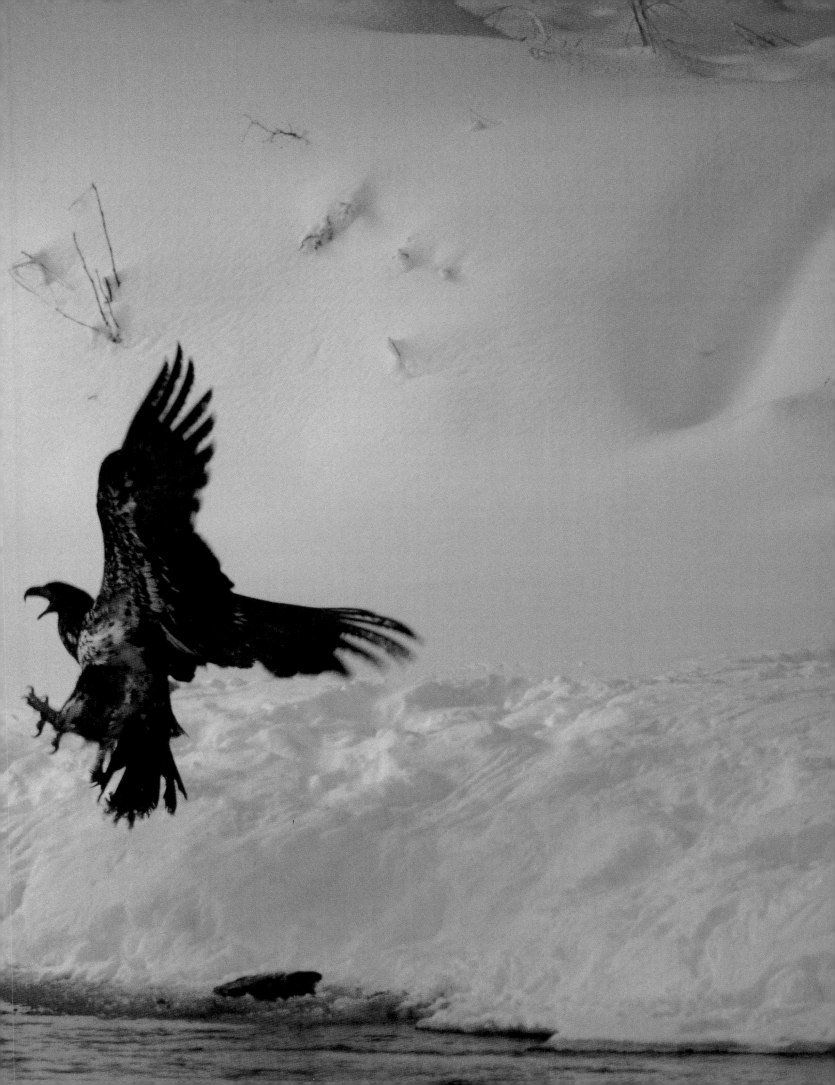

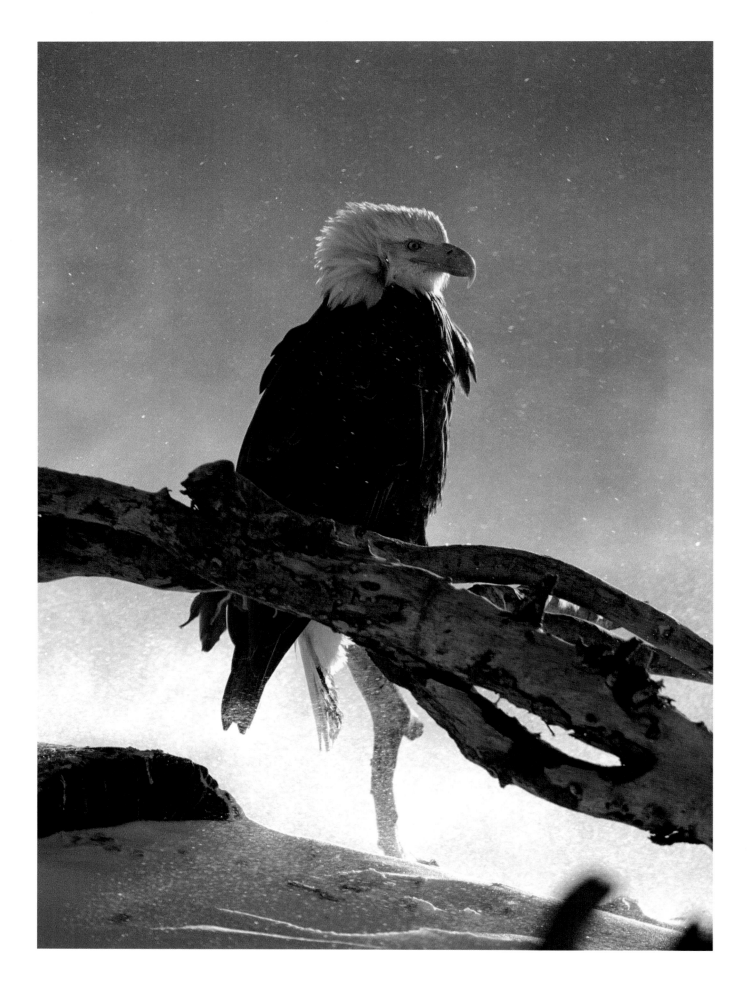

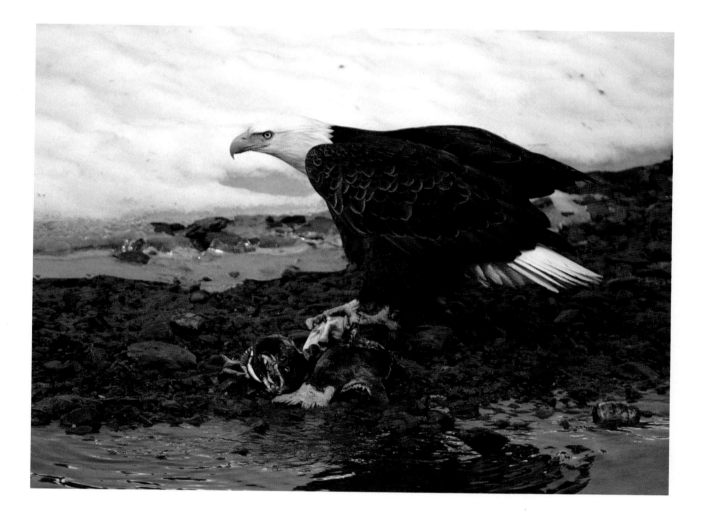

OPPOSITE: *A nearly mature bald eagle sits out a winter storm near Bar Harbor, Maine. In the early 1980s the general consensus in Maine was that their eagle population had rebounded from the effects of DDT and was doing fine. Therefore little effort or expense was devoted to enhancing the population, according to some park officials. Today, as the rest of the country's eagle populations continue to grow, Maine is still losing eagles because of high toxicity levels in the water, although the situation has improved in the 1990s.*

ABOVE: *Where the Rogue River greets the Pacific Ocean near Gold Beach, Oregon, a spawned out and decaying salmon makes a meal for this bald eagle. Eagles are extremely proficient at scavenging. Their immense size dictates a constant need for protein, especially during the winter months.*

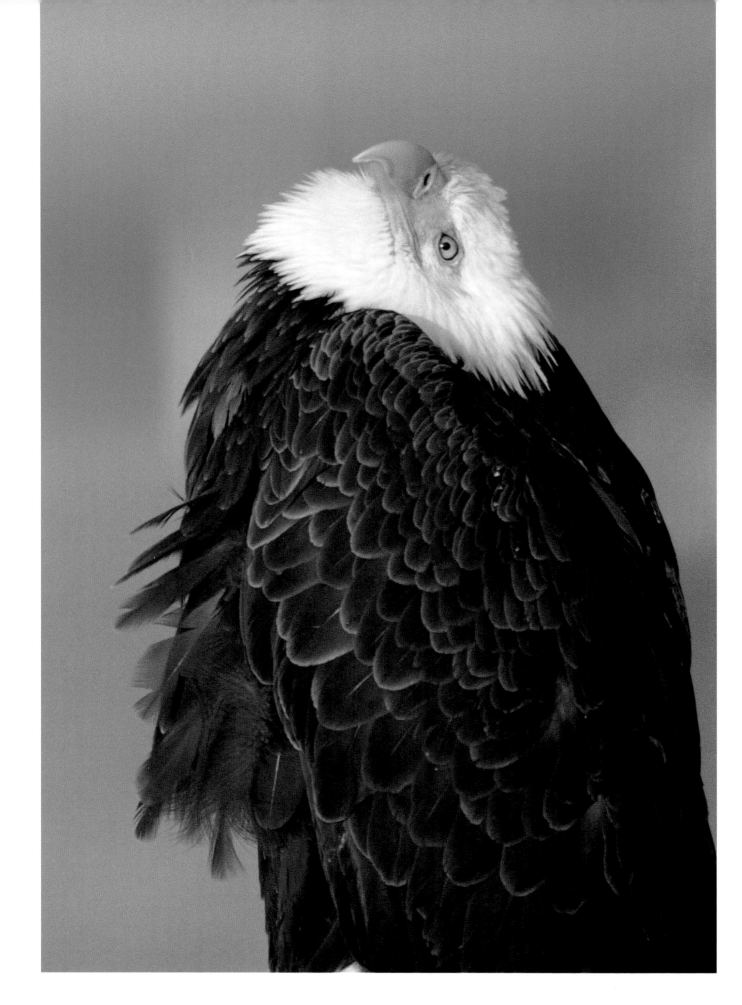

OPPOSITE: This mature eagle gathers as much of the sun's warming rays as his feathers will hold. Trapping the warmth within several layers of feathers will help lessen the amount of protein he needs to consume in order to keep warm.

BELOW: "Kii-kii, kii-kii," a mature male cries out in the frigid air of winter in Kachemak Bay, Alaska. Many people think the eagle's cry sounds weak for such a massive bird, but I believe that it suits such a solitary creature, and whenever or wherever I hear it I feel like I'm home.

FOLLOWING PAGES: A tragic midair fight over a fishing location leaves one eagle on the snow with broken wings. The eagle in the air knocked him from the sky with little mercy. Usually fights are not serious, as the smallest injury will bring about the demise of one or both eagles.

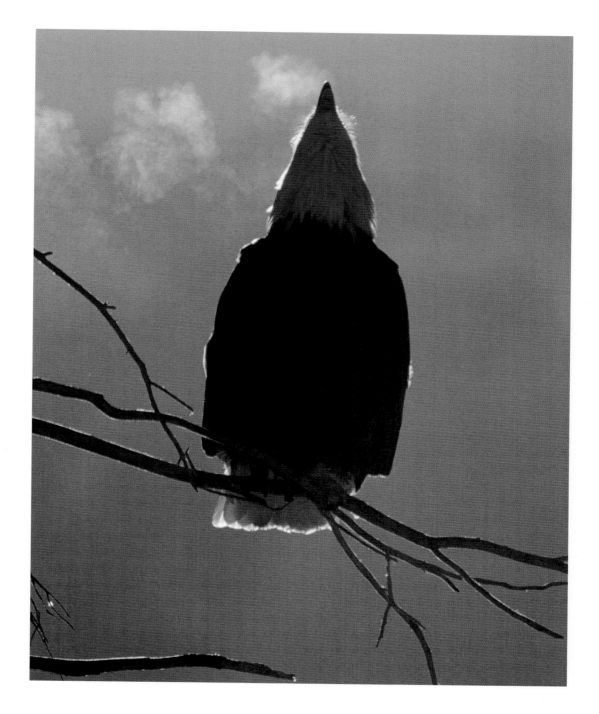

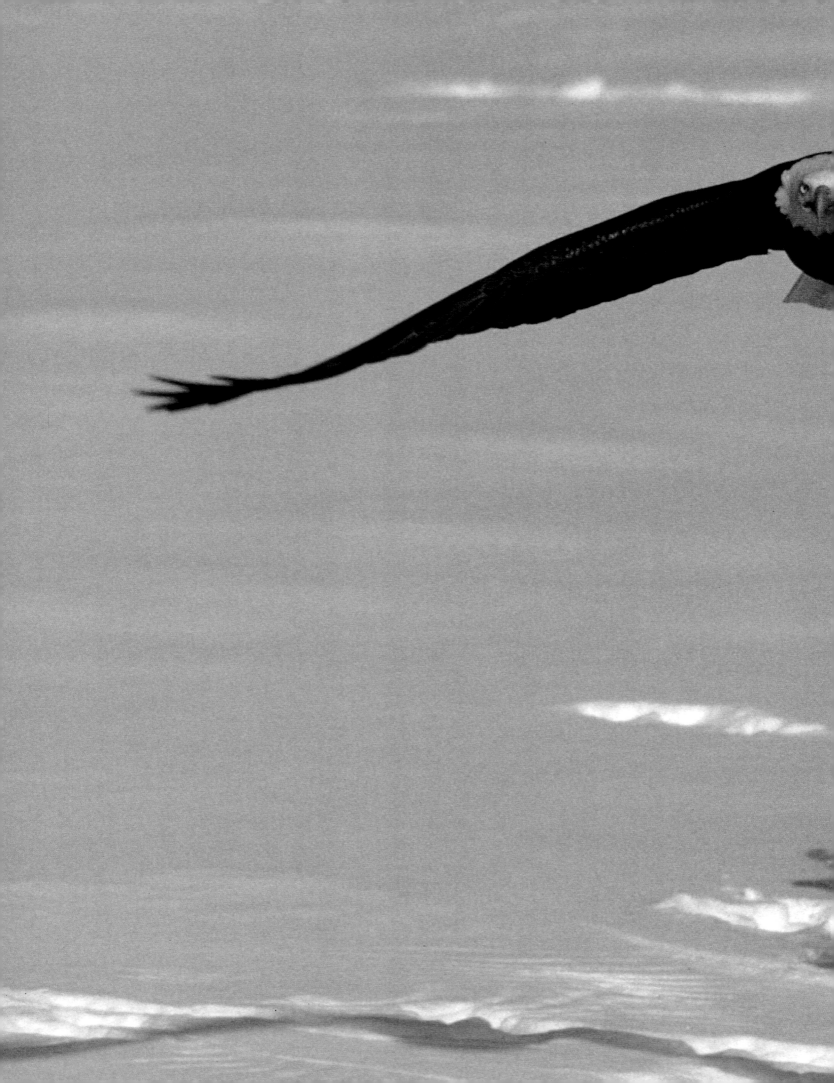

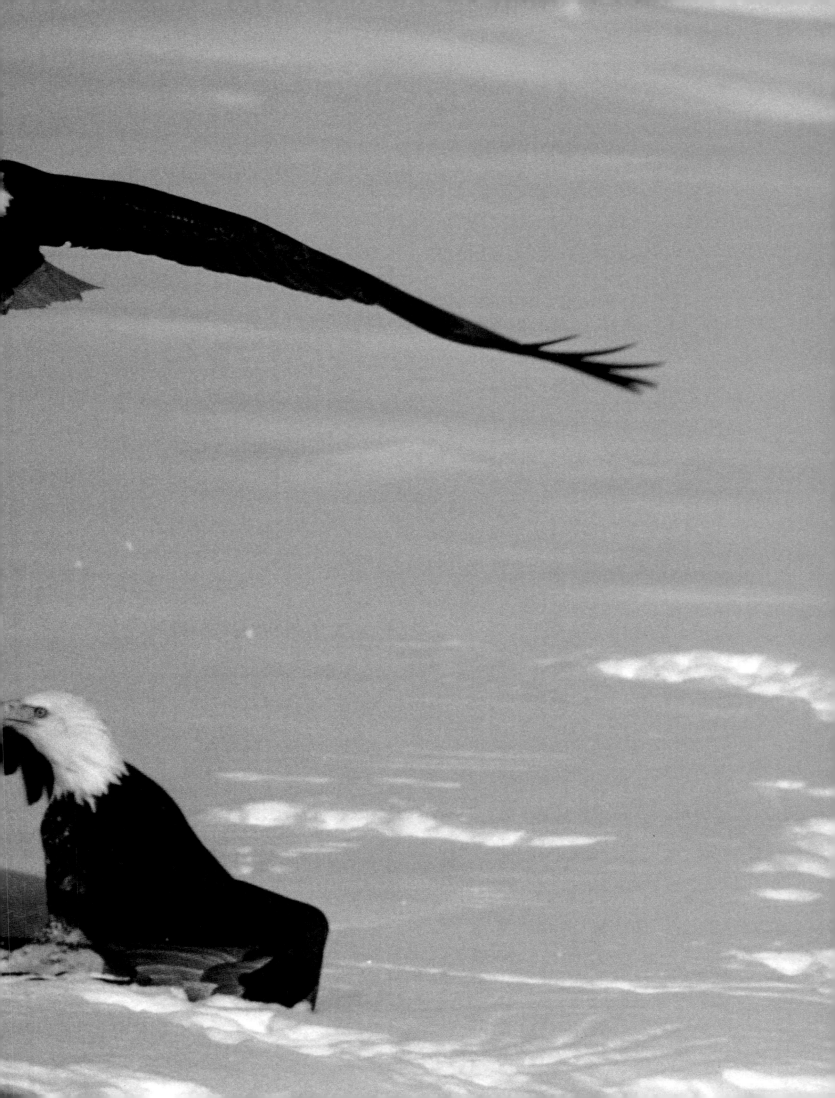

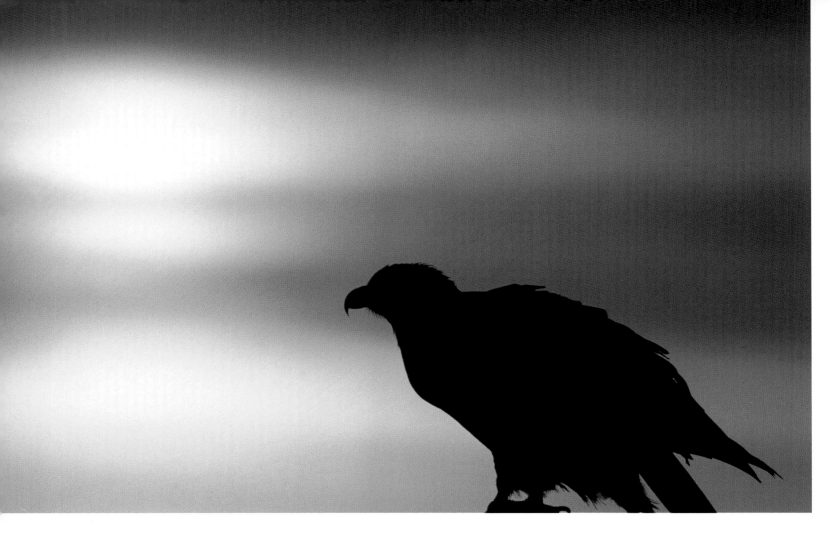

ABOVE: *One of the most difficult and frustrating times I've ever had working with eagles was in Big Sur, California, in the early 1980s. After three months of clambering up and down cliffs along the entire length of the incredibly beautiful Big Sur coast, I managed to take only one eagle picture.*

LEFT: *A bald eagle skull is relocated from its hiding place and left among the vines in the Everglades' interior a few weeks after Hurricane Andrew in August 1992. Although this savage storm wreaked unforgettable havoc on humans, the eagle population in south Florida sustained very few losses. Debra Jensen, an ornithologist, recalls rebuilding only one nest in Big Cypress National Preserve to house the surviving eaglets that toppled to the ground when Andrew came through.*

BELOW: A rare sighting of an American eagle off a dock in San Diego, California. A decade ago it would have been impossible to find even one eagle in this area. Now, as conservation efforts continue in southern California, we are beginning to see more eagles near major cities.

FOLLOWING PAGES: Twenty-five years ago you would be hard pressed to find a bald eagle, let alone a successful active nest, along the Gulf of Mexico. The long-lasting effects of DDT combined with water pollution took a deadly toll on Gulf eagles. After the ban of DDT in 1972 came the clean air and water acts that have brought an amazing return of these winged creatures along the shores from Florida to Texas.

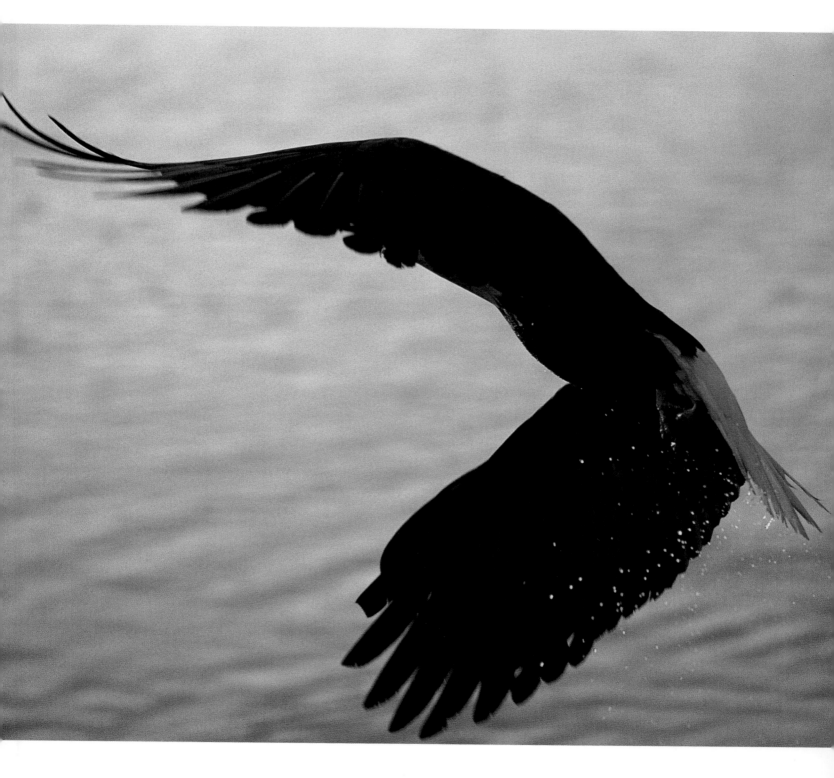

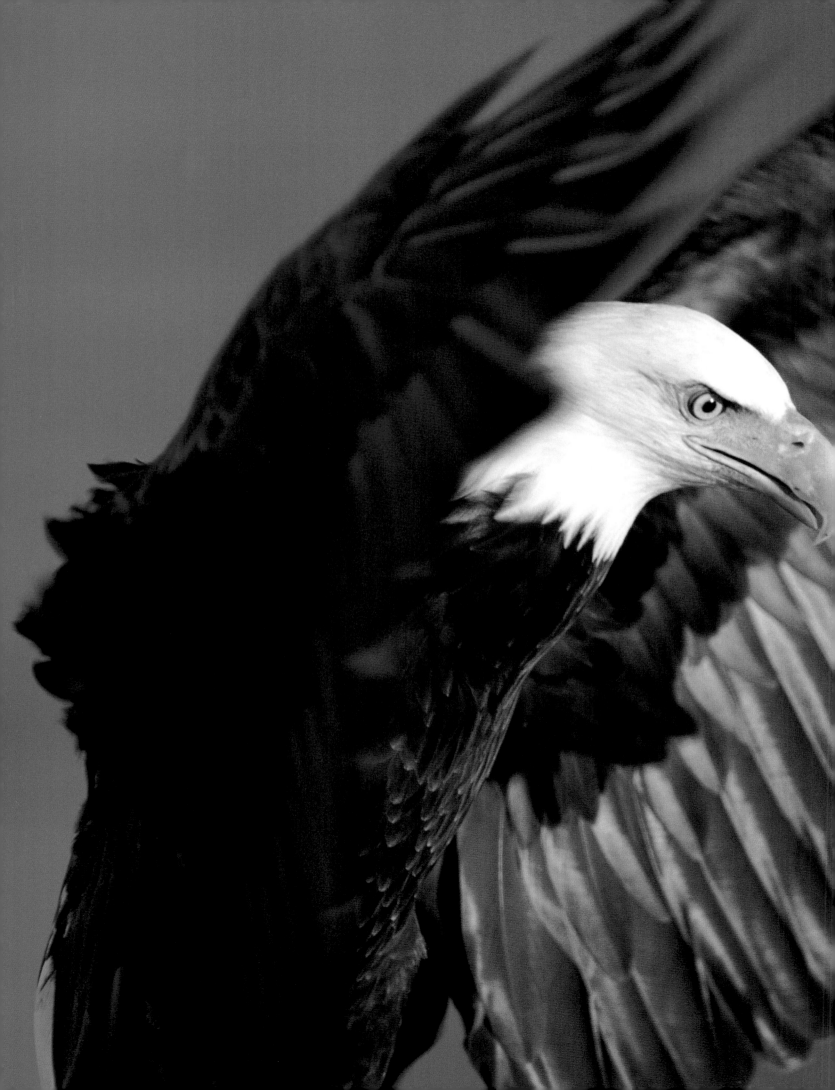

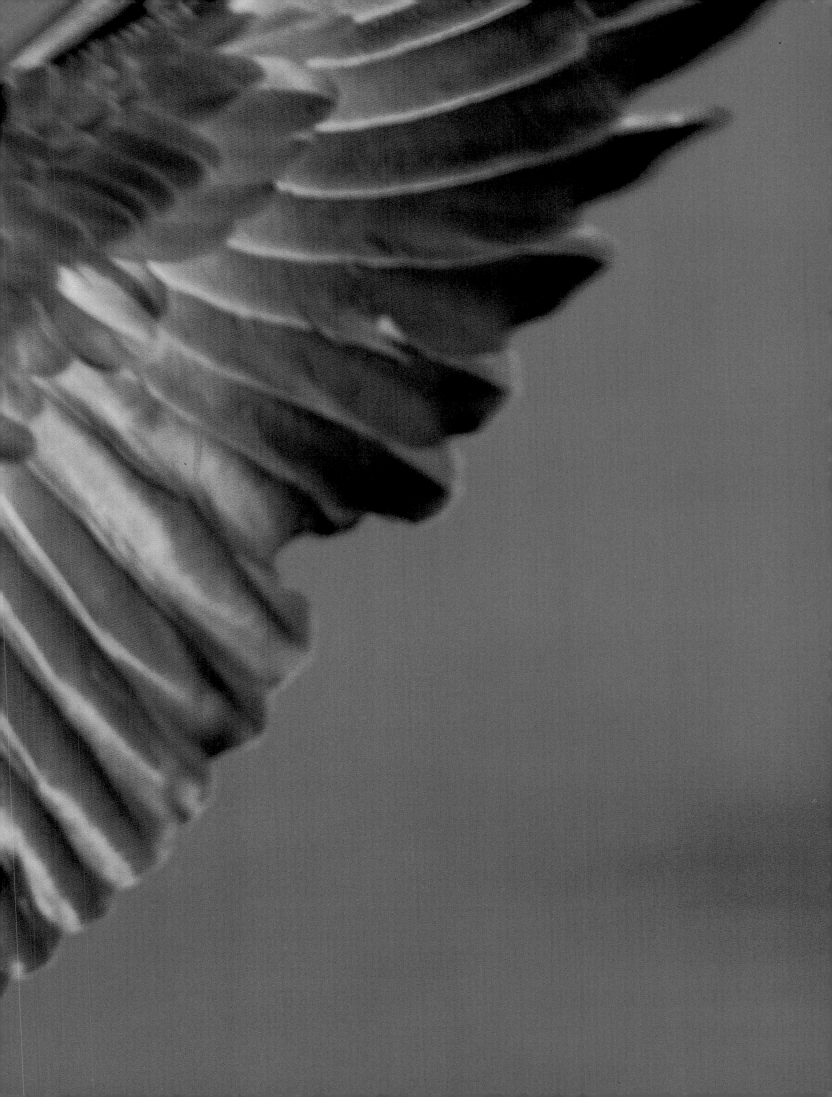

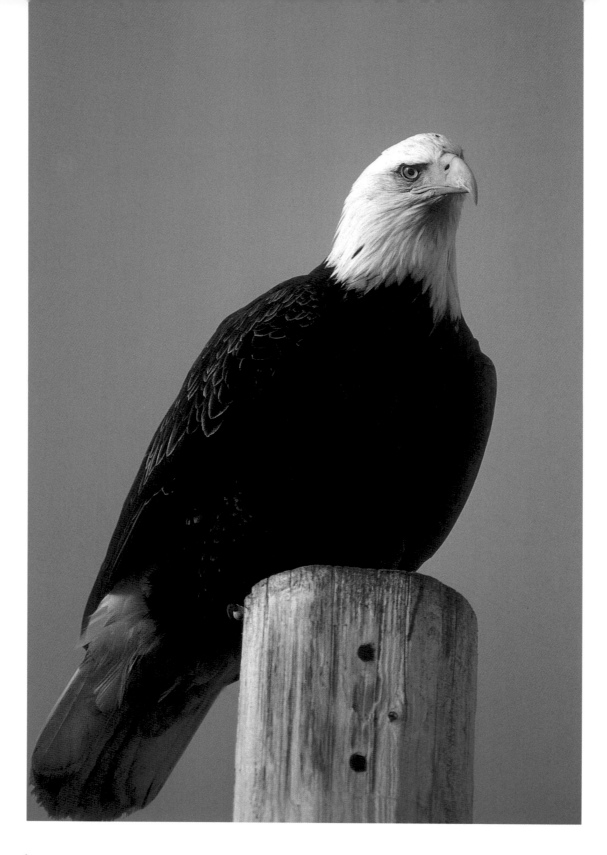

This rather large bald eagle represents the reality of our national icon's return to the skies and waterways of America. Sitting atop a mooring post in Wethersfield, Connecticut, this eagle is one of hundreds that grace the length of the Connecticut River today. For nearly fifty years it was almost impossible to see a bald eagle in this area.

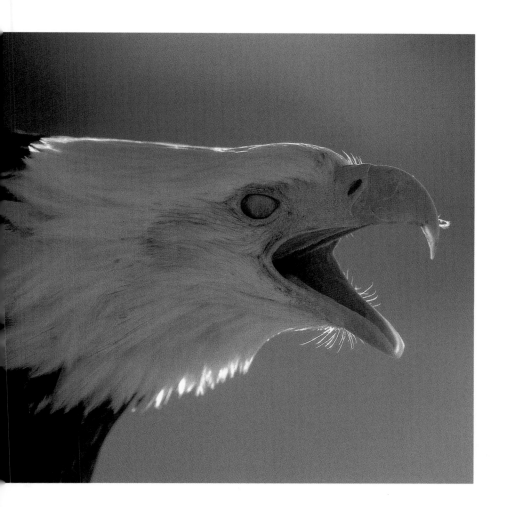

LEFT: The sun's piercing rays reveal this eagle's anger when another eagle approaches his prey on the banks of Yellowstone Lake in Wyoming. Yellowstone National Park has a small but stable population of bald eagles during both summer and winter.

BELOW: This unusually large, very majestic bald eagle that I nicknamed "the Last Emperor" has only one leg. He most likely lost his other leg in a varmint trap—a brutal trap that usually claims the bird's life. The Last Emperor somehow survived and I had the privilege of his company (at a distance) for several years among the fishing villages of Seldovia, Homer, and Halibut Cove, Alaska. As one would expect, it was very hard and often impossible for this proud creature to earn a living. Although severely handicapped, he never lost his noble air.

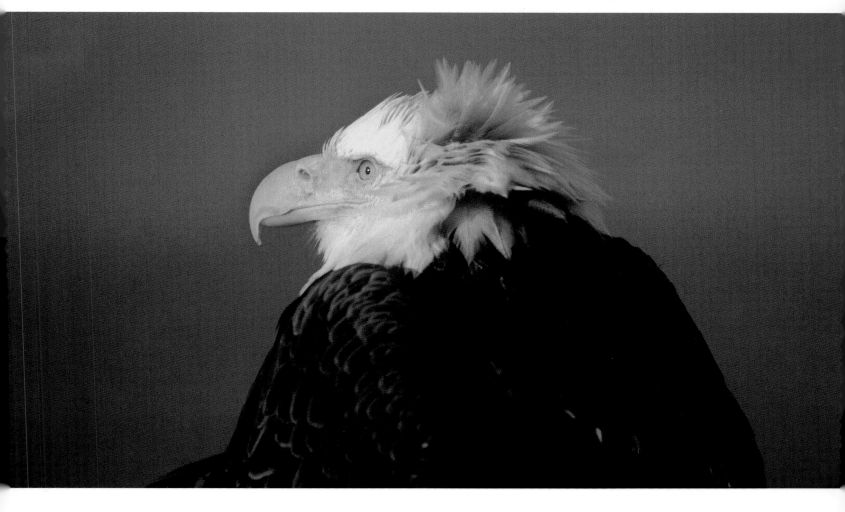

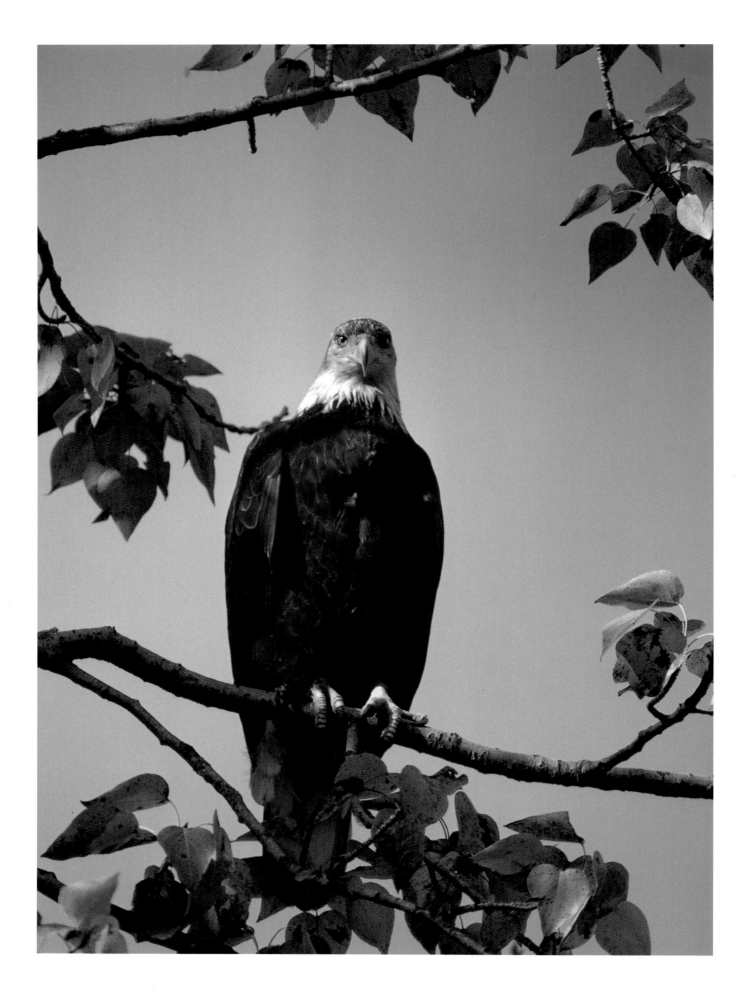

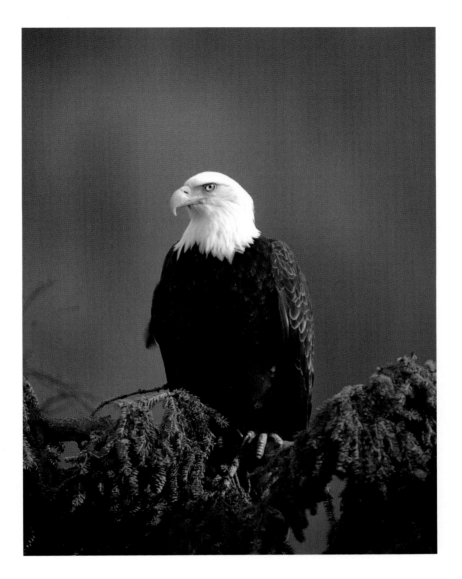

OPPOSITE: *Twenty years ago when I took this photo of a mature bald eagle along the banks of the Illinois River in Oklahoma, you could scarcely find a bald eagle in the entire state. Today approximately a thousand bald eagles winter among the state's lakes and rivers. The George Miksch Sutton Avian Research Center in Bartlesville, Oklahoma, has been responsible for raising and releasing 275 bald eagles between 1984 and 1992. Eggs were transported from nests in Florida to the center's captive breeding facility, where they were incubated and hatched.*

ABOVE: *Minnesota's lakes, rivers, and waterways have been a blessing to our eagles in this part of the country. However, some birds (most likely those that have flown down from Canada) still carry traces of PCBs and DDT because Canada continued to use DDT for another decade after the United States banned it. Fortunately, in our northern border states, trace elements of these poisons have nearly disappeared.*

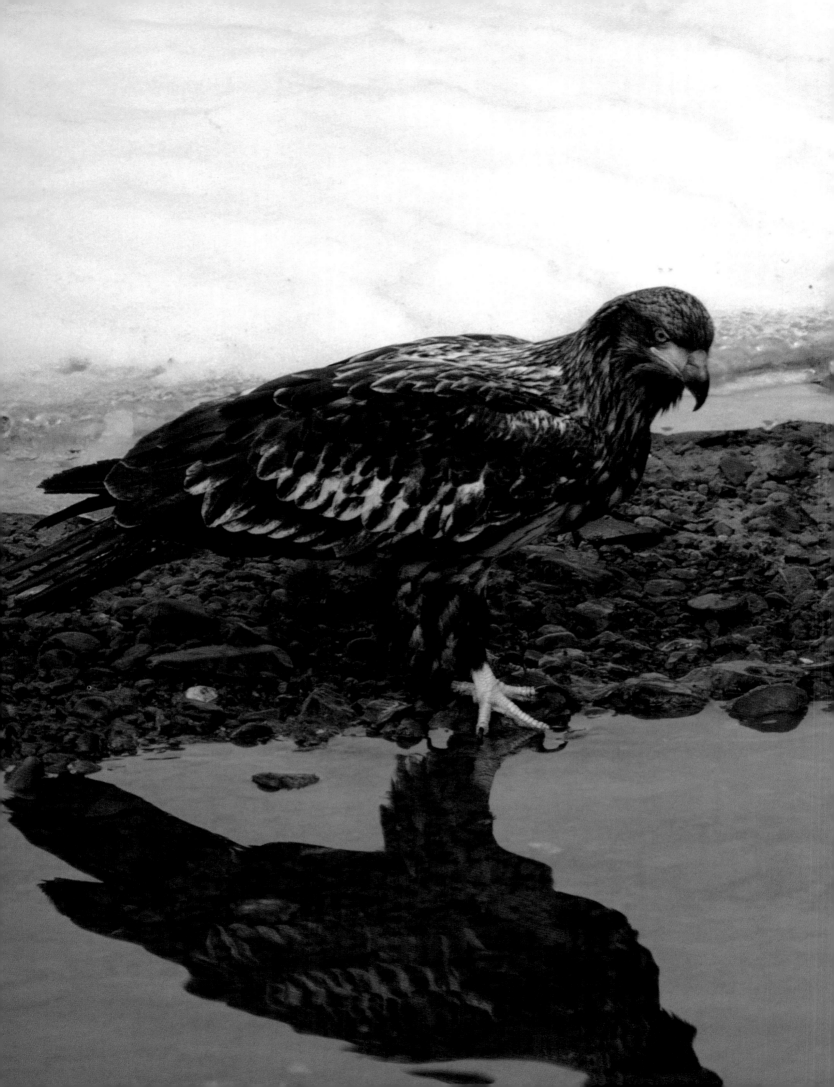

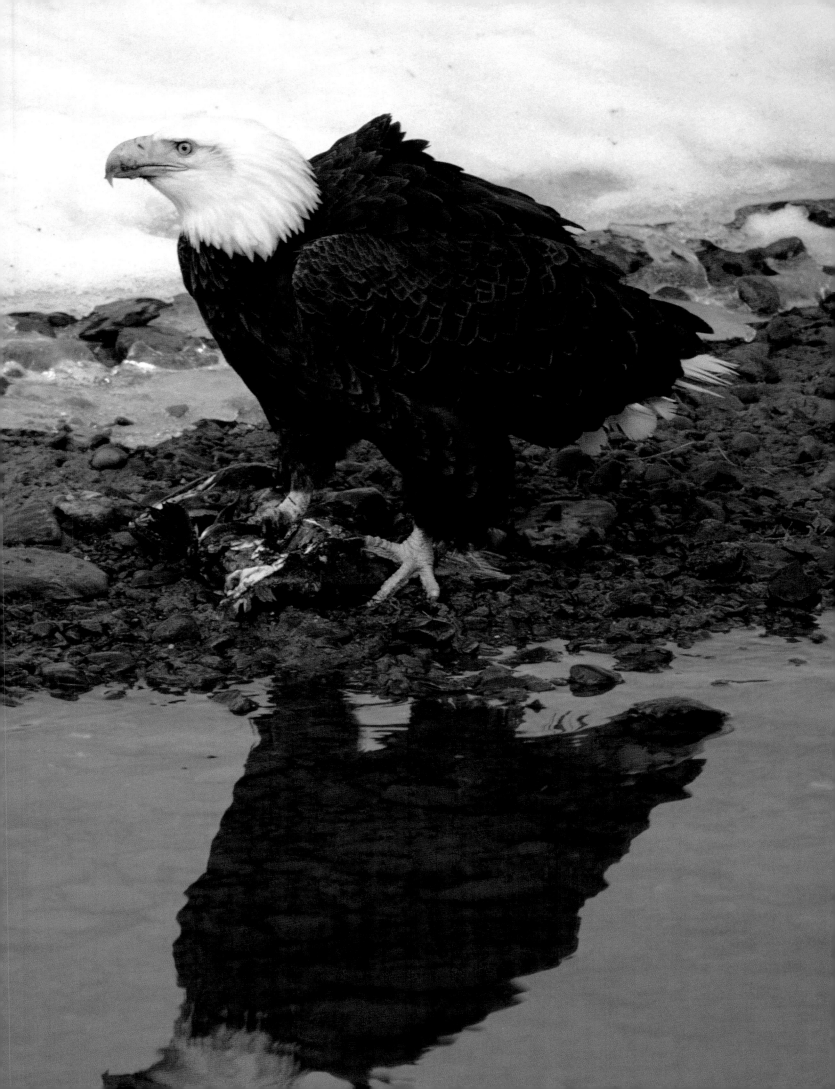

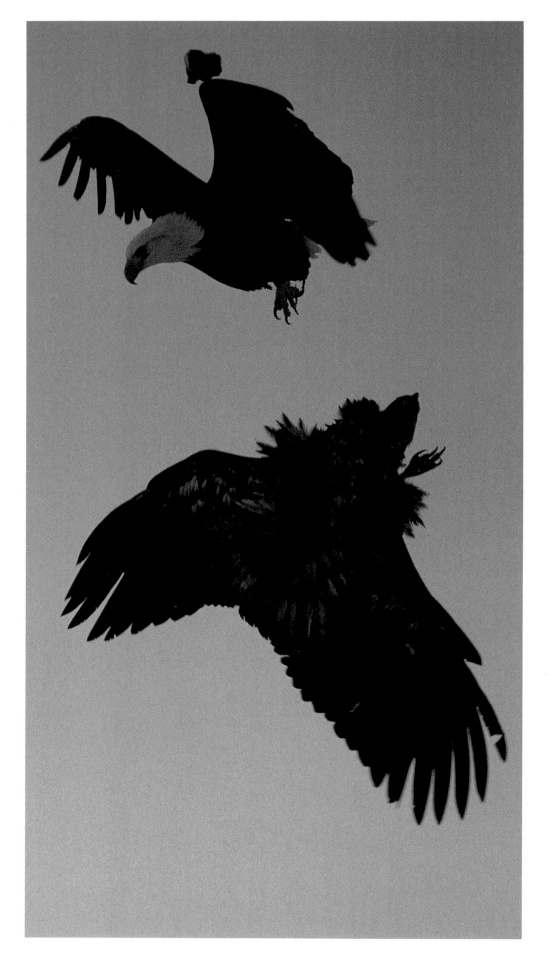

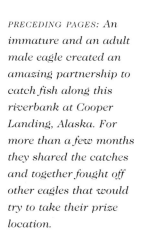

PRECEDING PAGES: *An immature and an adult male eagle created an amazing partnership to catch fish along this riverbank at Cooper Landing, Alaska. For more than a few months they shared the catches and together fought off other eagles that would try to take their prize location.*

RIGHT: *With great speed and agility, two eagles (the immature is on the bottom) play fight in the last few moments before sunset.*

OPPOSITE: *In a lightning-fast strike and a cluster of wings, one eagle is knocked off his vantage point.*

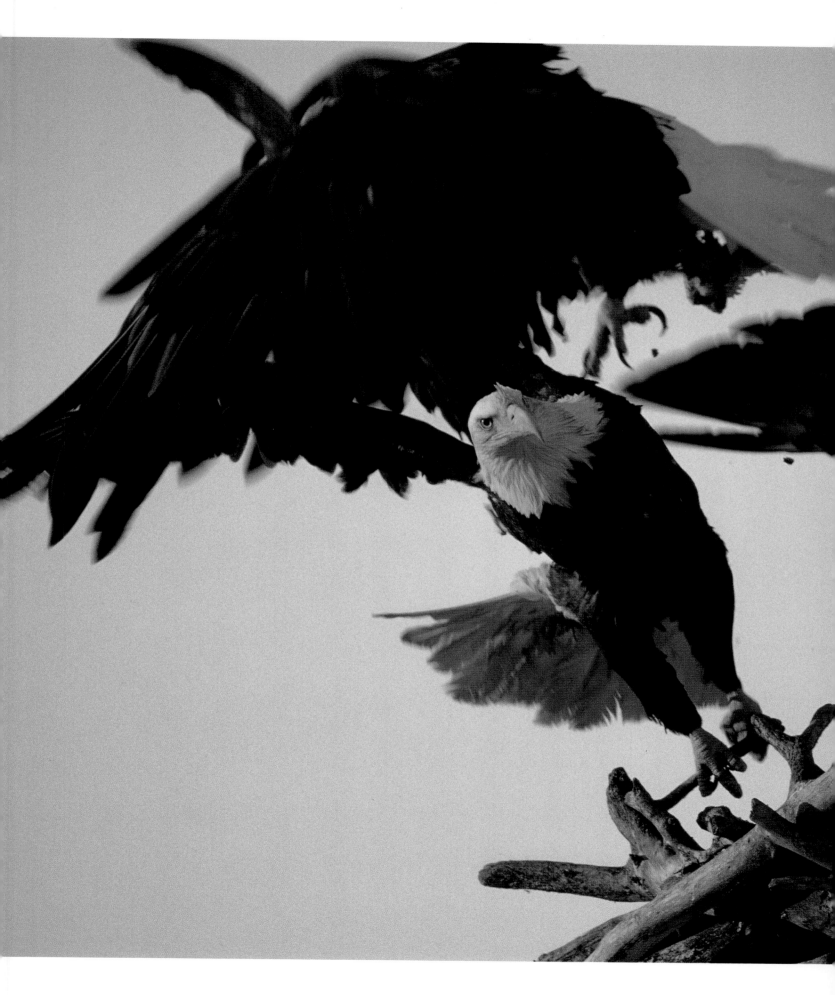

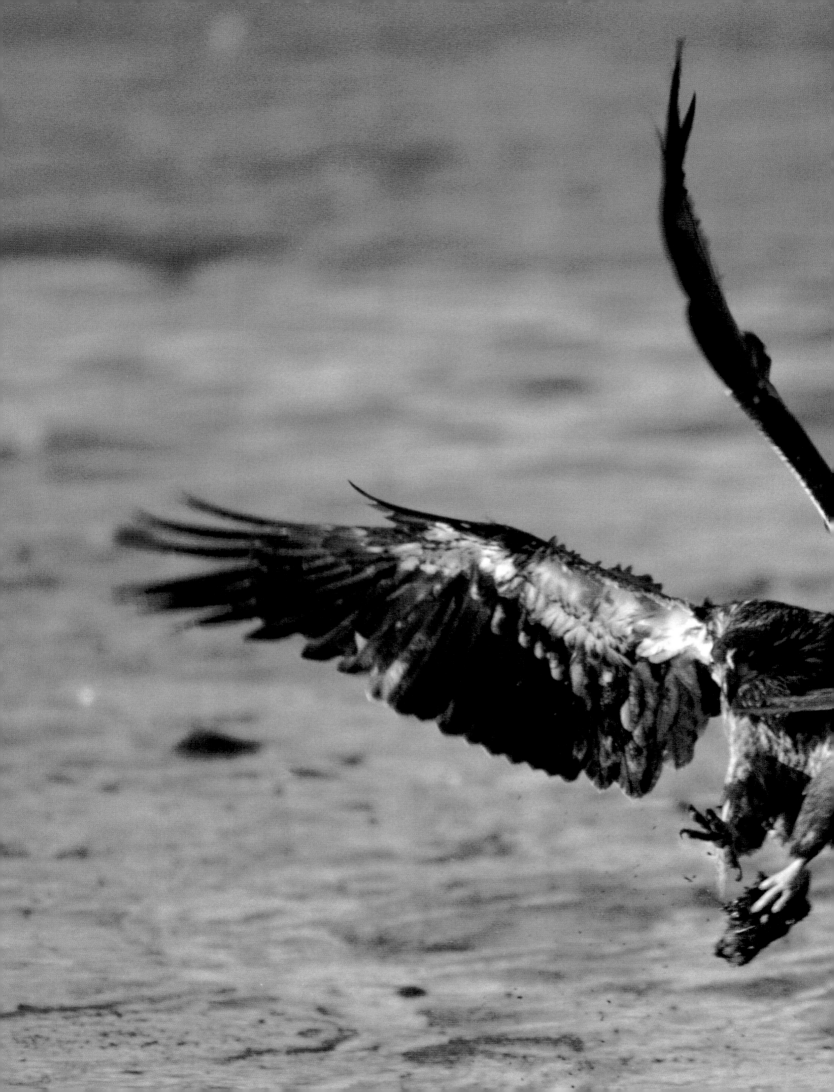

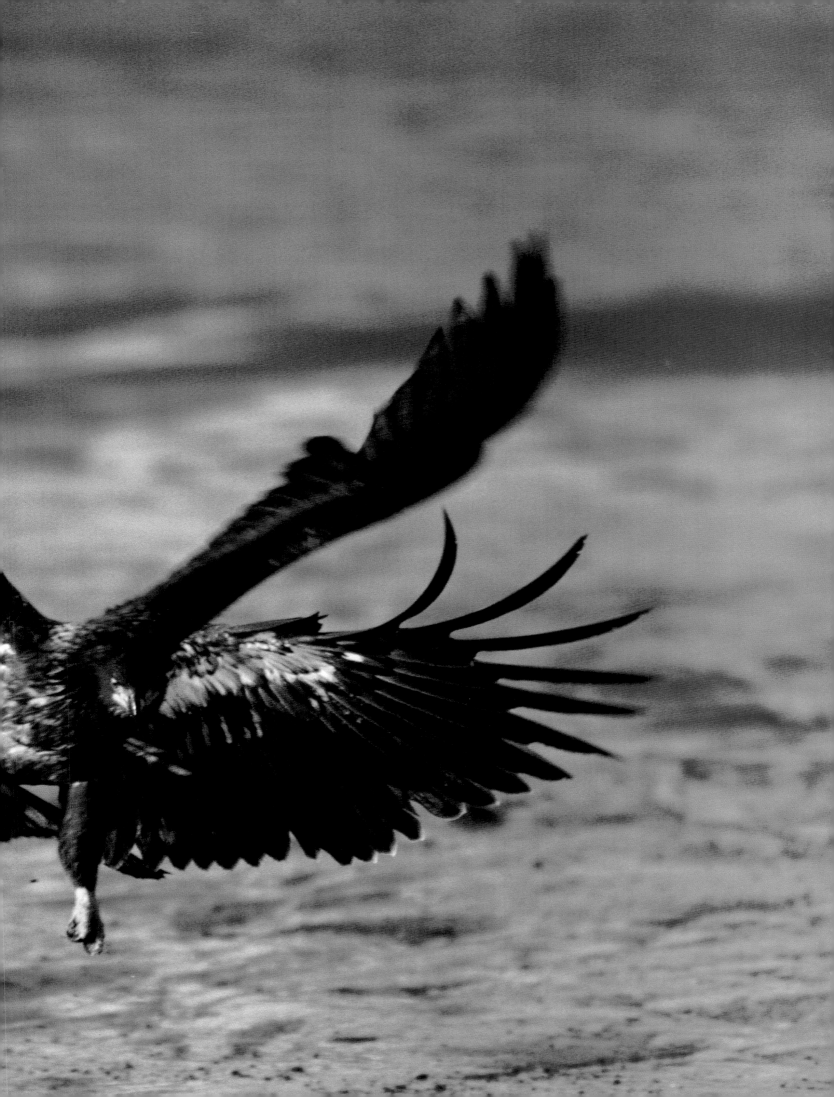

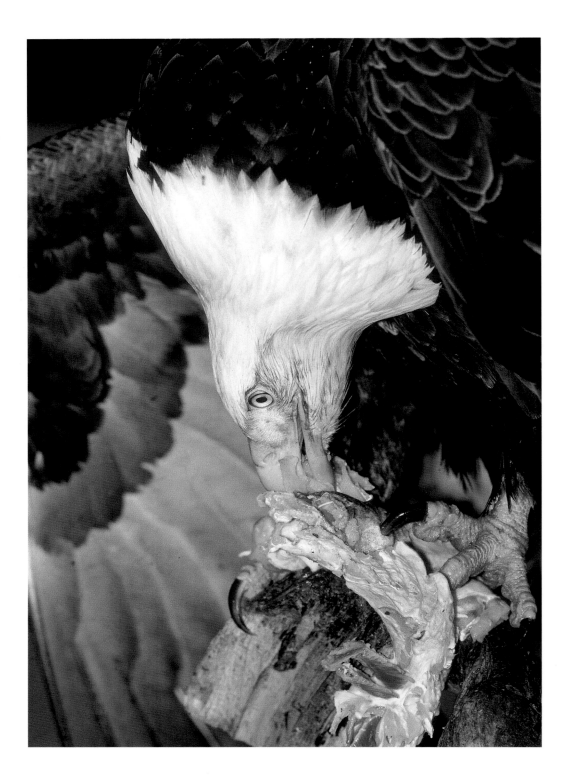

PRECEDING PAGES: Caught in the act of attempting to steal a meal in midair, the rear imma-
ture bald eagle tries to lock onto the prey in the front eagle's talons. Pirating among eagles
has been seen countless times but is rarely photographed.

ABOVE: This bald eagle feeding on a washed-up halibut carcass thrown overboard by a fish-
ing charter boat is exhibiting a behavioral pattern called "mantling." An eagle with food will
cape its wings about its meal for two reasons: to simply shield its prize from a would-be
pirating eagle, or to hide it before it is seen.

BELOW: *The larger of the three eagles chases off clam jumpers in Montana's Glacier National Park. From the mid-1980s to the mid-1990s the park had a healthy population of winter eagles due to a late run of salmon in the spring. But now the run has dried up and the eagles have gone elsewhere for a winter roosting area.*

FOLLOWING PAGES: *An adult and an immature fight over a clamming location in Polycreek, Alaska. When the salmon runs end in November, this population of bald eagles survives on razor clams. The only other place I've personally witnessed eagles clamming is Coos Bay, Oregon; however, this life-sustaining practice goes on wherever there are easily obtainable shellfish and a population of eagles. Opening a clam is quite easy for these giant raptors' talons. I have also seen eagles drop the clams on a rock from a lofty position, although this requires a considerable amount of precious energy.*

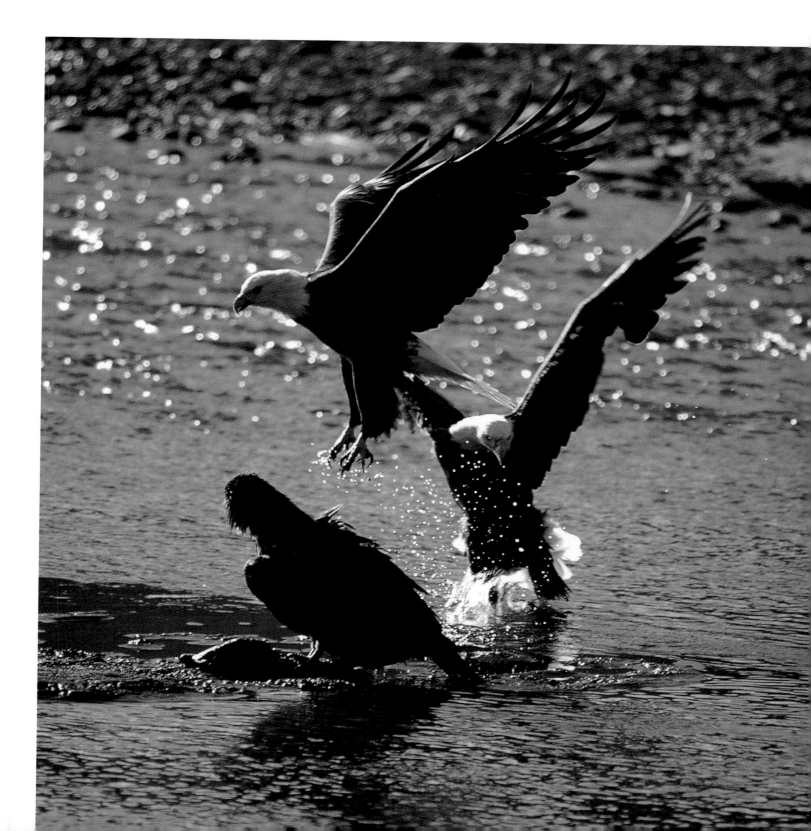

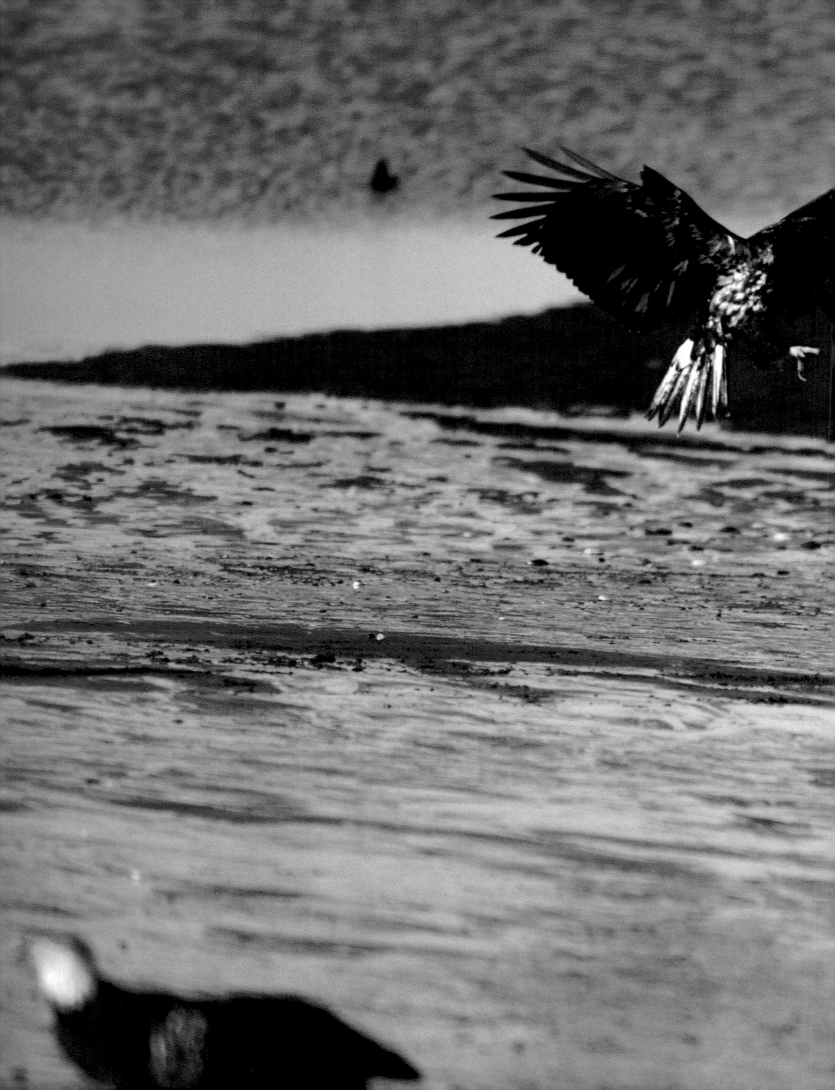

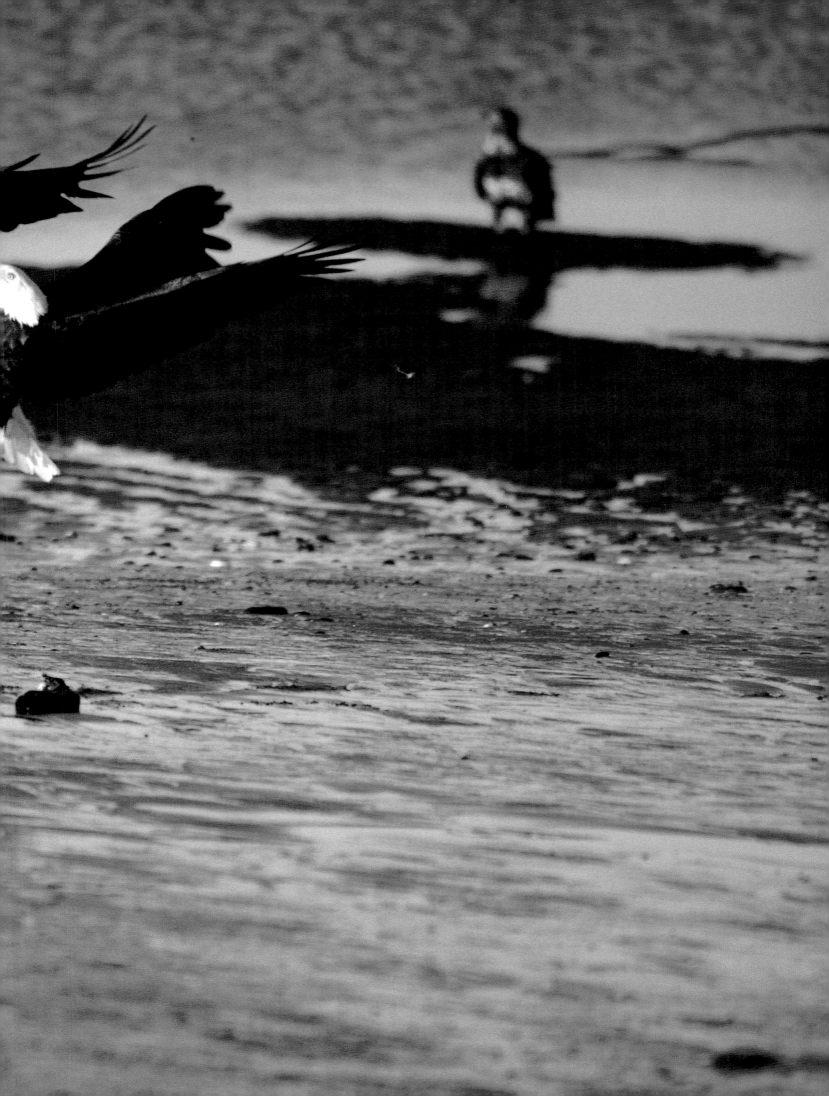

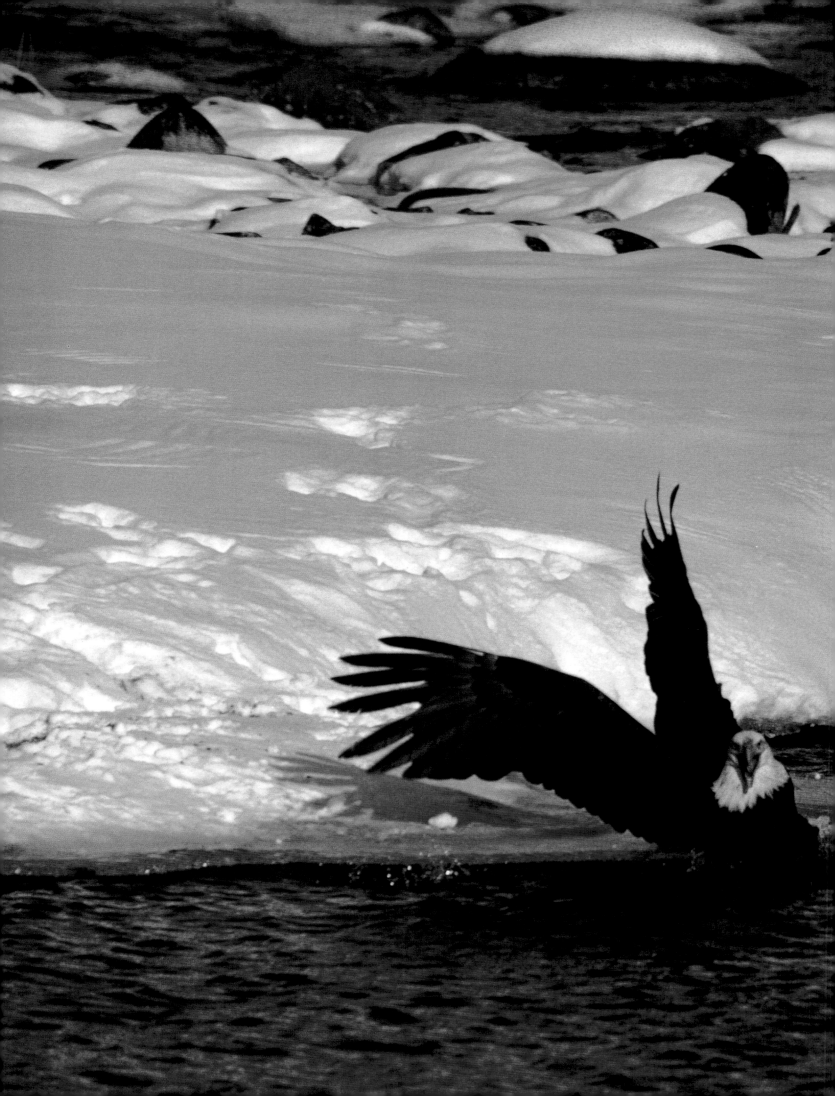

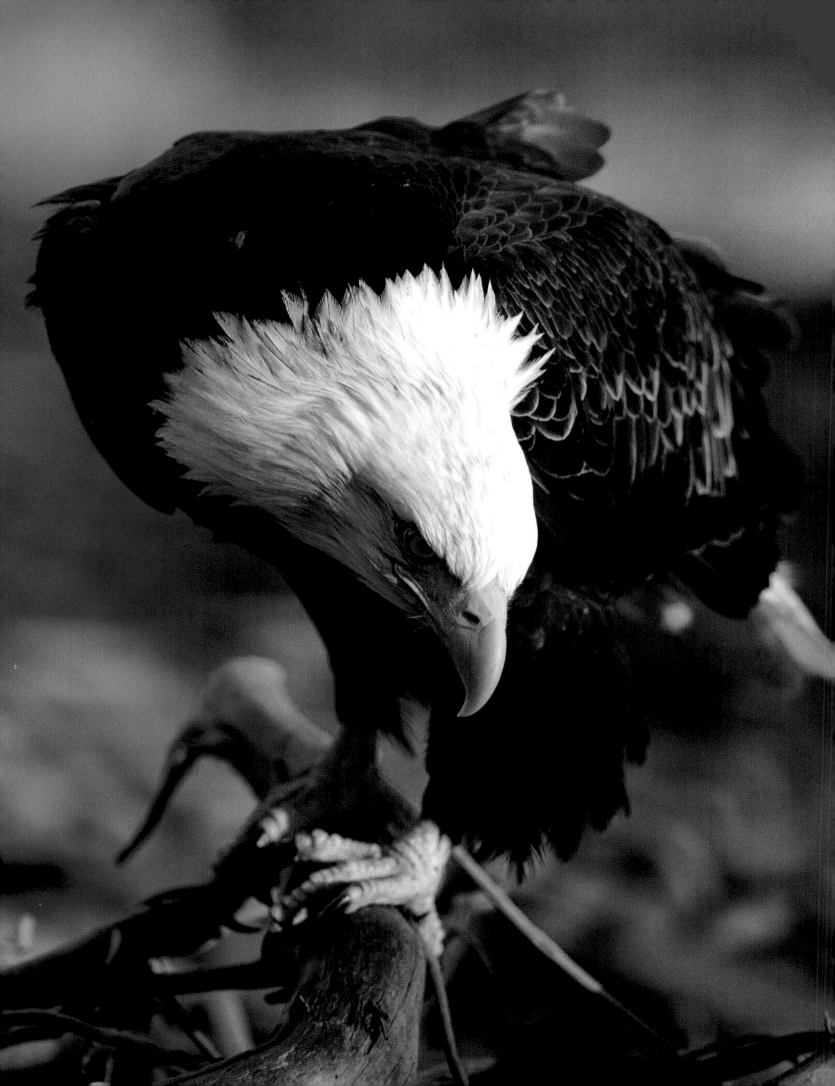

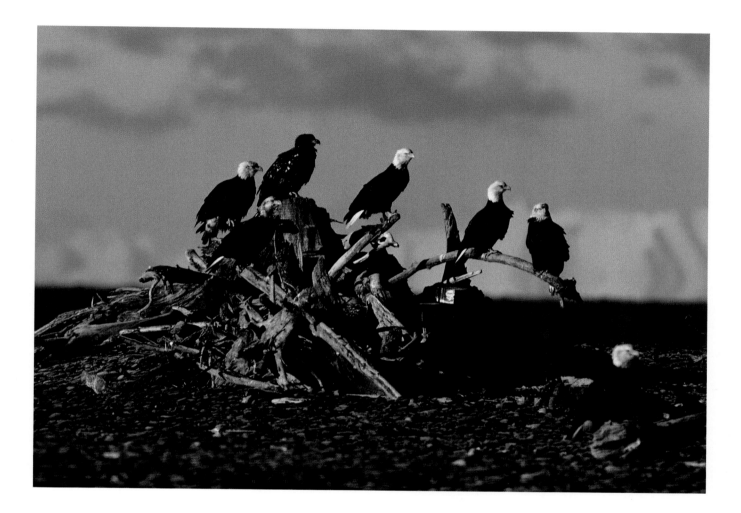

PRECEDING PAGES: *Engrossed in fighting over a prime fishing location, both eagles end up in the water. Only the mature bald eagle was able to paddle back to shore. The inexperienced immature bald eagle was caught up in the current and drowned. In my ten thousand field hours with the bald eagle I have witnessed hundreds of fights over food, but nearly as many over a good fishing location, and the majority of fights to the death that I've seen have been over location. Without a proper position to catch fish, starvation is inevitable.*

OPPOSITE: *The health of a bald eagle can be determined at a glance by how well it is groomed. If an eagle, or any bird of prey for that matter, has an unkempt appearance with dirty feathers or an excessive amount of lost feathers it usually means it is fairing poorly. It will most likely not live through the winter if it is lacking a heavy, clean, lustrous look.*

ABOVE: *This group of eagles resembles a gathering of vultures. It is often forgotten that eagles are truly opportunistic scavengers. I admire the intelligence and resourcefulness of these large birds that have been able to adapt to shrinking food supplies and habitat destruction.*

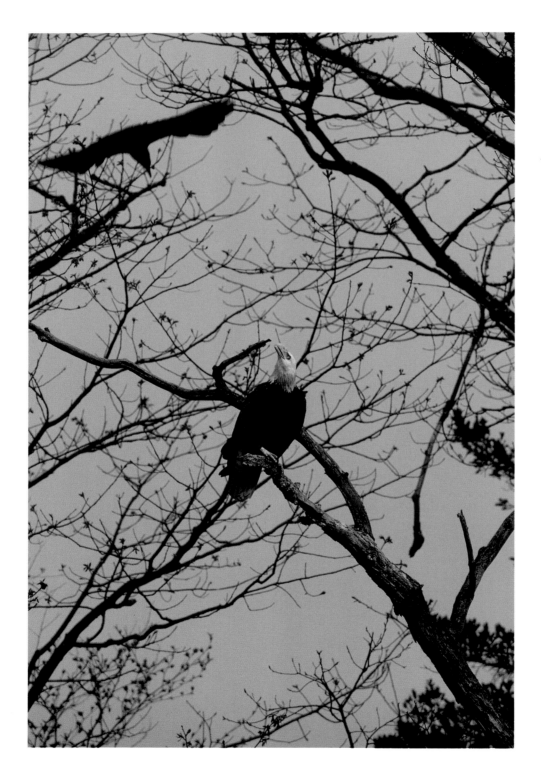

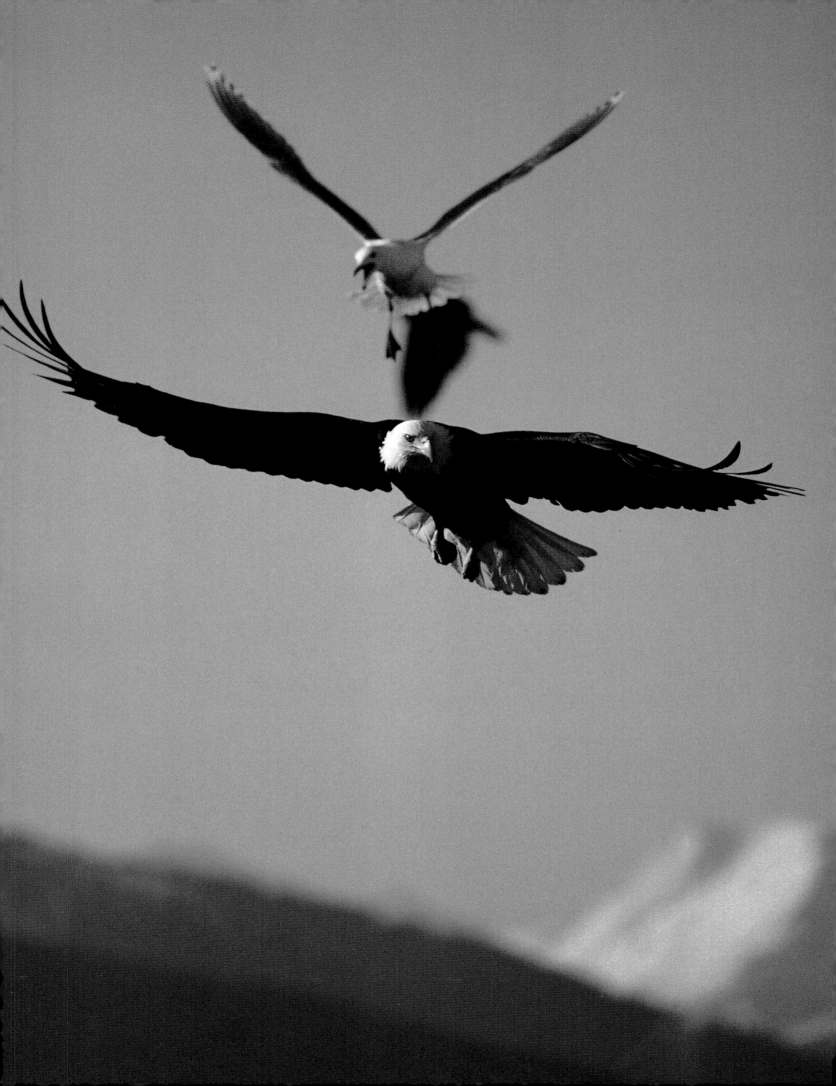

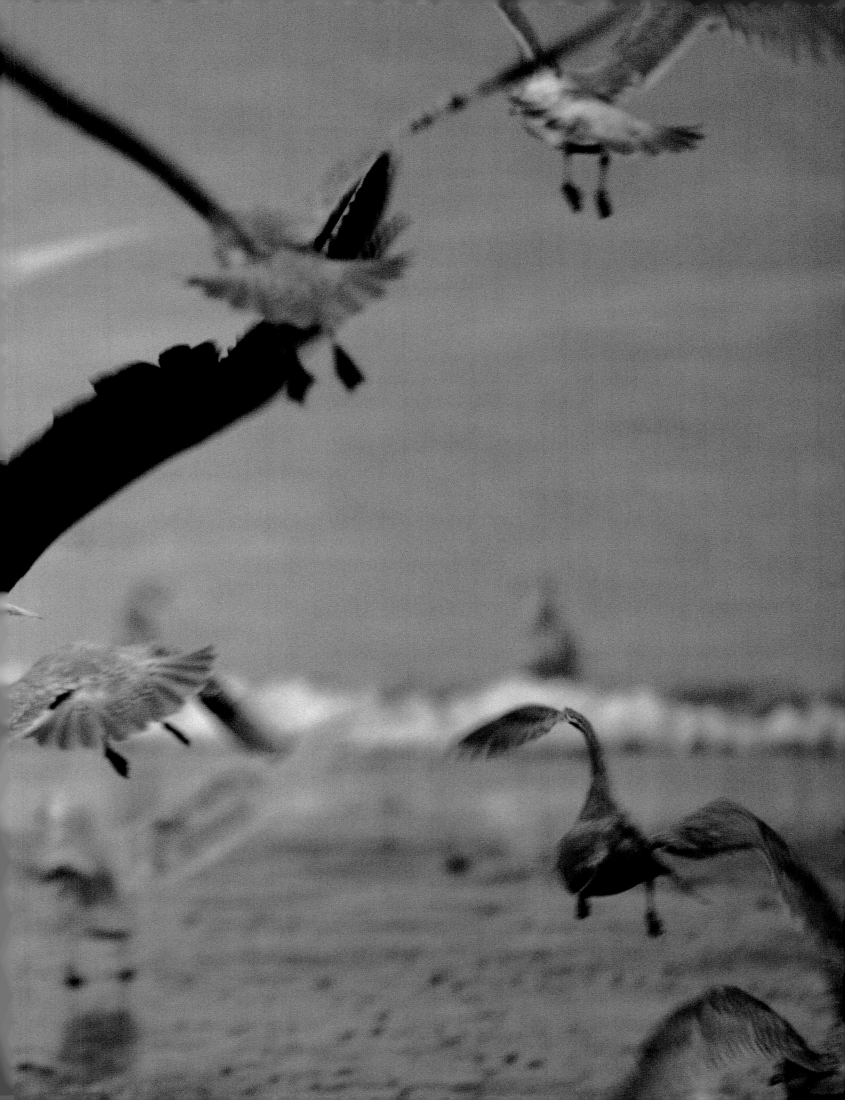

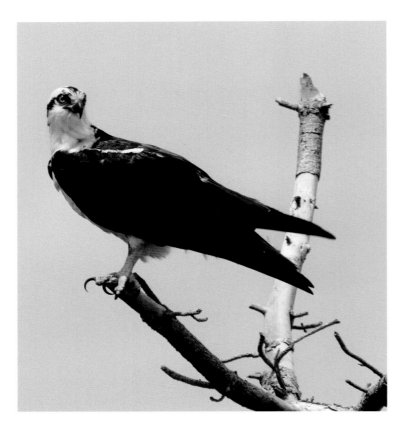

LEFT: *One of the most skilled fishing hawks in all of nature is the osprey. Unfortunately, ospreys are frequently the target for pirating eagles.*

BELOW: *On a remote island in the Pacific this female eagle stricken with grief carries her dead baby aloft in an attempt to make it fly. She did this repeatedly with both of her dead babies. Observing this behavior taught me that human beings are not the only animals that grieve for their young. Never again will I take the death of a wild animal for granted.*

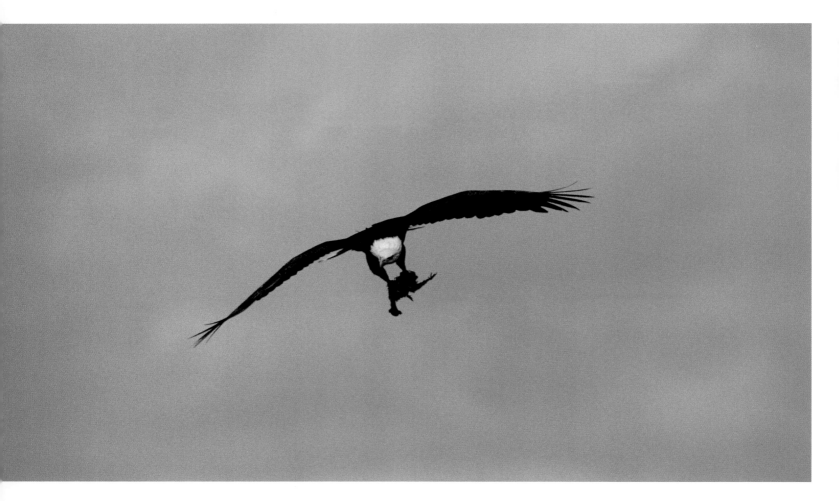

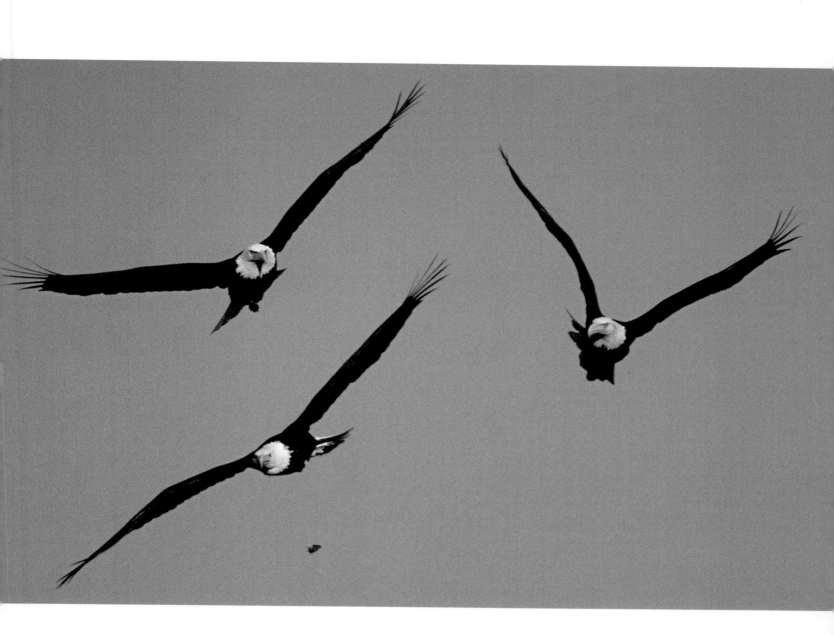

ABOVE: A courtship flight among three eagles shows two males rivaling for the female below. The males glare at one another, yet are still aware of the space needed for the female's wings. It is thought that eagles mate for life, and in my field research I have found this to be true. I have witnessed the same mating pairs return to the same nests, and even to the same roosting trees, year after year in several parts of the country. Generally only mature eagles will mate or pair bond, and the courtship, which is repeated each year, is an impressive display of calls and aerobatic maneuvers. Courtship and mating times vary throughout the country.

FOLLOWING PAGES: A mature eagle and his shadow plummet toward his mate. She is eating a silver salmon on the banks of the ice-free upper Kenai River in Cooper Landing, Alaska. Females can weigh about fourteen pounds and have a wingspan of up to eight feet, while males are smaller, weighing seven to ten pounds with a wingspan of about six and a half feet.

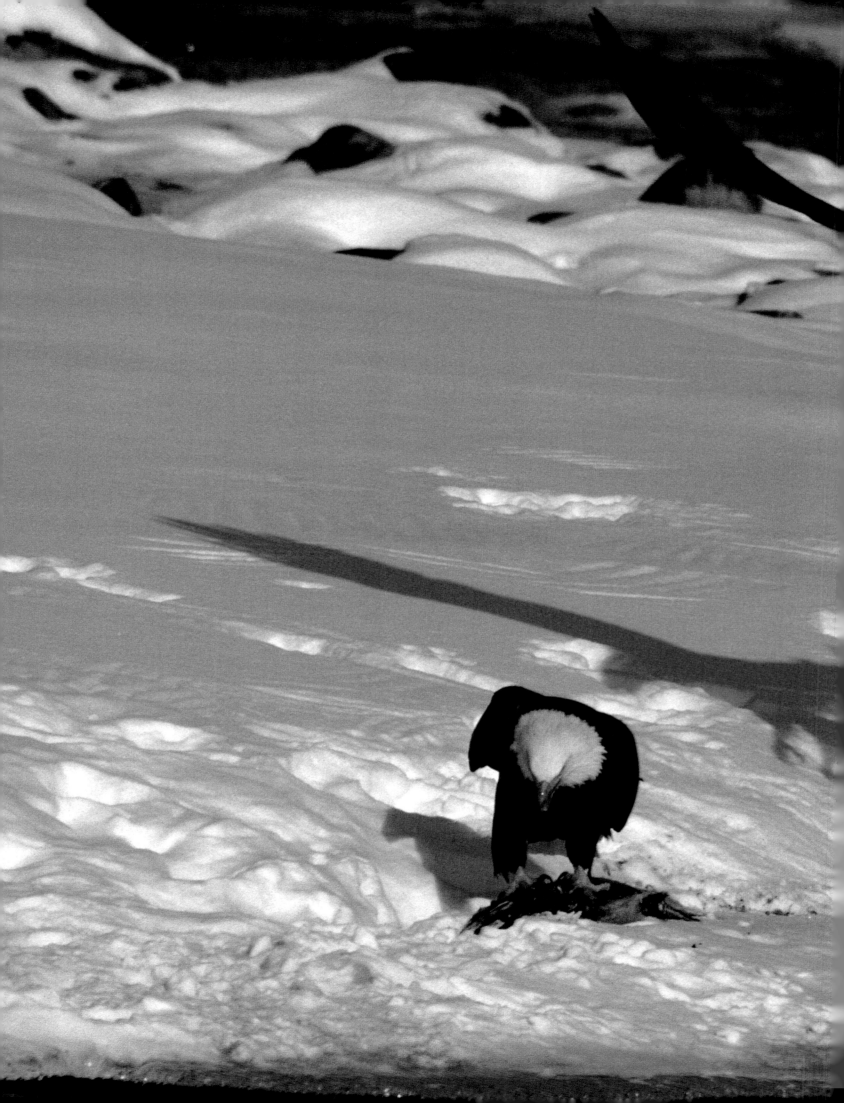

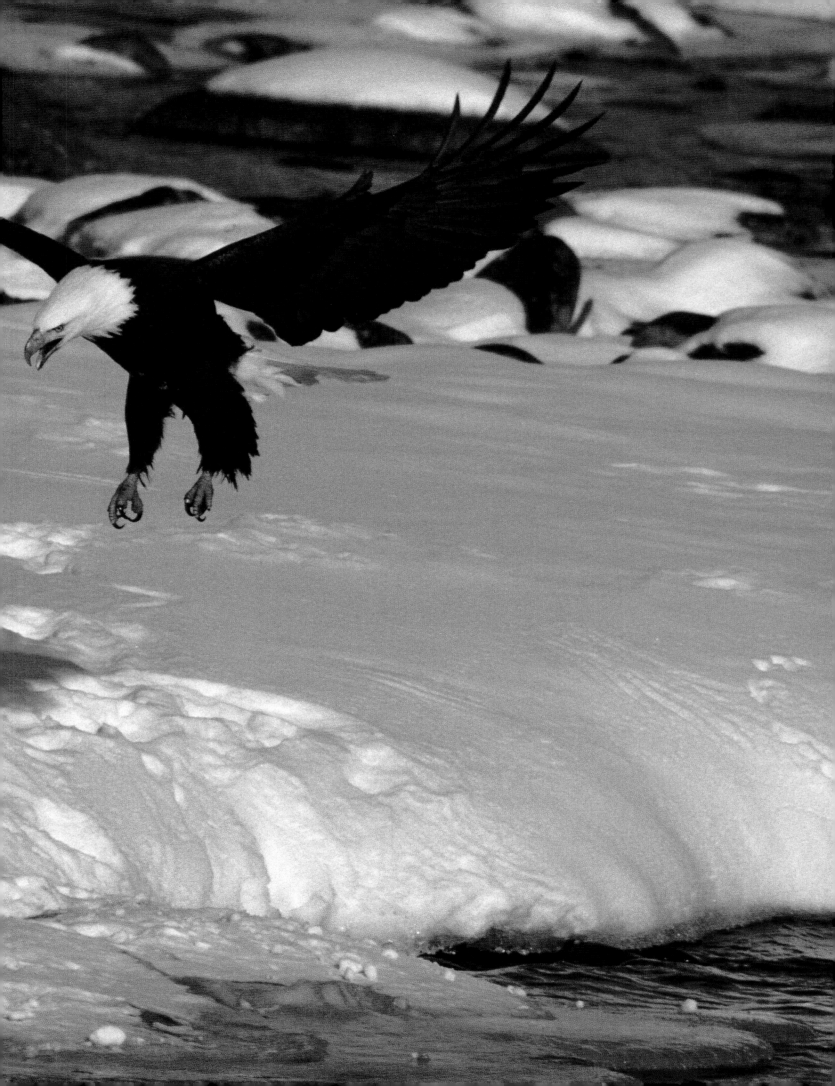

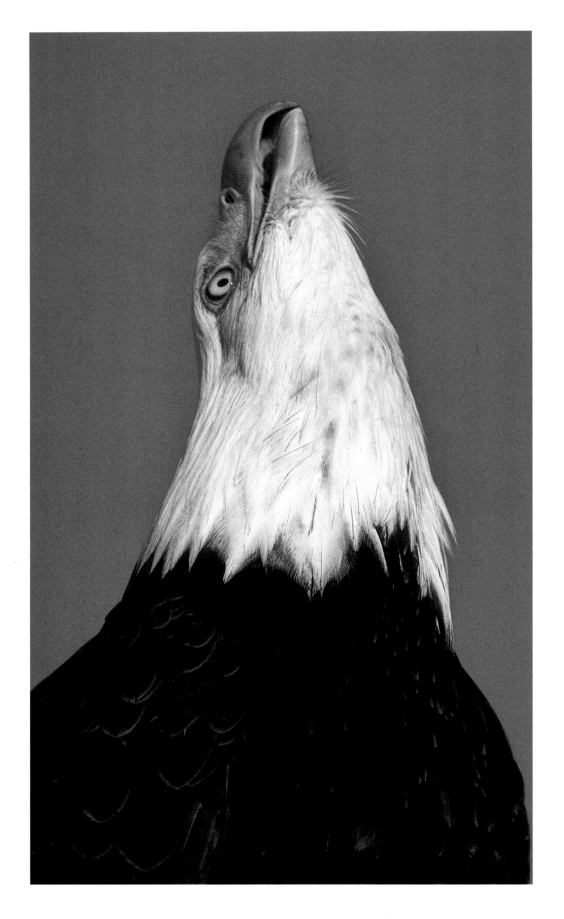

LEFT: *A female eagle greets her long overdue mate with great jubilation. Although there have been few studies on eagle communication, it is certain they use their cries when threatened, to welcome a mate, or at communal eagle gatherings, which are most prevalent in the winter months. An eagle can scream in many positions but the really loud and heartfelt ones are produced from this kind of vertical position.*

OPPOSITE: *As early as 350 B.C. Aristotle wrote about the eagle's territory, noting that eagles are especially protective of their nest sites, breeding areas, and hunting range. This eagle stares intently at a group of seagulls diving on herring near Juneau, Alaska's Eagle Beach State Park.*

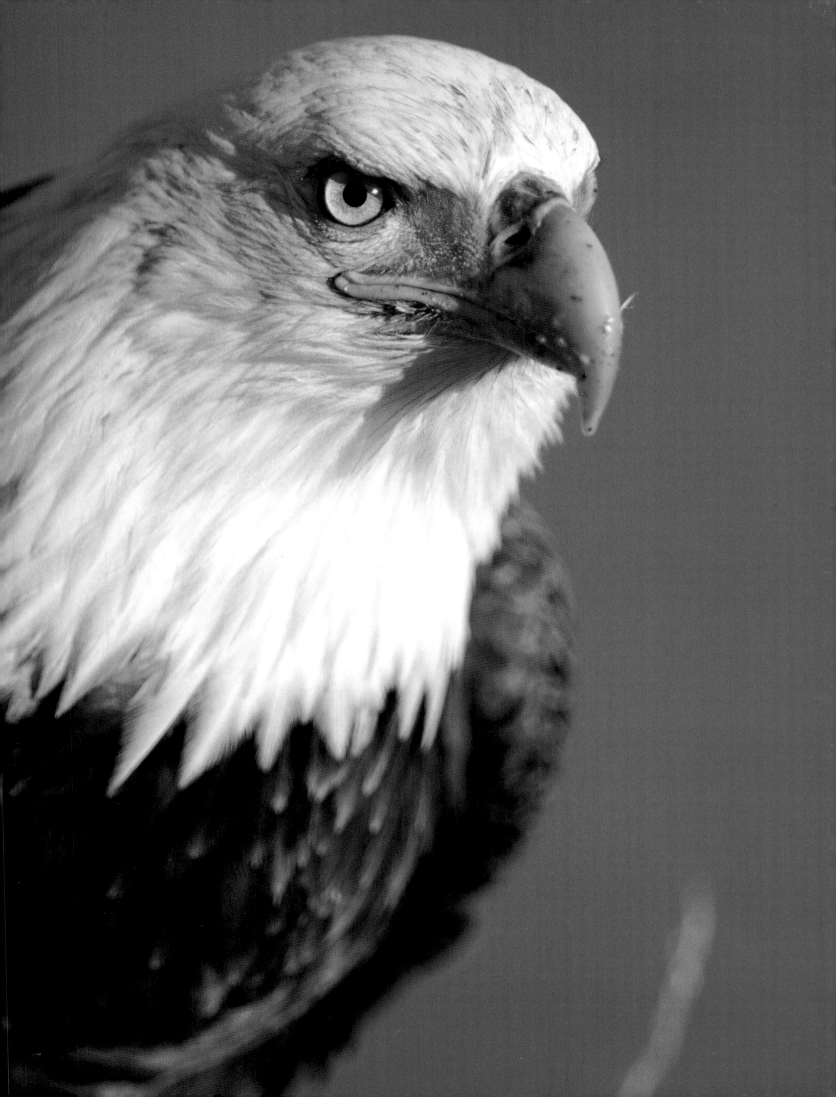

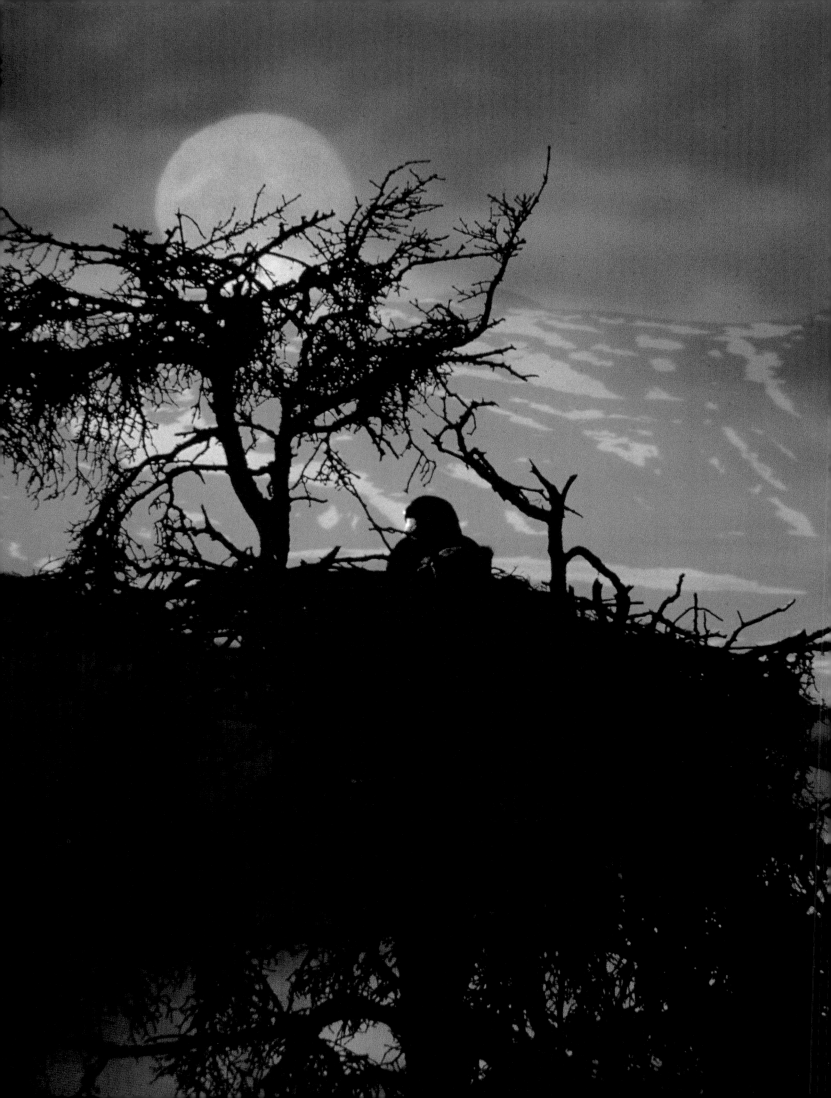

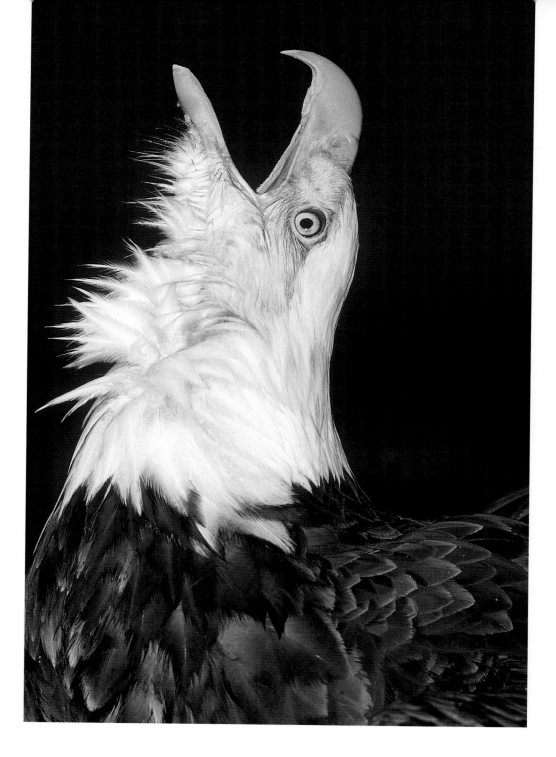

OPPOSITE: *For three years on and off I observed this eagle nest along the Continental Divide in Alaska. Because it was so far north, there were very few fish in the lakes and streams, and parent eagles had a twenty-four-hour job finding food for their young in the midnight sun. Every winter the parents would migrate south to Prince William Sound, but the young would often stay because they did not want to leave their familiar surroundings. In the time I spent there I saw all the inexperienced offspring either freeze or starve to death when the temperature dropped to forty degrees below zero. It is hard to understand why these eagles nest in such a harsh climate, but I believe it is because here they have a large range free from the conflicts that arise when other nesting eagles are in the area.*

ABOVE: *A mature male warns his mate that intruders are in the area. Eagles are always very protective parents, but this male actually followed me, hissing and screaming as I attempted to study his nesting habits at night in Soldotna, Alaska. He was so vehemently opposed to my group's presence that we abandoned all studies on this endangered nest site.*

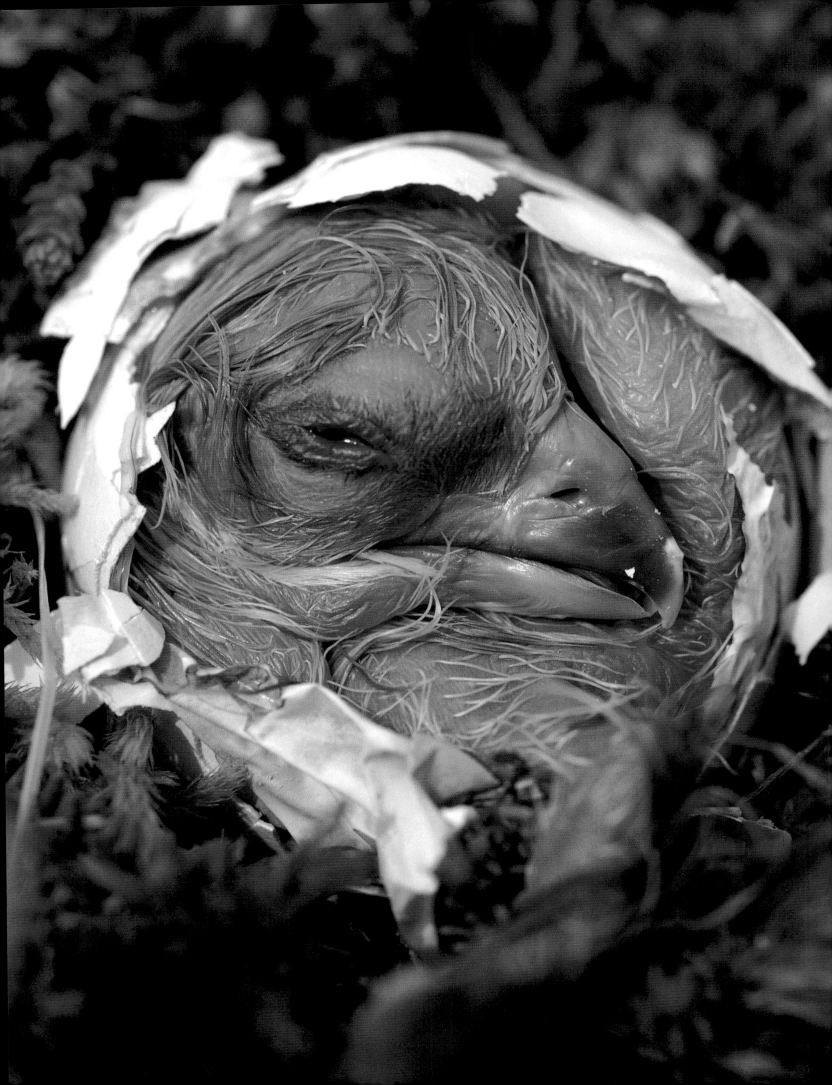

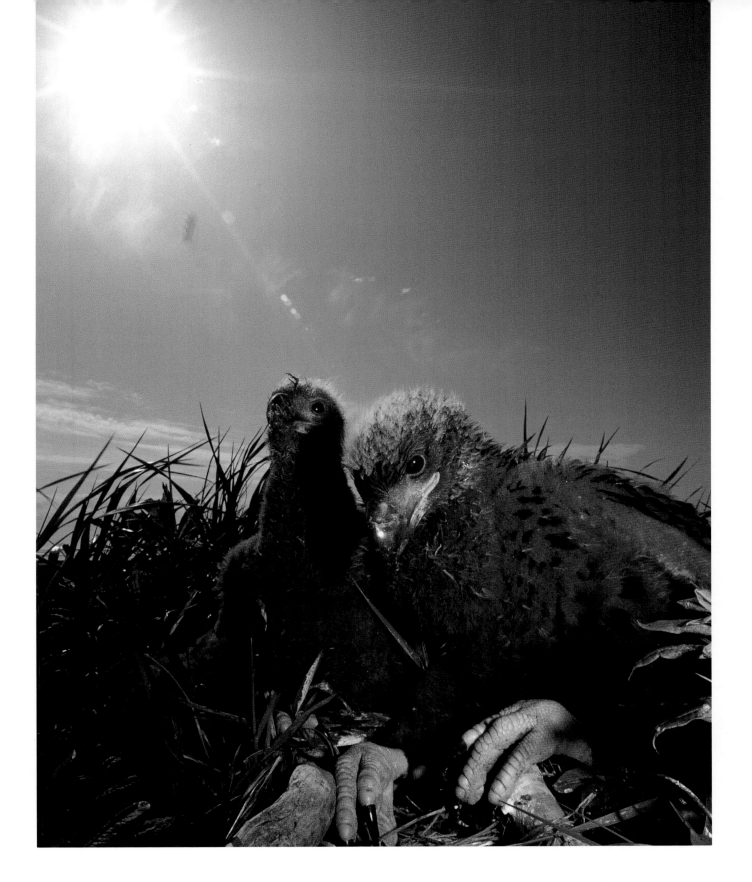

OPPOSITE: *A baby bald eagle on the Trinity Islands in the Gulf of Alaska hatches with great difficulty after chipping open the egg from inside, using its pipping tooth atop its beak. The hatching process takes more than twenty-four hours.*

ABOVE: *These two young eaglets wait on the corner of their ground nest for the return of their parents on this small island in the Pacific. I had been trying to take a photograph of eaglets with this type of prehistoric-looking setting for five years. The picture was taken with a wide-angle architectural lens, three flashes, and remote control cameras.*

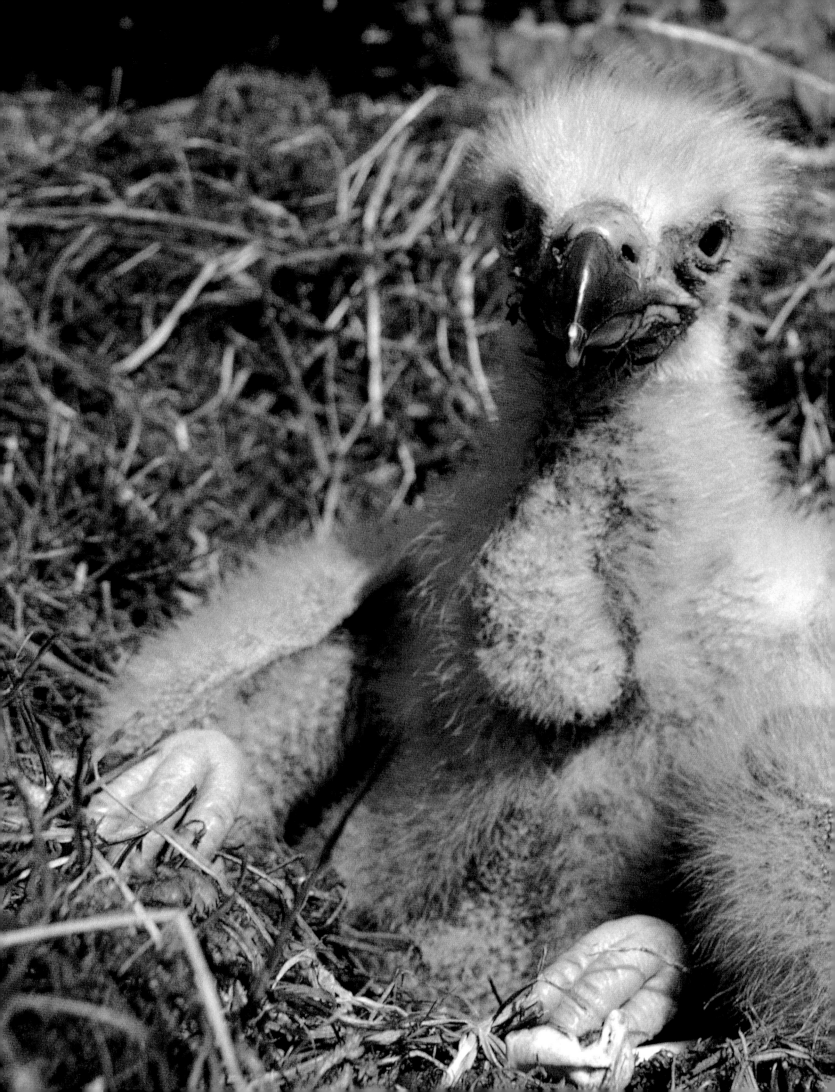

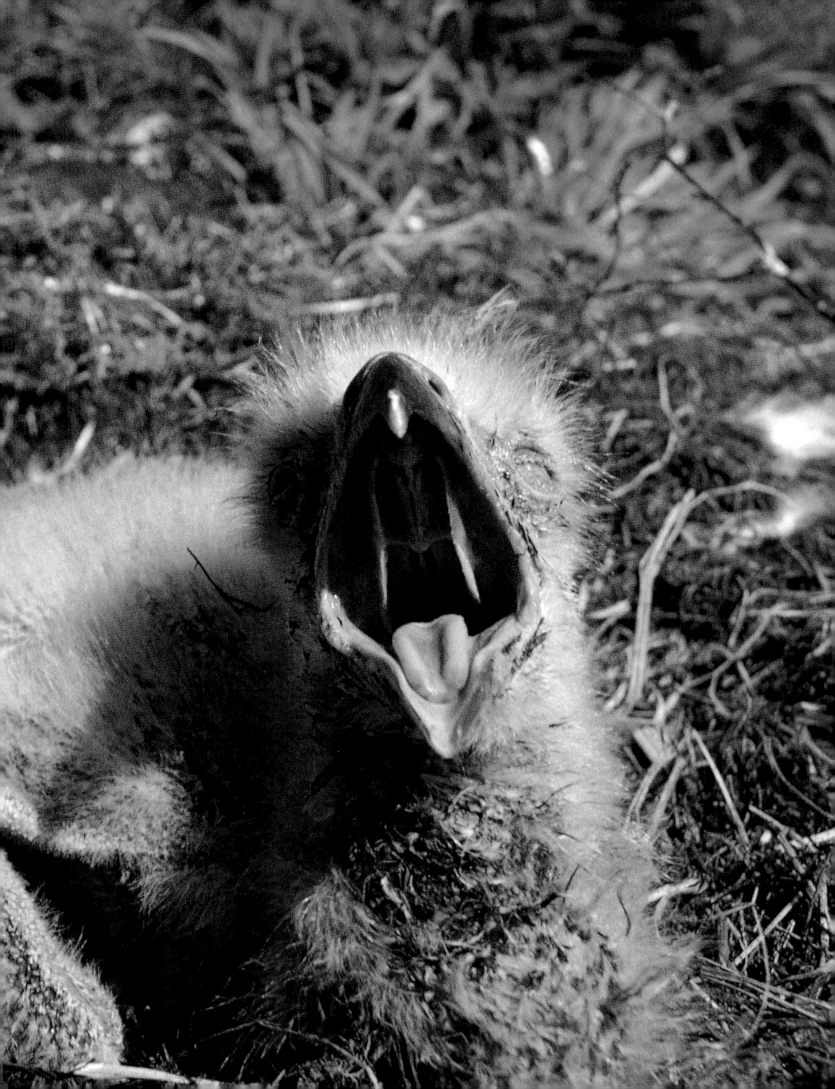

PRECEDING PAGES: *Two ten-day-old bald eagles await the return of their parents while staring at the remote control camera. These are the crucial days of survival for eaglets. If young are laid and hatch too soon, a spring frost or a several-day heavy rainstorm will kill them. Eagle eggs are laid anytime between December and June, depending on location and climate. The average nest of two eggs has an incubation period of about thirty-five days. The parents share the task of sitting on the nest, although the female assumes the duty 75 percent of the time.*

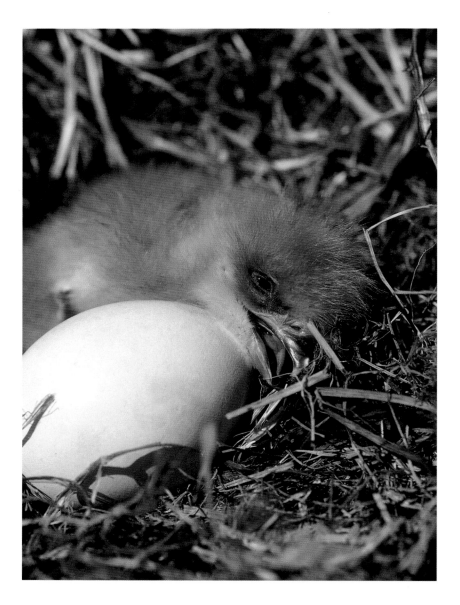

LEFT: *This eaglet lies exhausted after spending time in the sun to dry its natal down plumage. The female parent, and sometimes the male, will brood or sit over the eaglet as soon as it is hatched to keep it warm.*

OPPOSITE: *Although hard to imagine, this tiny eight-day-old eaglet will be ready to leave the nest in approximately ten to twelve weeks. Eagles are the fastest-growing bird in North America, and amazingly, in eight to twelve weeks a baby eagle will grow from roughly the size of a softball to almost three feet tall. The eagle goes through three periods of development: hatching or natal down stage, secondary down stage, and juvenile transition stage. After this growth period the young may stay in the area and even roost in the nest as they learn to hunt and fish.*

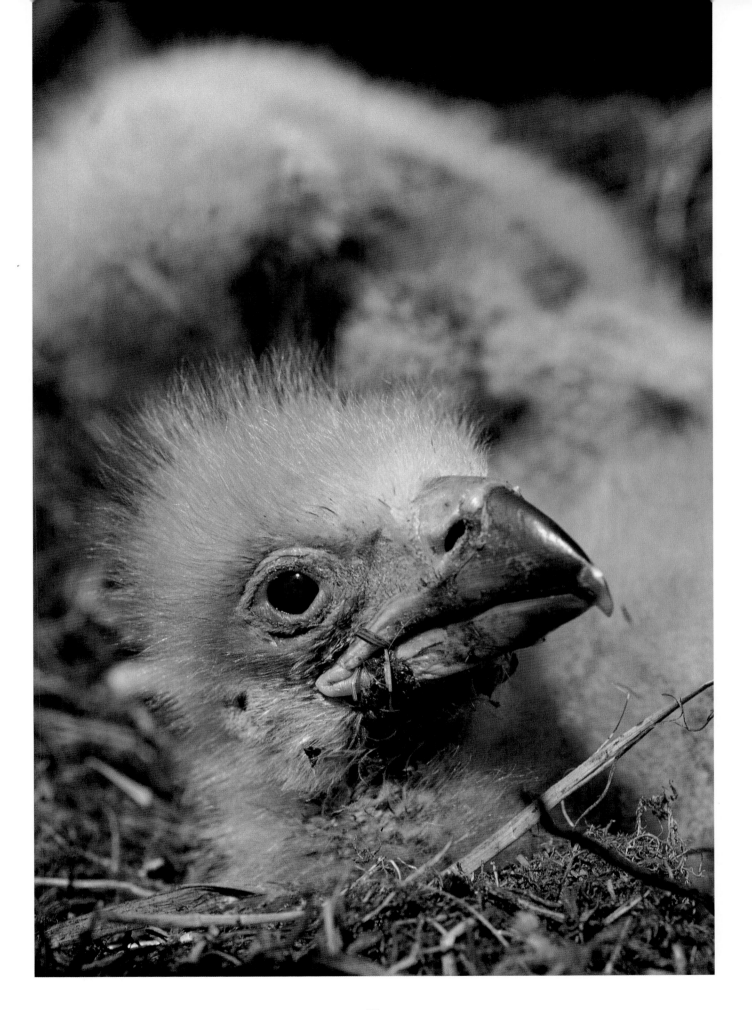

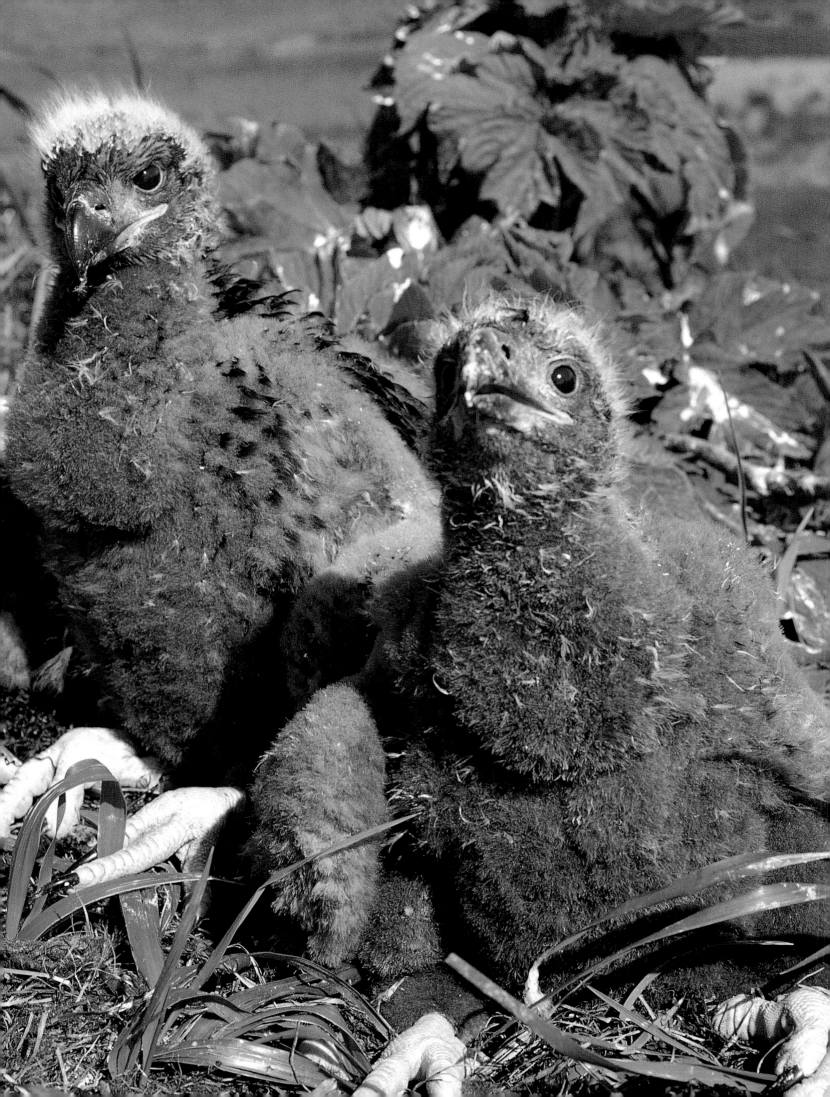

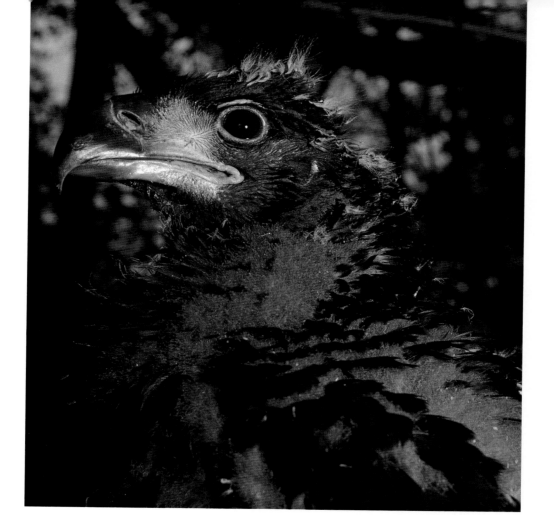

OPPOSITE: Two four-week-old eaglets now have their secondary down plumage, which has replaced the lighter gray natal down. In comparison to the natal plumage, this down is a thicker, darker charcoal gray, often making the eaglets resemble a pincushion at this stage. The secondary down is also denser and keeps the young eaglets warmer. This frees up both parents for fishing duties, although the mother will not leave the nest for more than fifteen or twenty minutes at a time.

ABOVE: At five to six weeks, brown and black feathers start to replace the secondary down. Although still awkward, the young are actually able to move around the nest. Many young birds fall from tree nests at this age because of their clumsy maneuverings. It will be another six weeks before this eagle has the muscle development needed to fly, even for short flights at first.

RIGHT: Tree nests come in all shapes and sizes and are often stolen from another species of bird. The nest pictured here has two eggs in it and was newly remodeled with an extra layer of strong branches on the outside and soft grasses on the inside after a great white heron abandoned it deep in the Florida Everglades. Eagles will return to their nests year after year and each time add a new layer to the old site.

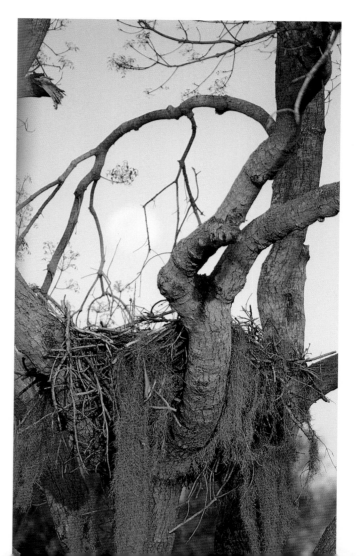

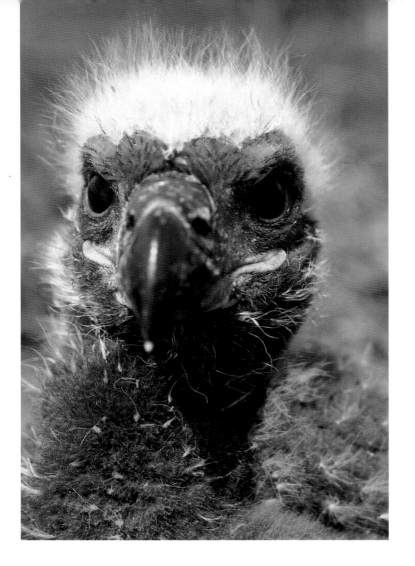

LEFT: This thirty-day-old eaglet on the Trinity Islands in the Gulf of Alaska already displays the attitude of a full-grown male.

OPPOSITE: This young eagle, about thirty-two days old, will soon share its nest with one of Tom Ricardi's captive-born eaglets. The nest is high above Bartlett Cove on the Connecticut River in Massachusetts.

RIGHT: Nestlings keep from overheating in hot nests by panting to expel water from their bodies.

FOLLOWING PAGES: An eagle dries his feathers in the sun. Bald eagles have approximately eight thousand feathers.

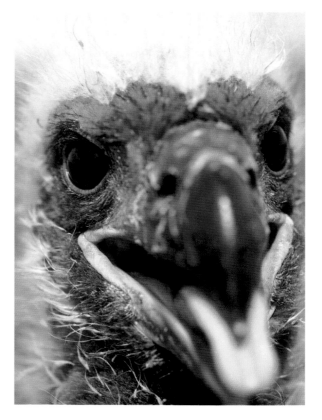

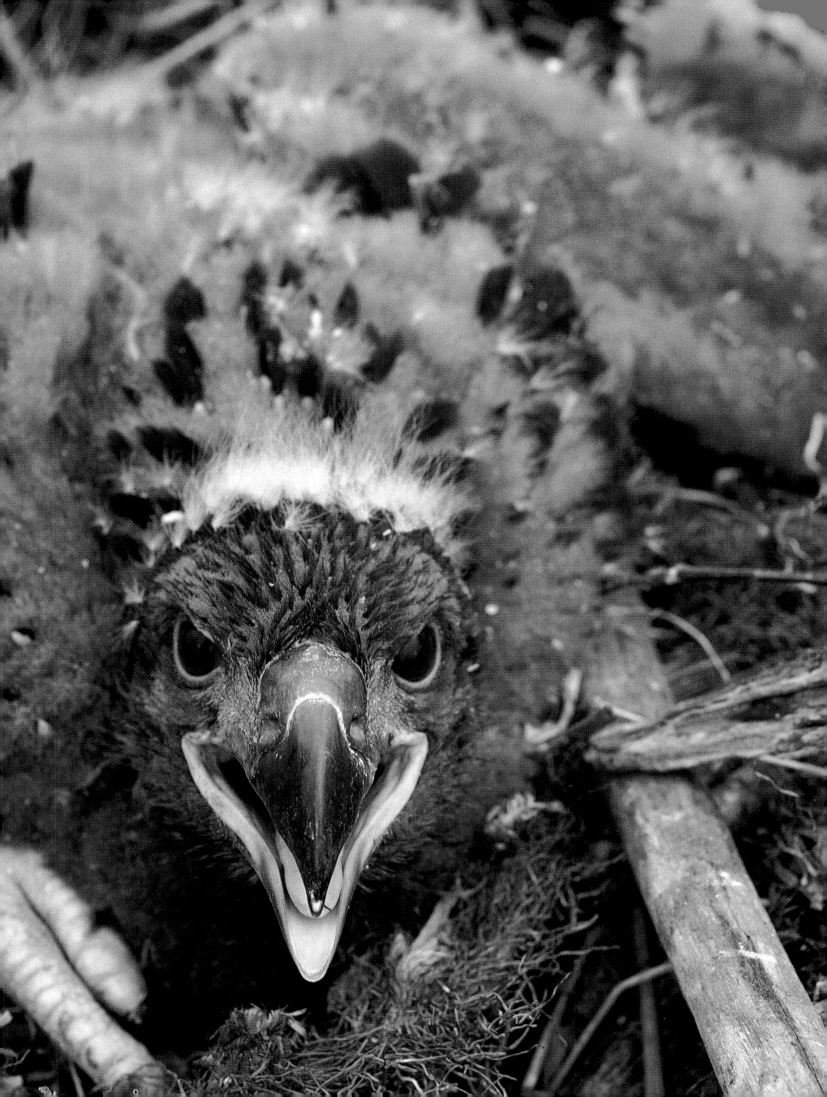

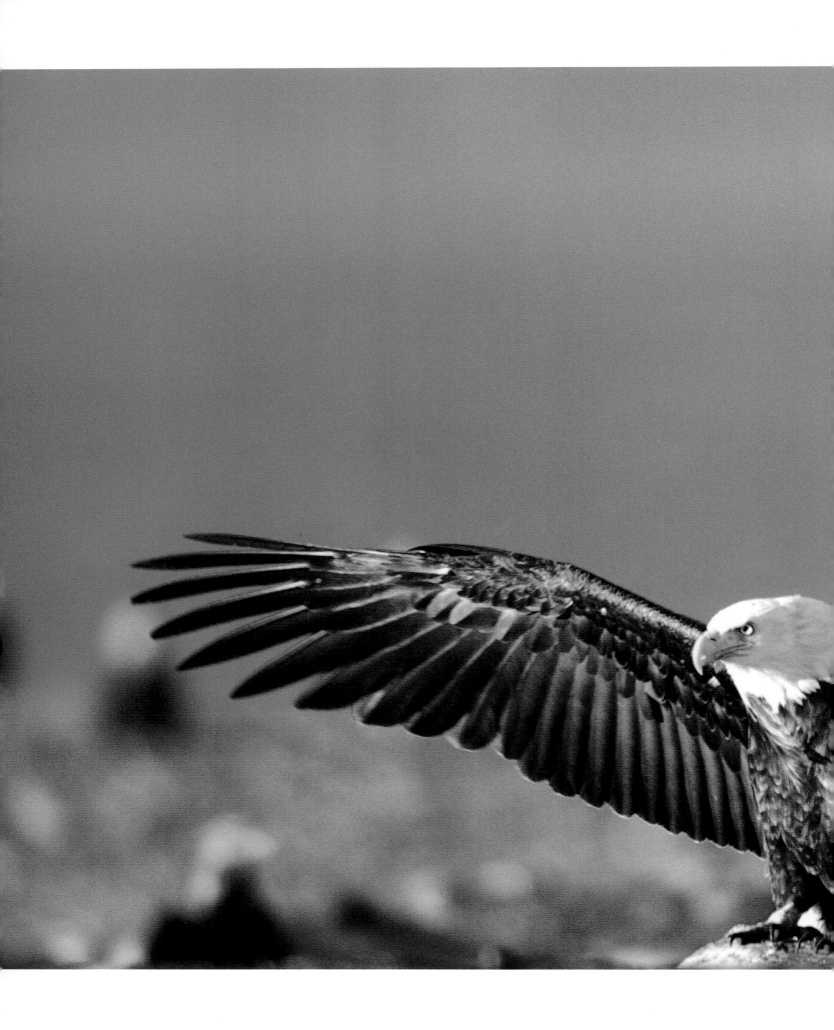

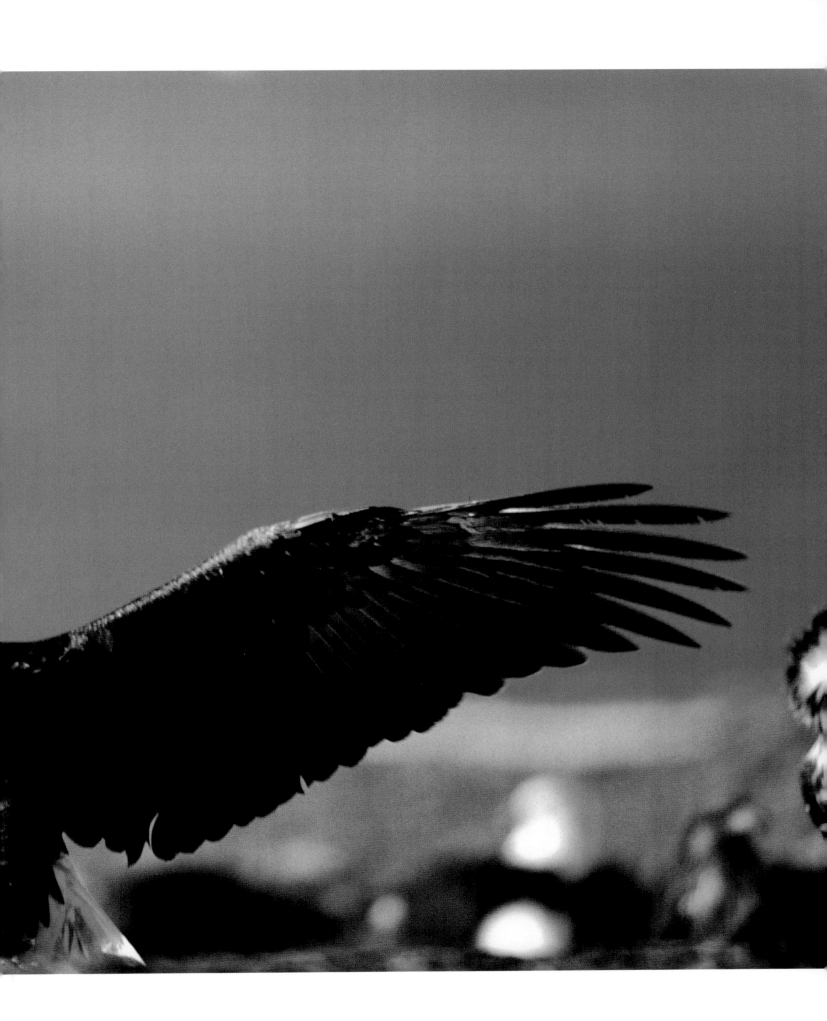

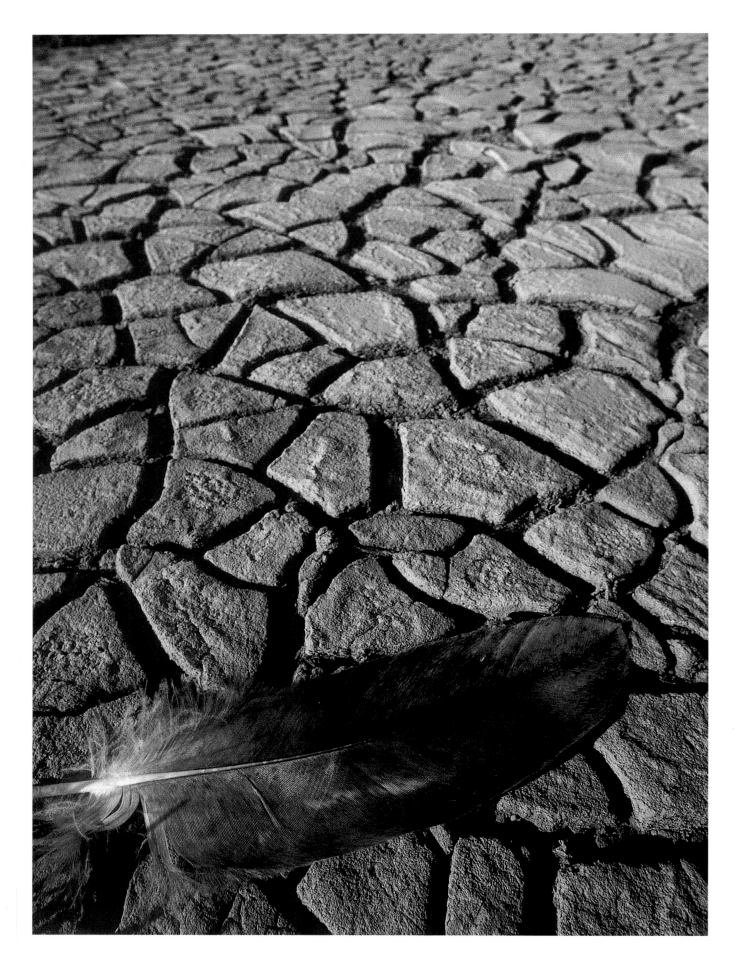

74

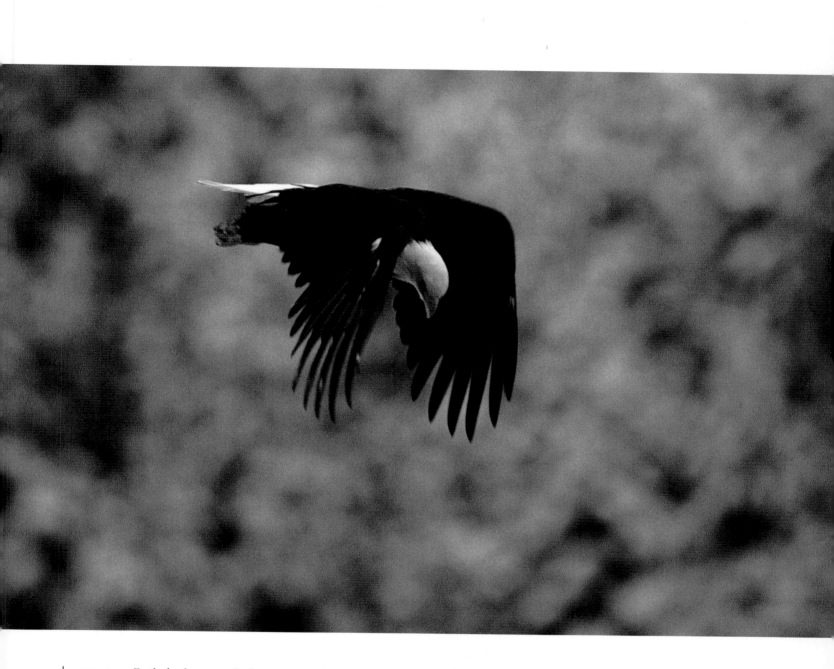

OPPOSITE: *Eagle feathers are shed in stages each year to make room for new ones. Molting is a gradual process that occurs from spring until fall, with the most feathers shed in the summer months. The feathers are highly prized by Native Americans, who use them for clothing, ornaments, and spiritual purposes that vary from tribe to tribe.*

ABOVE: *In perfect formation, this eagle dives from a tree in an attempt to catch a meal. In other countries bald eagles are called white-headed fish hawks.*

FOLLOWING PAGES: *The strength of an eagle's talons and feet is amazing. The eagle on pages 76–77 hopped nearly twenty feet into a tree from the ground without a wingbeat. The force with which an eagle leaves the ground is evident in the photograph on page 78.*

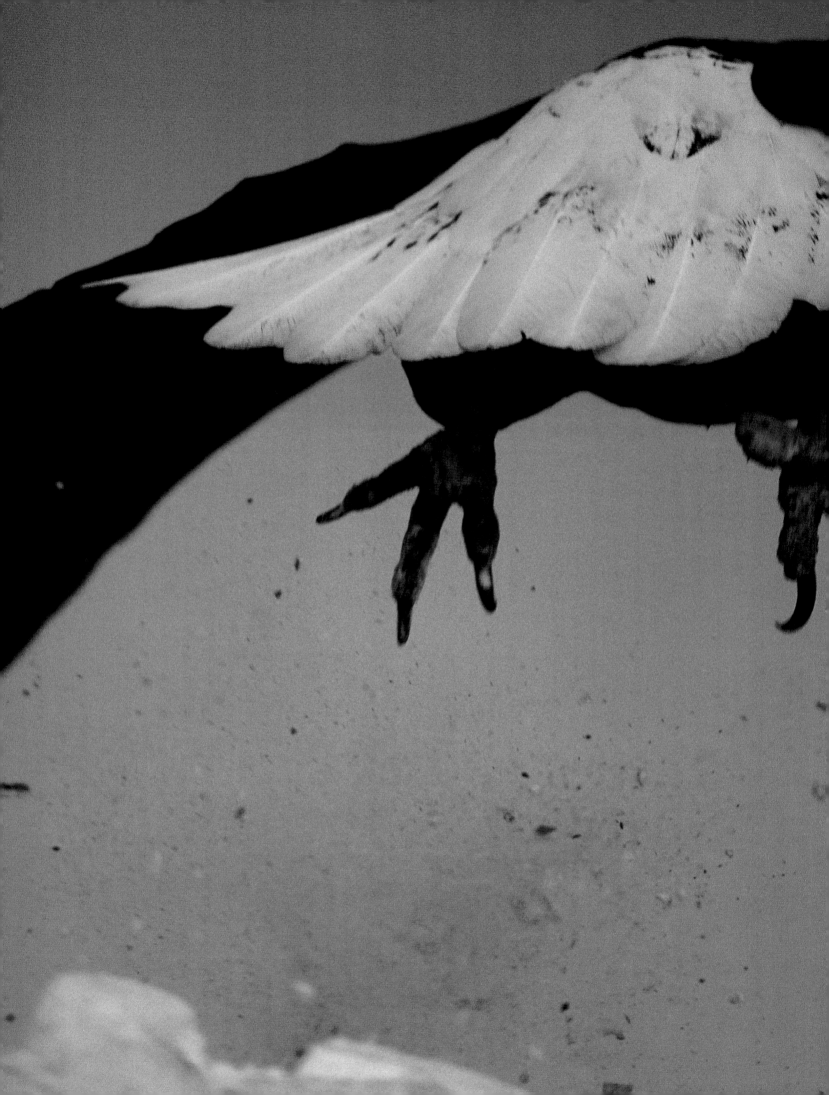

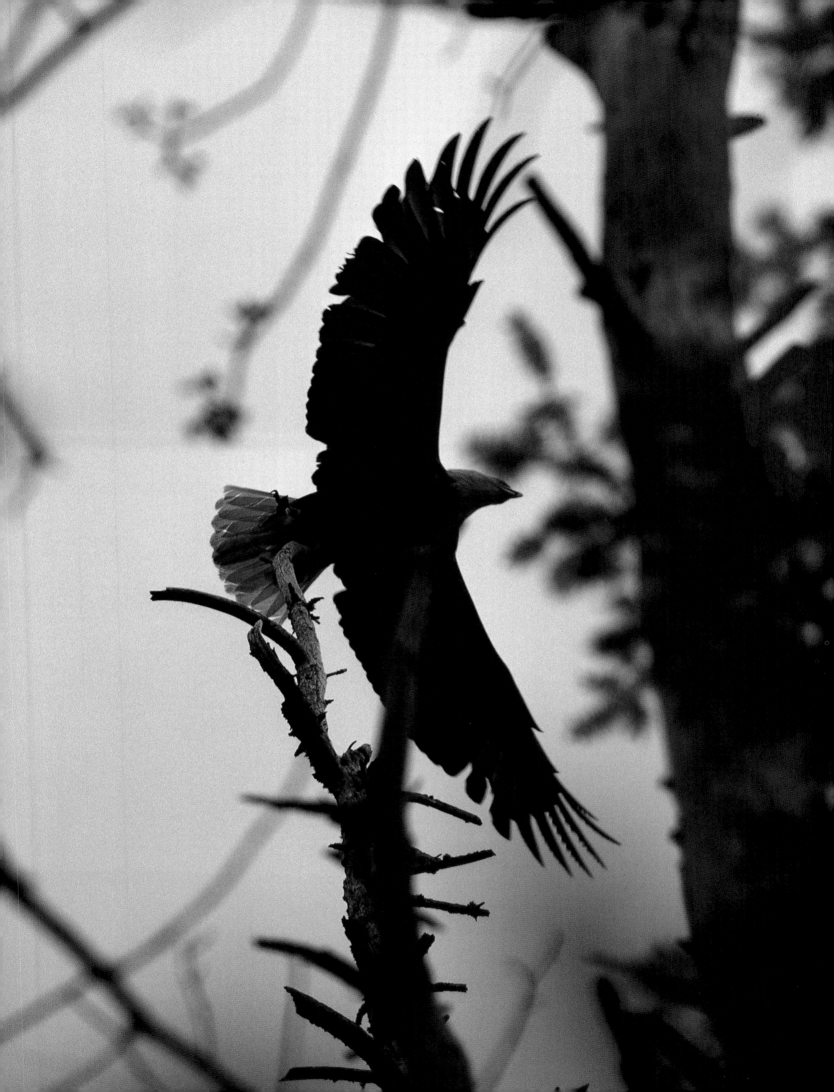

PRECEDING PAGE: On Bar Island in Acadia National Park in Maine, this male eagle has built his nest lower than usual to avoid detection in such a populated area. Normally an eagle nest is situated at the top of a tree, providing easy takeoffs and landings. Watching these eagles maneuver with an eight-foot wingspan through the dense Maine forests is awe inspiring.

BELOW: An eagle's wings go from full flap to slow to stop, just like an airplane. Their shoulder and wing muscles are incredibly strong, enabling them to hold such large wings full into the wind.

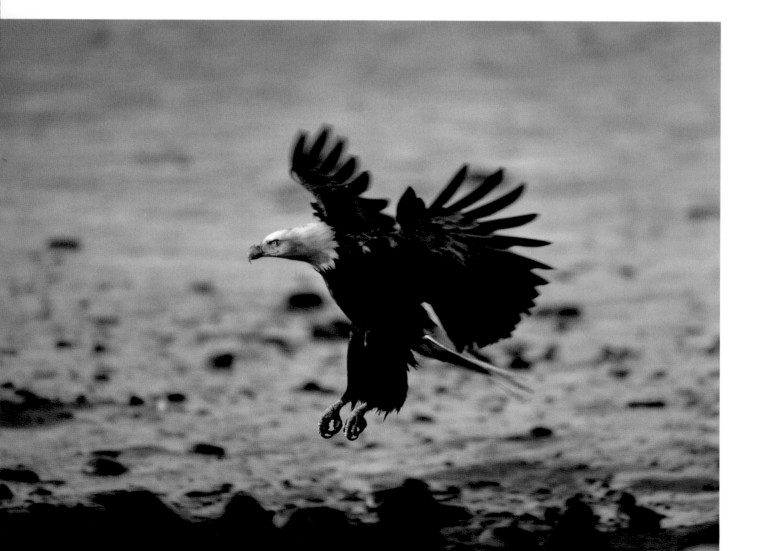

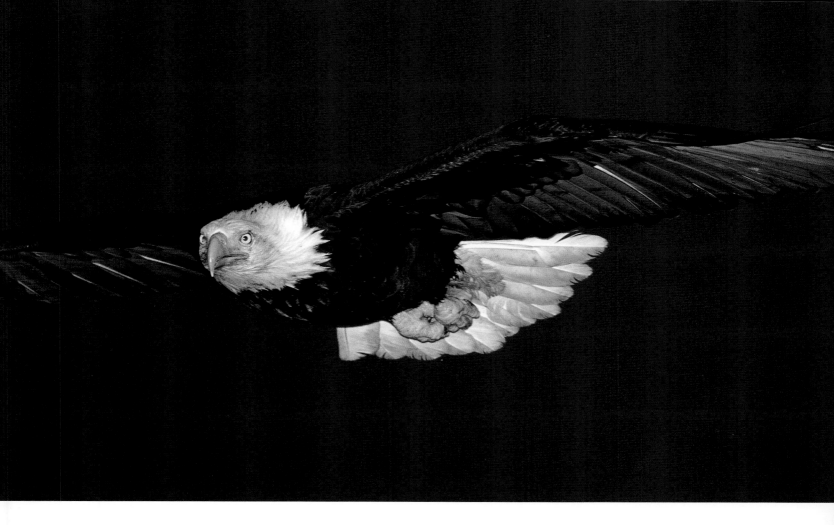

ABOVE: Although eagles have vision far superior to ours, their eyes do not adapt well to the dark, so they very rarely fly at night. This eagle takes one last pass along a creek at the Chilkat Bald Eagle Preserve in Haines, Alaska, in search of fish before roosting for the night.

RIGHT: In my life spent among birds great and small I have witnessed only two birds able to hover in midair: hummingbirds and arctic terns. However, this eagle in Homer, Alaska, is actually hovering aloft while lowering himself much like a helicopter—visual testimony to the great strength of his wings. In the early days in North America, people held the ridiculous belief that eagles carried off children and cattle, and many eagles were killed because of this. The truth is that it is almost impossible for a large bald eagle of ten to twelve pounds to lift off with something weighing more than four pounds.

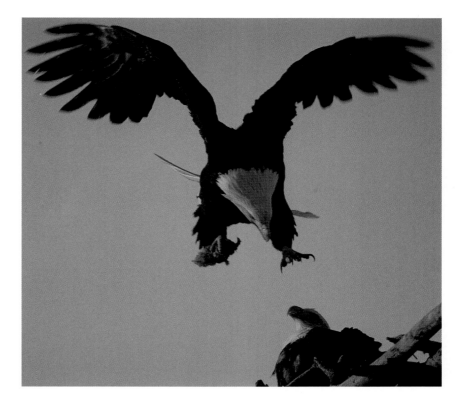

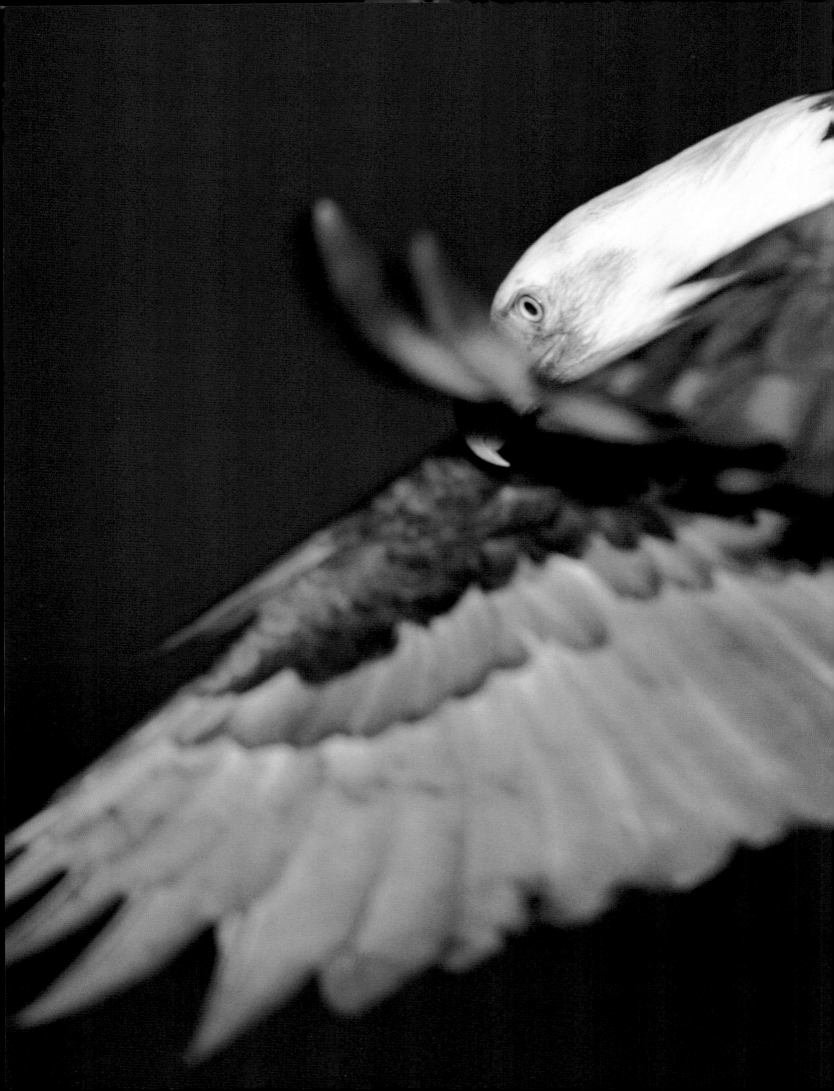

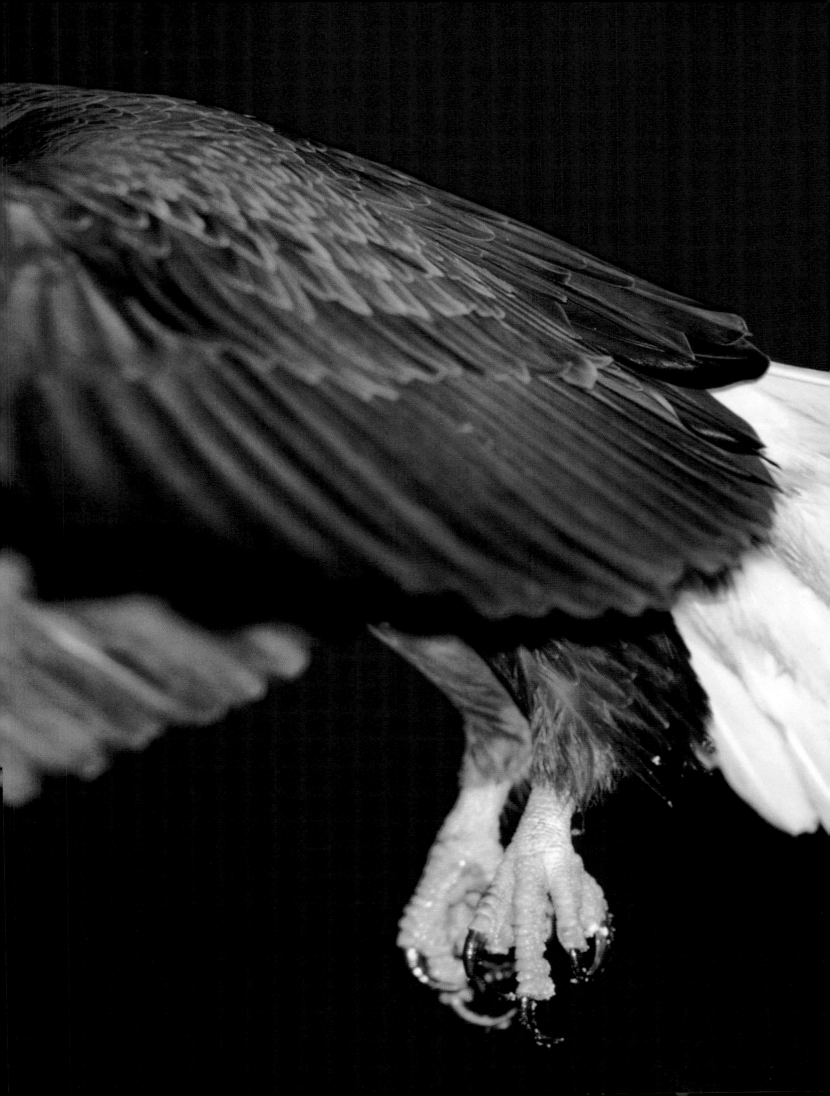

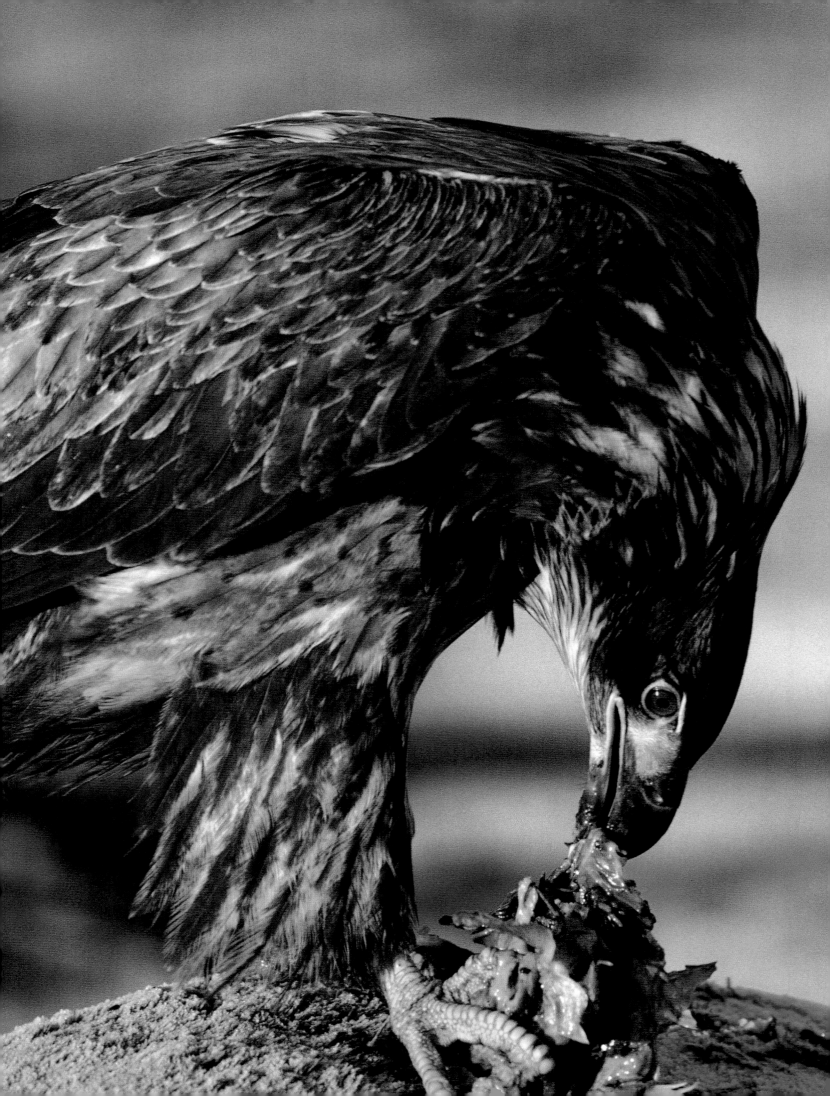

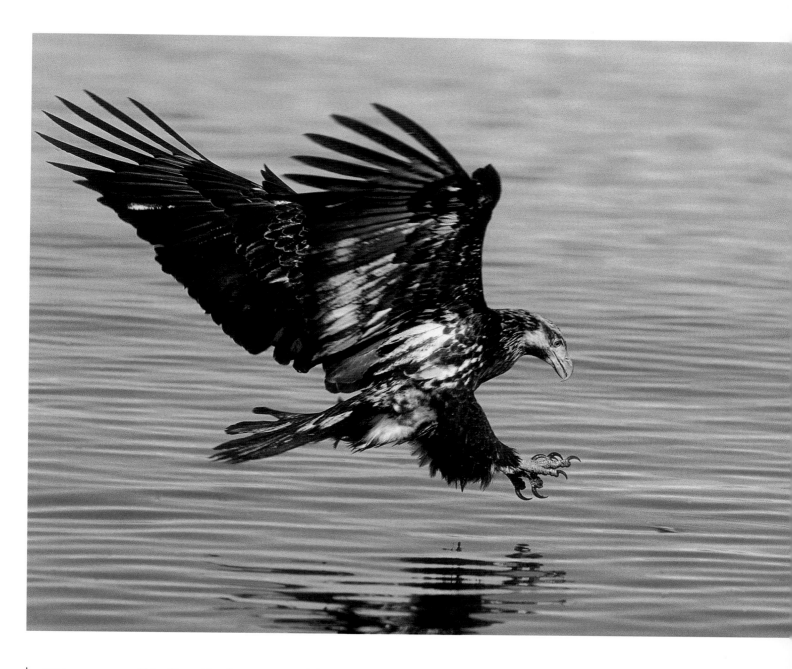

PRECEDING PAGES: *Takeoffs and landings are two of the most laborious maneuvers for these large birds and require enormous amounts of energy.*

OPPOSITE: *Immature bald eagles are frequently mistaken for golden eagles because they have not yet developed a white head and tail. They have this subadult plumage for the first four to five years of life and are extremely beautiful in this color phase.*

ABOVE: *Once leaving the nest, immatures are still in an extremely critical stage of life. Their fishing skills are very poor and many must scavenge for food. Studies show that it is possible to gauge an eagle population's health by the number of immatures that can be spotted in a certain area.*

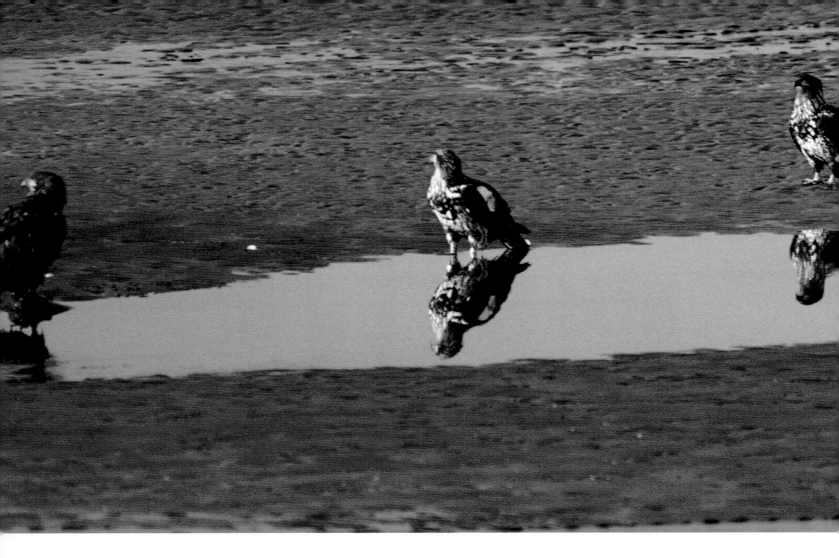

ABOVE: *All color phases of immatures are present here as the young birds gather together in Polycreek, Alaska, to scavenge for even a starfish to sustain themselves. Their main diet here is razor clams.*

OPPOSITE: *At about four months old, immatures are generally left by their parents to fend for themselves. Although the parents will leave the nest area to migrate north or south, depending on what part of the country they're in, their offspring will almost always remain at the nest. This is a hard time for them, as they must compete with mature eagles for food. Not surprisingly, the immatures are generally left with only the worst fishing or hunting sites.*

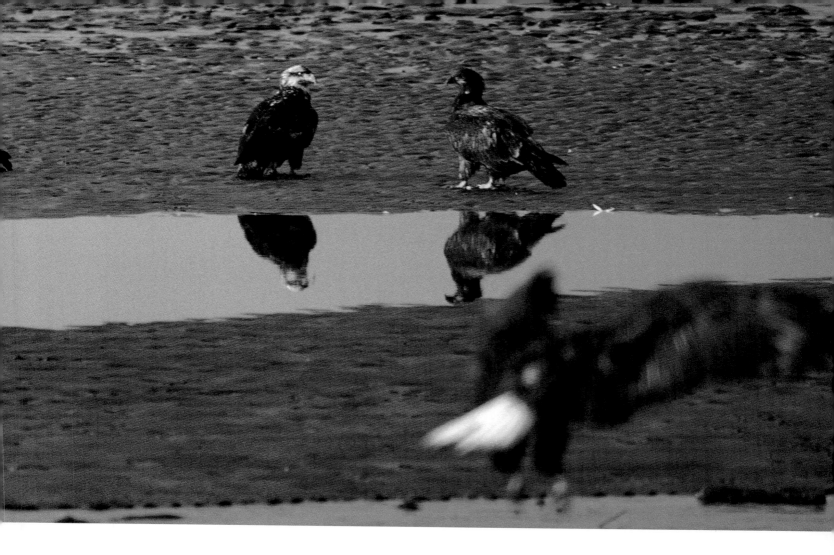

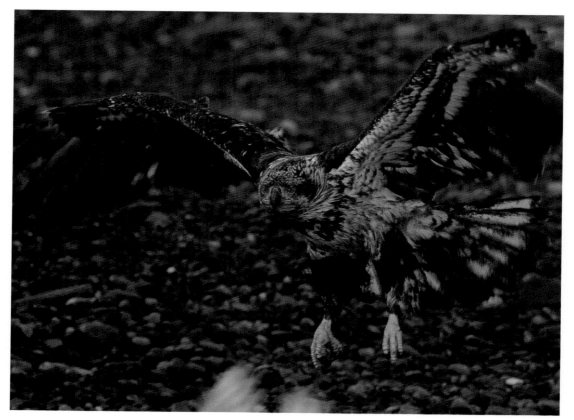

BELOW: *The white under an immature bald eagle's wings can sometimes fool even an expert into thinking the young bird is a golden eagle.*

OPPOSITE: *Immatures have three to four color phases to go through before they reach maturity. Pictured here is the last phase. The beak has turned from black to yellow and a great deal of white is starting to show through on the head feathers.*

FOLLOWING PAGES: *Although not fully grown, immatures appear bigger than mature bald eagles. Mother Nature has provided them with an advantage: They appear bigger because during certain phases of growth they actually are bigger. The added size of their wings allows them to stay aloft with less effort and also helps them to intimidate mature bald eagles in hopes of stealing a meal. As the young eagles develop, their muscle mass becomes more defined and their size reduces as they become heavier and denser.*

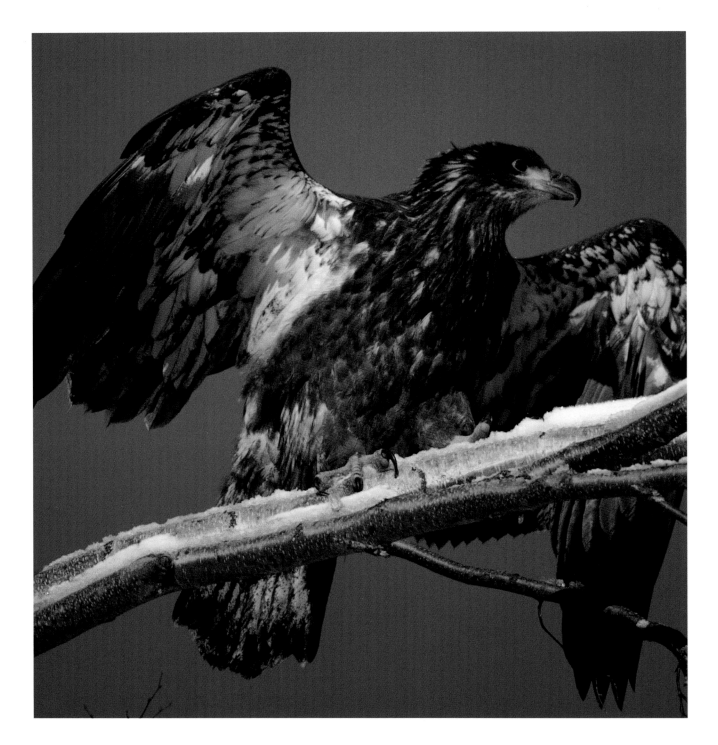

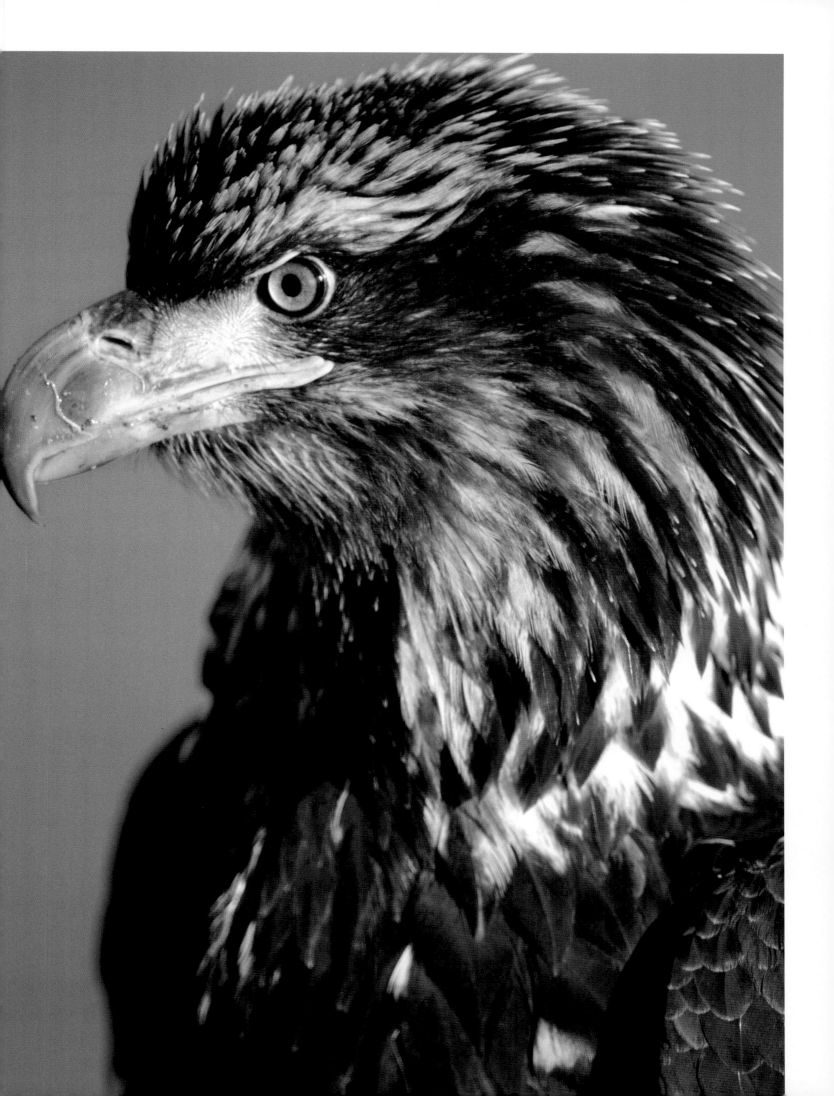

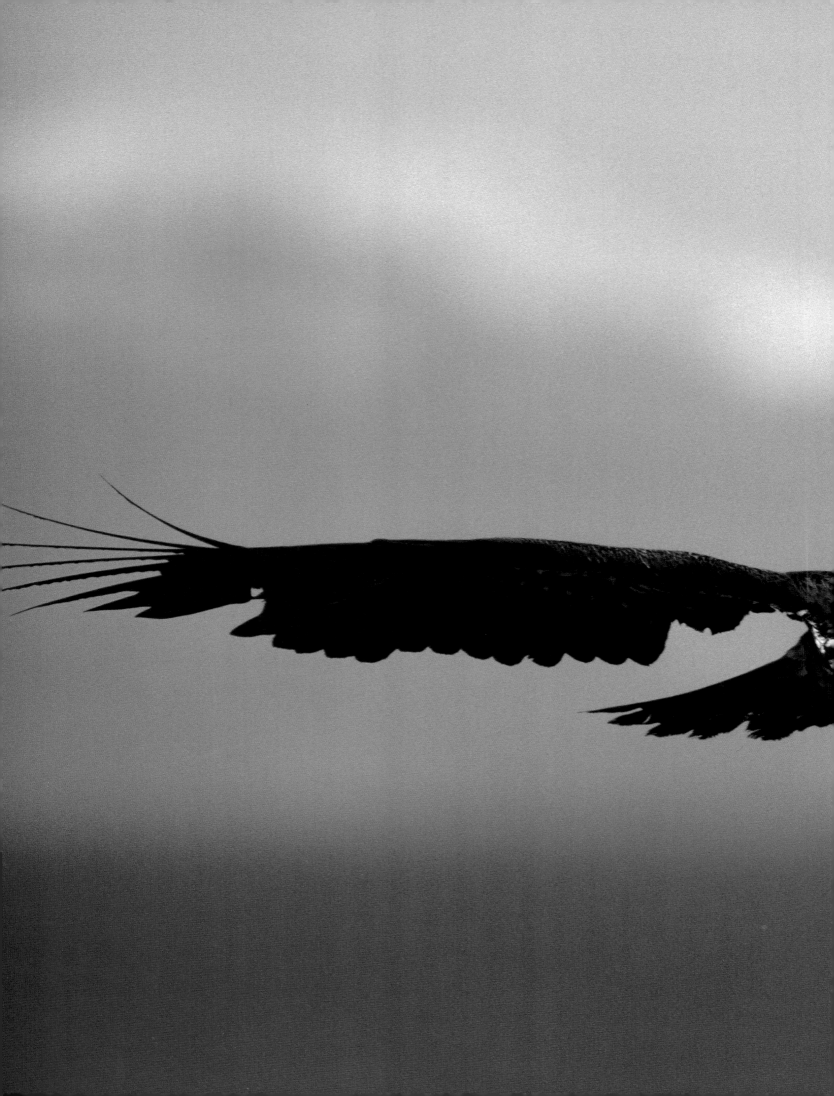

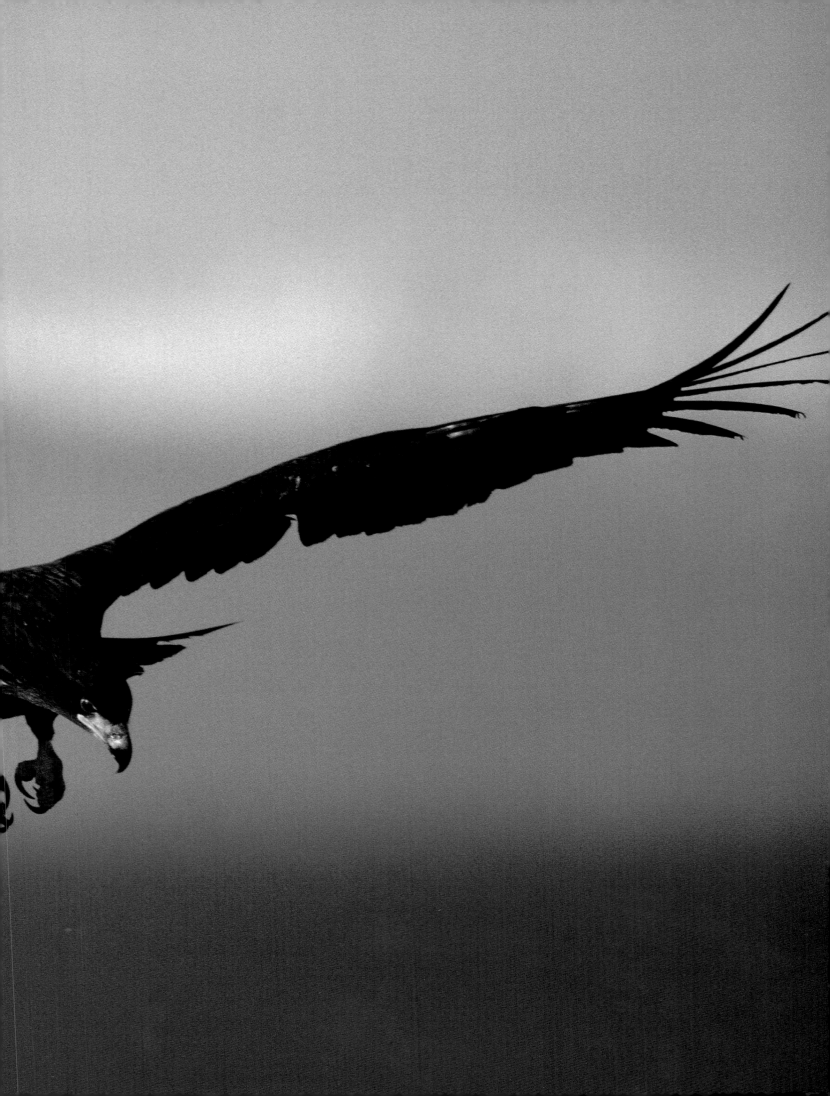

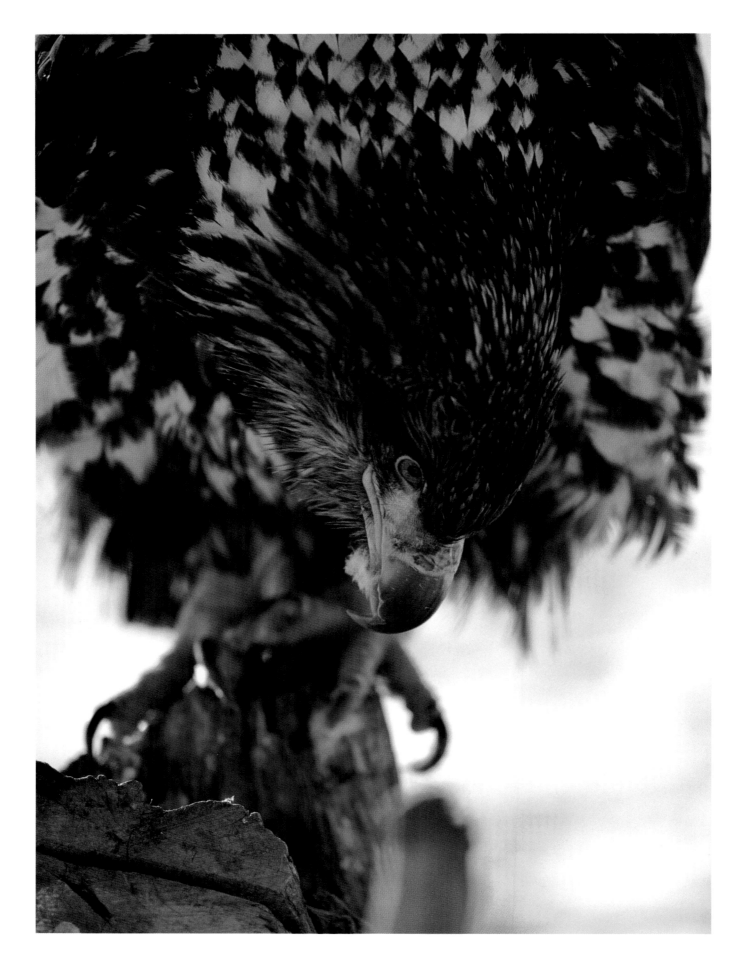

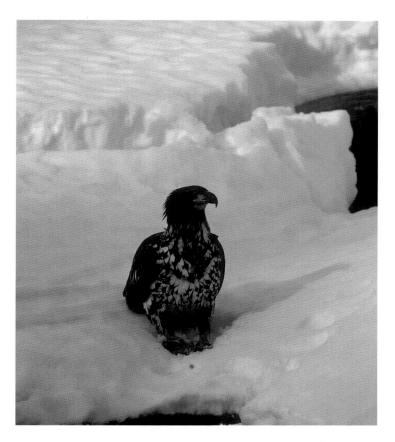

OPPOSITE: *A starving immature searches among the piers and rocks in Niantic, Connecticut, for anything nutritious, even wharf rats and snakes.*

ABOVE: *This young eagle attempted to fish at this hole in the Gulkana River in interior Alaska until eventually he starved to death. There were no fish in the river at that time of year.*

RIGHT: *A northern subadult looks as though he won't make it through the winter. He nervously feeds on a spawned-out salmon near the Columbia River in Washington State.*

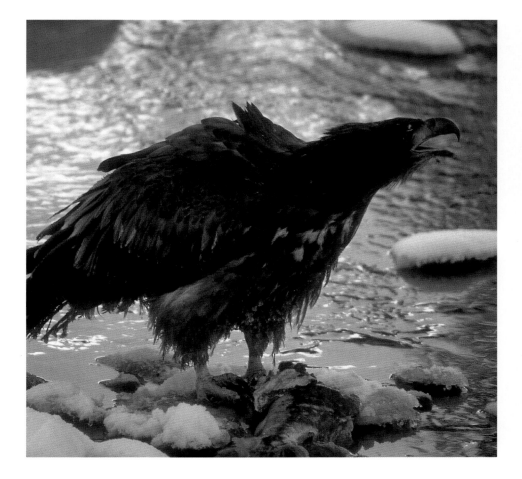

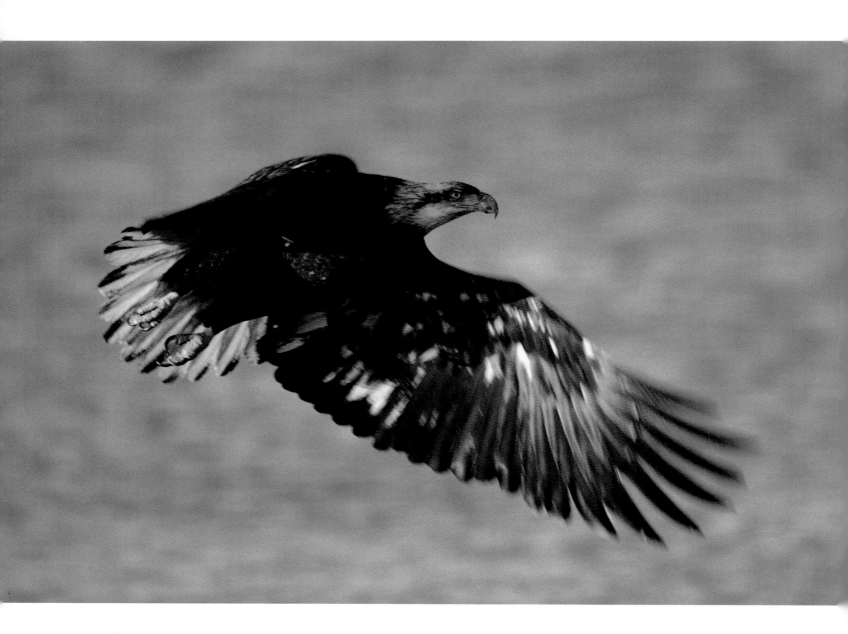

ABOVE: *A nearly mature bald eagle searches the beaches of Fisher's Island, New York.*

OPPOSITE: *Even in an environment rich with fish such as Kodiak, Alaska, death still takes its toll on young eagles.*

94

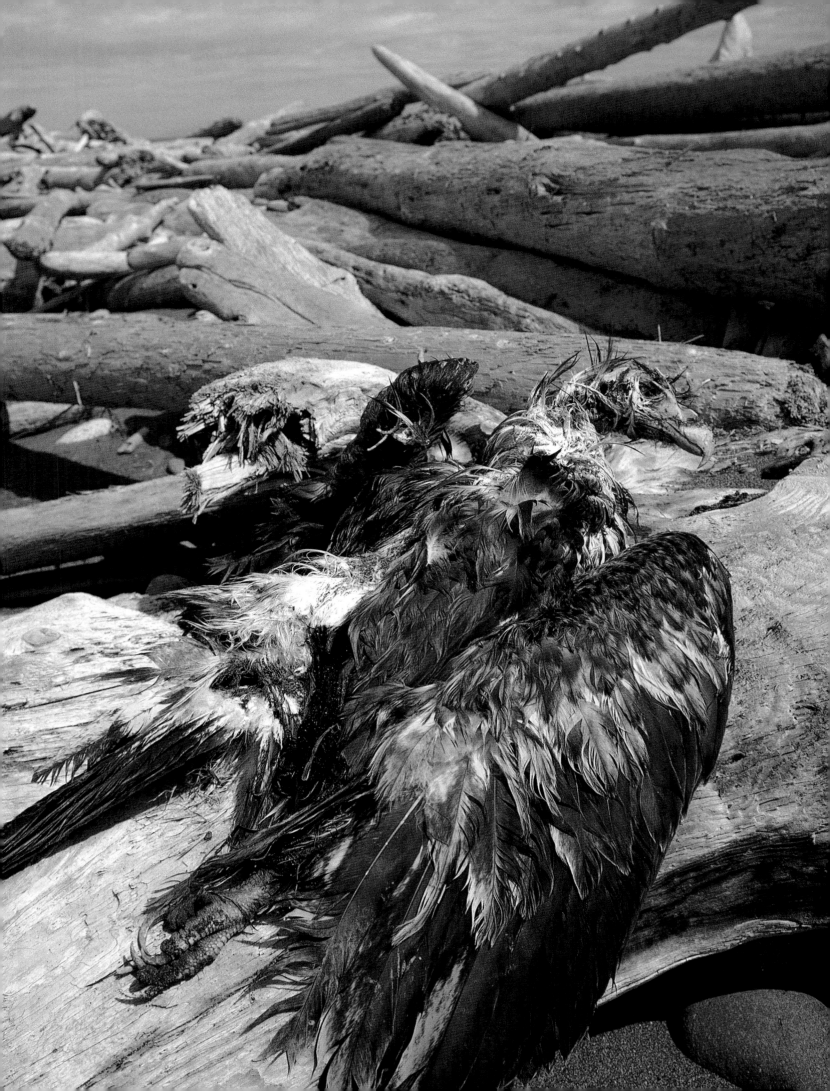

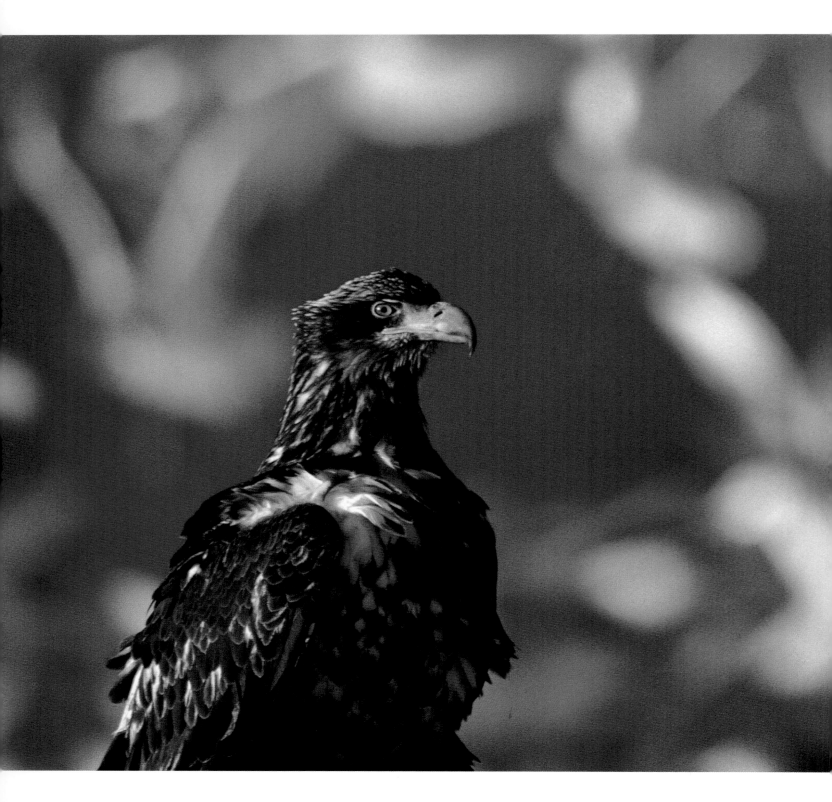

ABOVE: *Two immatures sit in a confused state as they are engulfed by seagulls in Old Saybrook, Connecticut.*

FOLLOWING PAGES: (Left) This magnificently colored subadult living in the southern states has faired well during his first year of life. Little is known or documented about the overall survival rates of immatures, and existing studies vary greatly. It is believed that only 10 percent of young birds survive to become mature eagles. (Right) Although this nestling hasn't finished forming his wings, he's taken on the appearance of a rather large subadult.

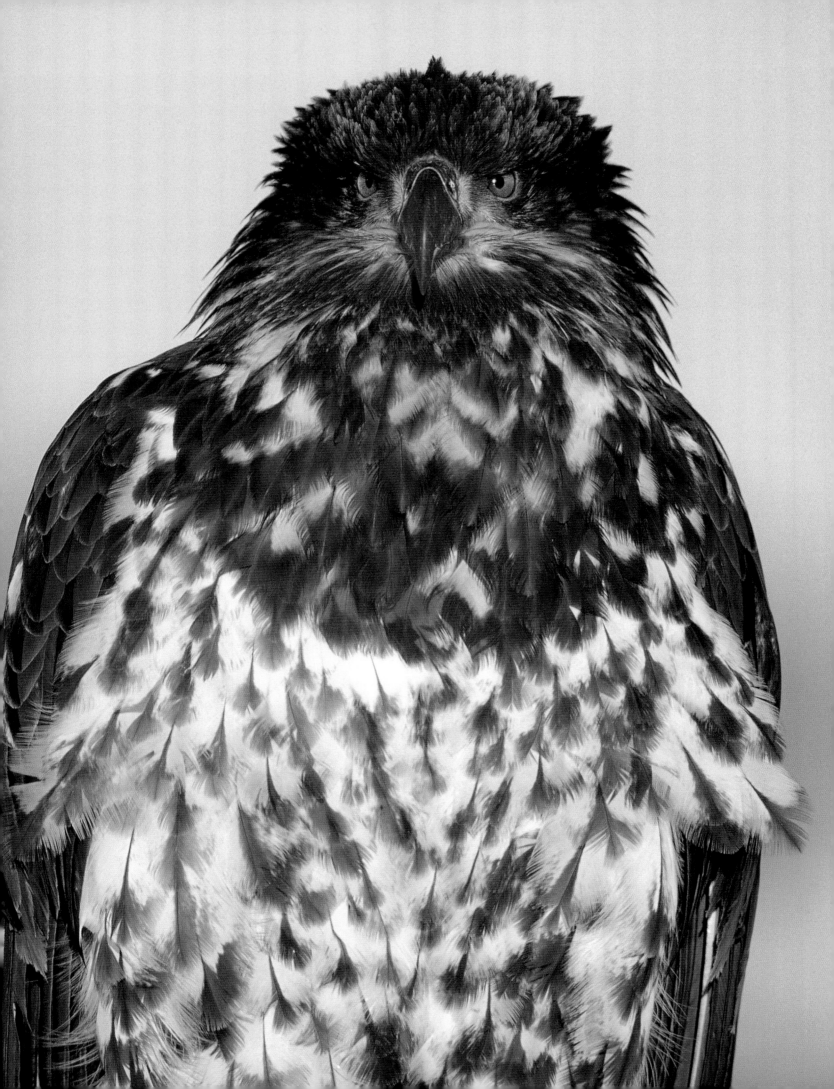

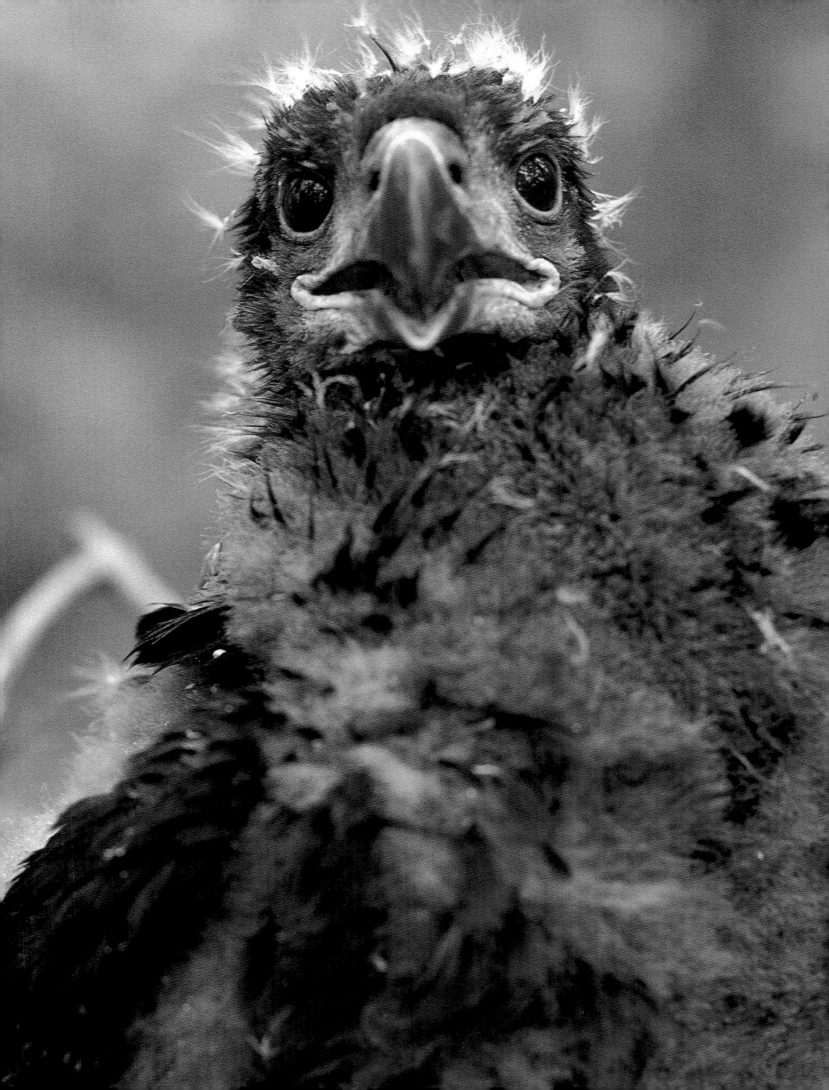

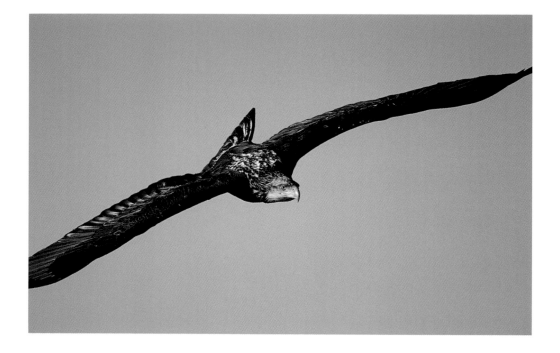

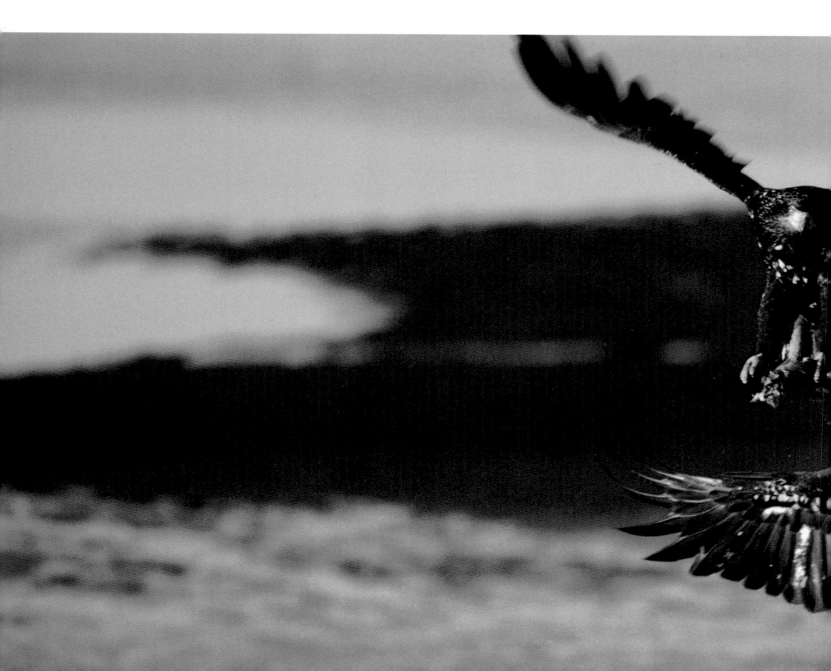

OPPOSITE: *Nearly two and a half years old, this immature has learned to master the wind currents and thermals along the Skagit River, in northwest Washington State.*

BELOW: *Rarely have I seen two subadults fighting in midair. Usually two matures or an immature and an adult engage in aerial combat. The eagle on the bottom with outstretched talons must be starving if it is willing to fight for such a meager scrap of food.*

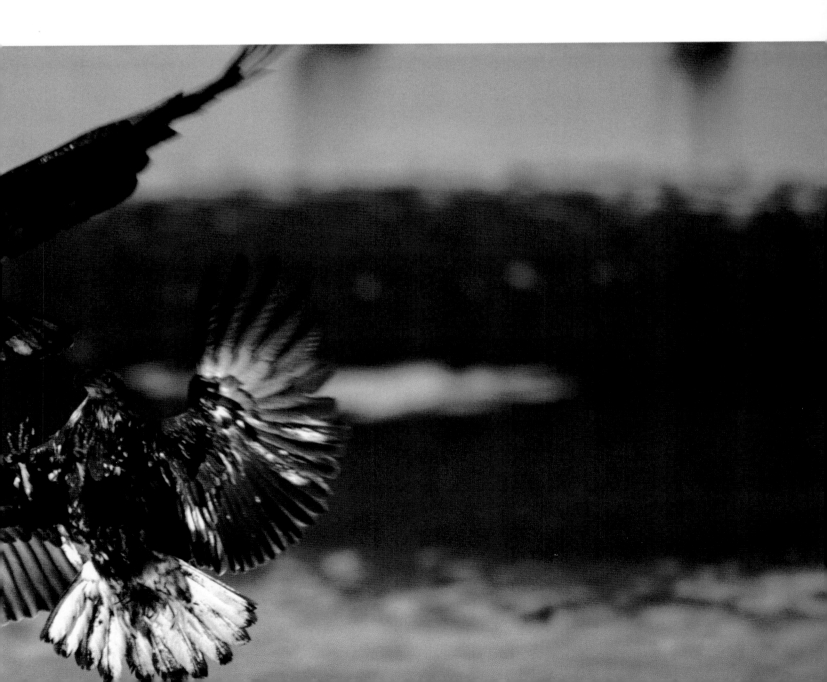

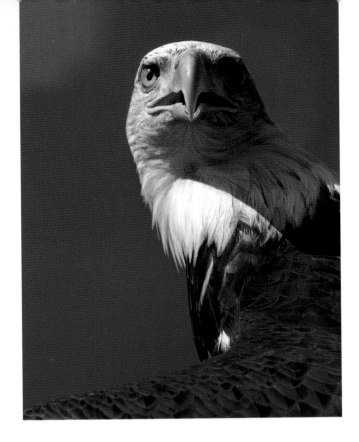

LEFT: *A nearly mature bald eagle has the appearance of dirty head feathers, although it is actually the final stage of its brown subadult plumage growing out.*

BELOW: *This eagle with a malformed beak will have a completely white head within a few months. The beak of the bald eagle is designed for ripping and tearing, and although quite forbidding looking, it has no function in the killing of prey. An eagle's mouth opens to a surprising width. It can swallow hunks of fish the size of tennis balls, as well as ten-inch herring. The malformation in this eagle's beak is rare but doesn't severely hamper the bird's ability to feed. It does, however, make it more difficult for the eagle to rip open prey without having the larger hook that is present on normal beaks.*

OPPOSITE: *This beautiful, pristine bald eagle about five and a half years old has finally lost all of his subadult plumage. Life spans of the American eagle vary greatly depending on climate and abundance of food. It is believed that a healthy eagle can live twenty to thirty years in the wild and is able to reproduce for its entire life. Captive bald eagles that are pampered and fed have been known to live more than forty years.*

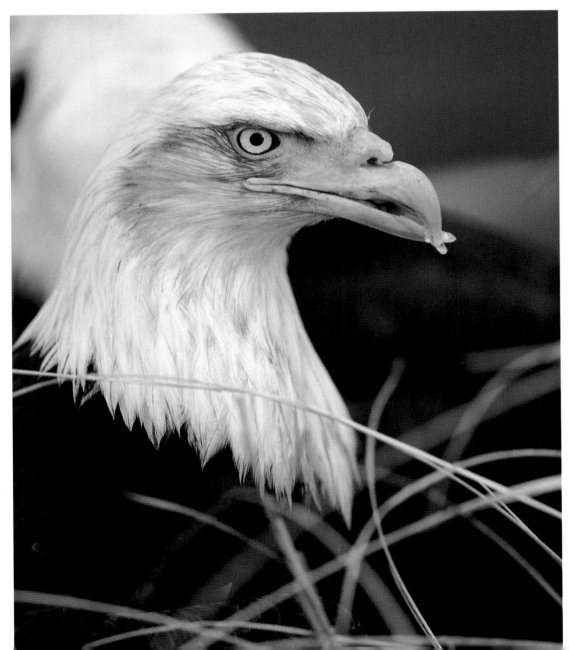

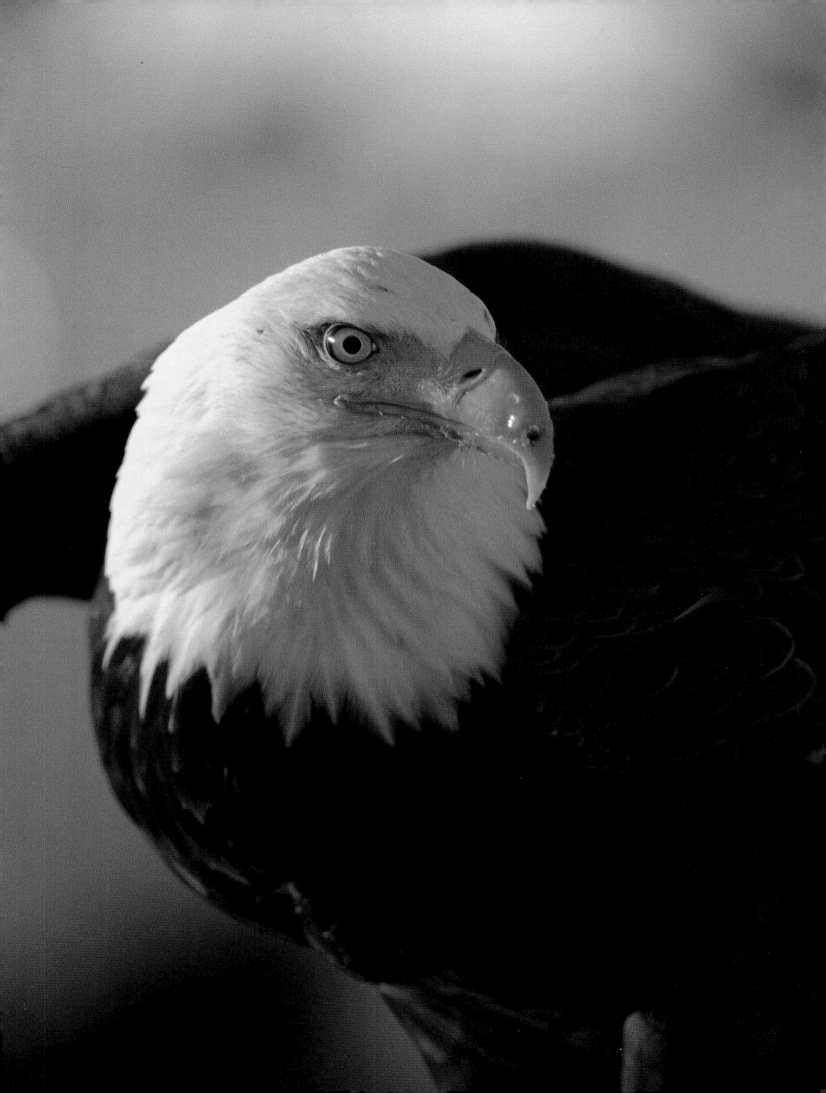

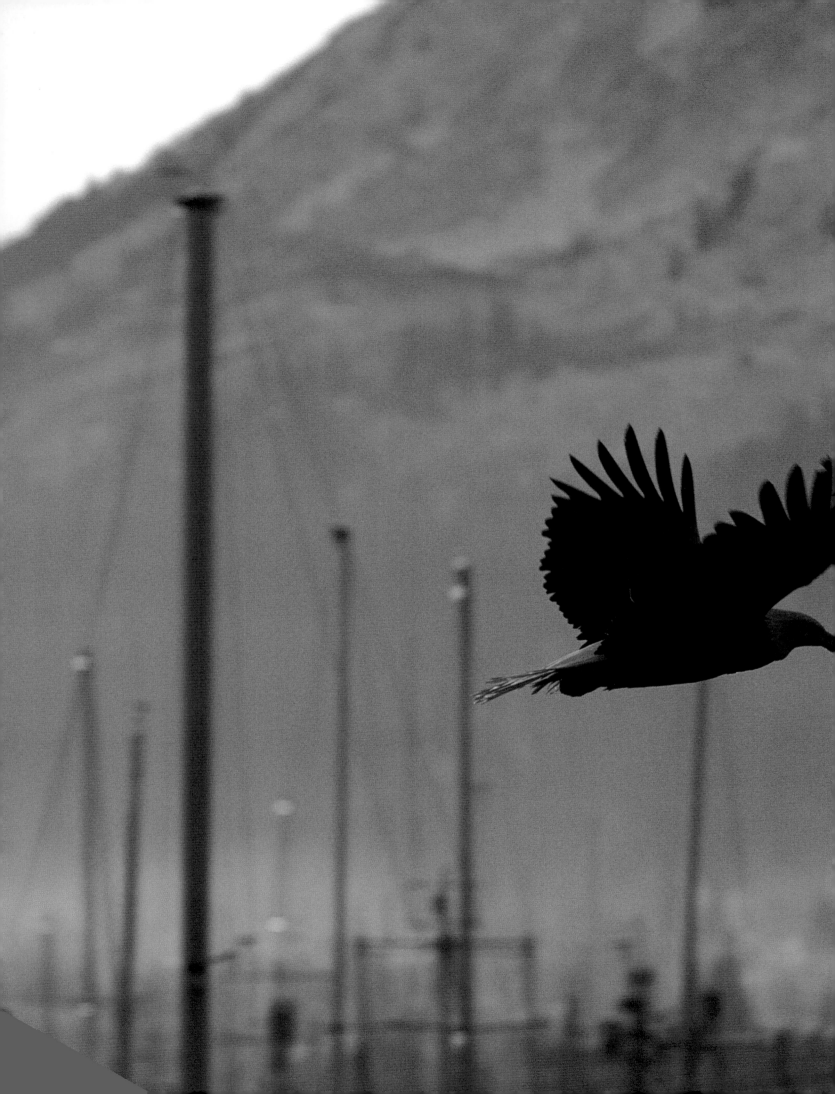

PRECEDING PAGES: From San Luis Obispo to Virginia Beach to San Diego and up to this port of Seward, Alaska, eagles can be found more frequently in and around our seaport cities.

BELOW: In the winter months, eagles need to spend 98 percent of their time roosting, or perched motionless, to conserve energy. People fortunate enough to be able to see an eagle up close must remember that each time we approach an eagle close enough to make it fly and expend energy, we lessen the great bird's chance for survival. And although you may only bother it once, fifty people might do the same thing in a day.

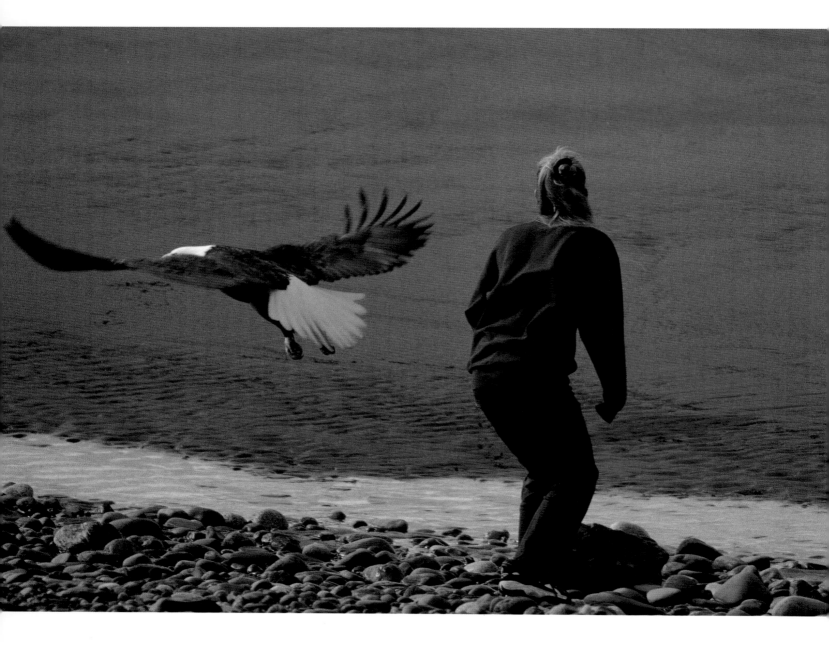

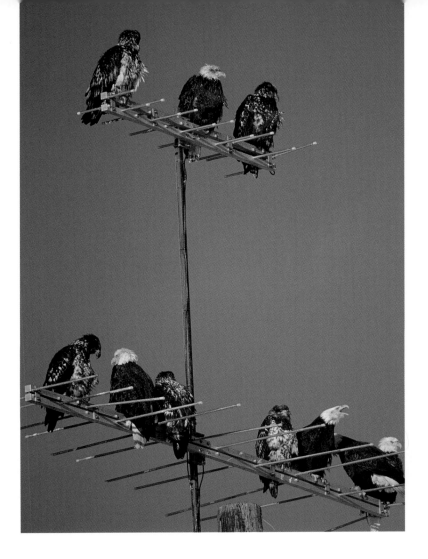

LEFT: *Ten eagles grace this antenna in the city campground near Homer, Alaska.*

BELOW: *A bald eagle nest tree is observed by two people fishing in Cooper Landing, Alaska. The sign states that it is unlawful to approach within three hundred yards by order of the federal government.*

LEFT: *Longtime Alaskan resident and seasoned fisherman Ed McKoy rigs up to fish for silver salmon near Soldotna, Alaska. The eagle nest above him that had been occupied for thirty-five years was abandoned when developers began to build in the area. Further up the Kenai Peninsula, a large tour company's construction of a remote lodge destroyed critical habitat where eagles had roosted for thousands of years. Although Alaska has the largest concentration of bald eagles in the world, loss of eagle habitat due to rapid development in this frontier state is still very much a concern.*

BELOW: *For years Nikki Stewart ran a tackle shop on the Kenai River in Alaska, despite her many misgivings about the effects on the local eagle population. Fishing hooks lodged in dead salmon seriously injure the eagles that feed on them. A nest in her area, the famed Eagle Rock nest on the lower Kenai Peninsula, loses eaglets each year to these unavoidable and tragic mishaps.*

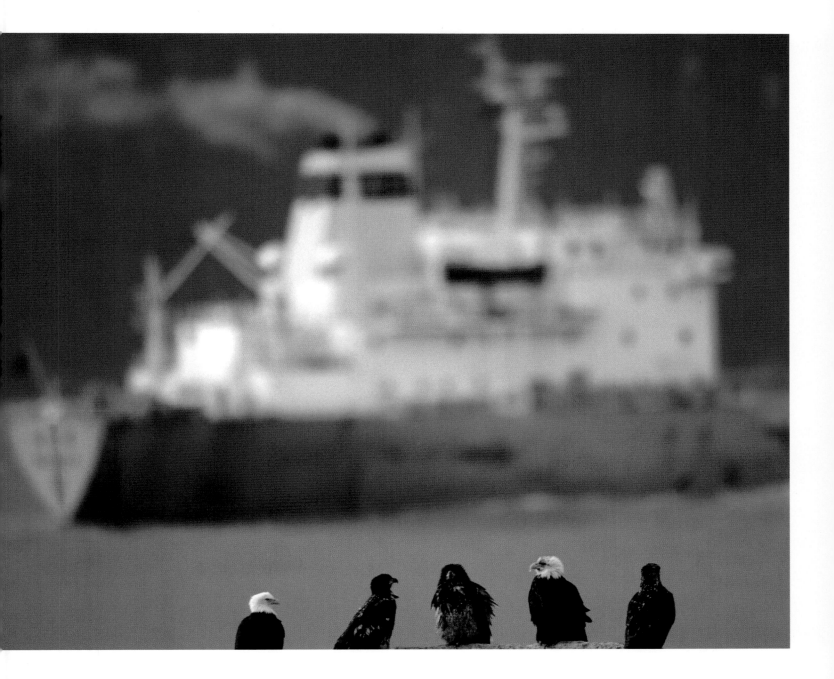

Pollutants in the waters from large ships still kill the American eagle as well as countless other animals and plant life. The Exxon Valdez oil spill in March 1989 left behind thousands of dead eagles on Prince William Sound, Alaska.

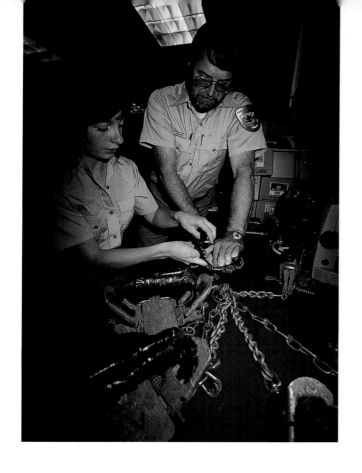

OPPOSITE: This bend in the Kenai River is one of the most famous fishing holes in the world. In one of the trees on the bend is the very large Eagle Rock nest. Some offspring are lost nearly every year to razor sharp hooks in the salmon they feed on.

LEFT: Dr. Theodore Bailey and biologist Mary Portner, both of the United States Fish and Wildlife Service, prepare a trap system that will catch the eagle's foot without harming it. Dr. Bailey's work on bald eagles in Alaska has been studied nationwide. He's one of my heroes, and also one of the reasons we have eagles in this country today.

BELOW: Bailey and Portner's padded traps are placed in this river with salmon lures. This is the most humane way to catch and band eagles.

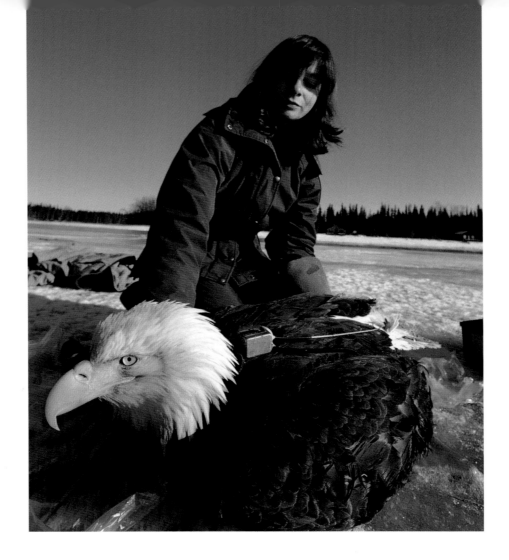

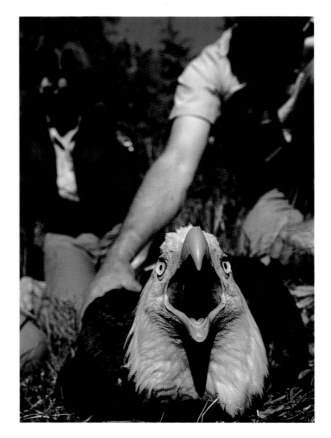

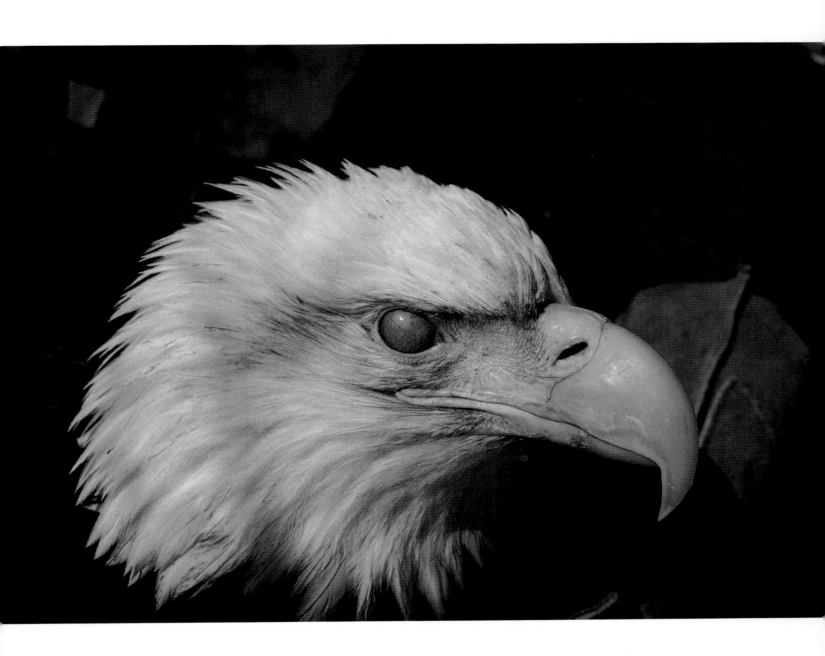

OPPOSITE ABOVE: *Biologist Mary Portner fits a radio control collar onto an eagle's back with twine that will eventually deteriorate. This particular eagle was released on Alaska's Kiley River and flew more than two hundred miles in about three days—the farthest documented flight by any radio-collared bird.*

OPPOSITE BELOW: *Sight is a bald eagle's most important sense. An eagle's vision is four times greater than a human's. It can see small fish in the water at great distances or detect another eagle in the sky more than five miles away. Although eagles cannot rotate their eyes much, their heads can rotate to nearly three-fourths of a full circle. It is thought that eagles have the same hearing capabilities as humans. Their ears are located just behind the eyes and are slightly covered with a layer of feathers.*

ABOVE: *An eagle's eyes are so large that they actually take up the major portion of the skull. Eagles have a second eyelid, called a nictitating membrane, shown here, which protects and cleans the eye. When feeding their young, diving on fish, or fighting, they close this second eyelid for protection.*

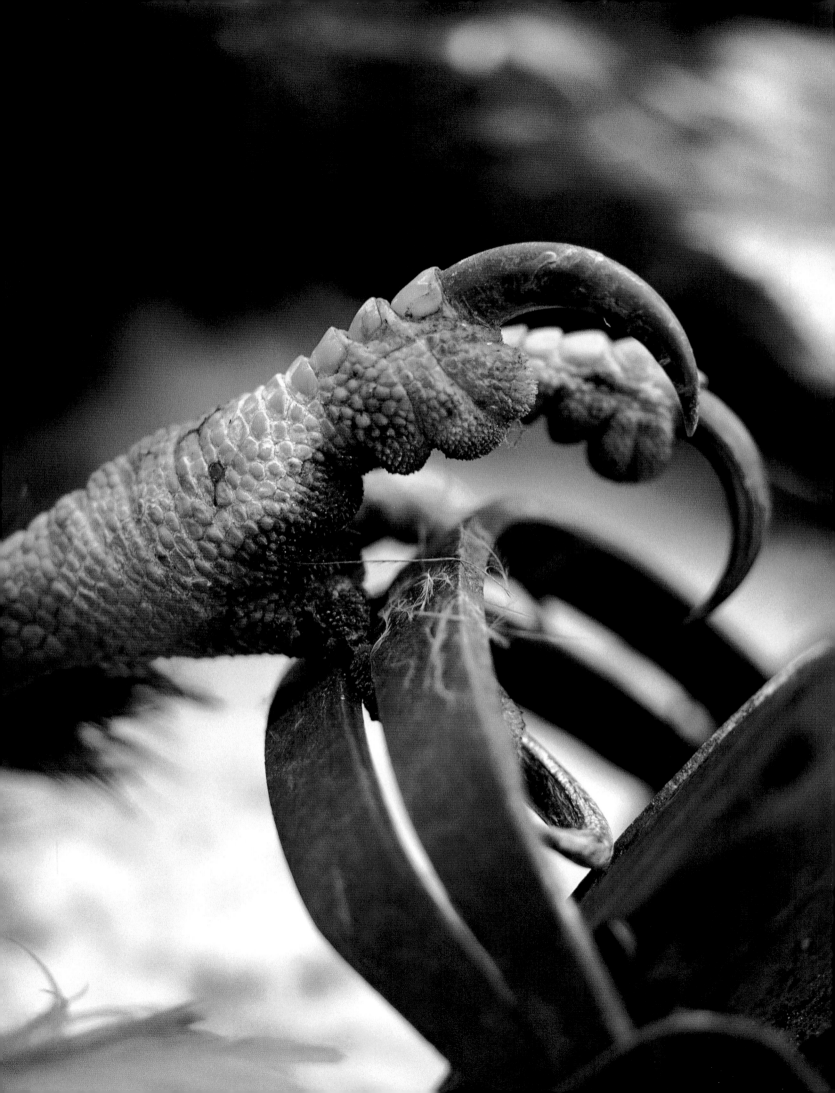

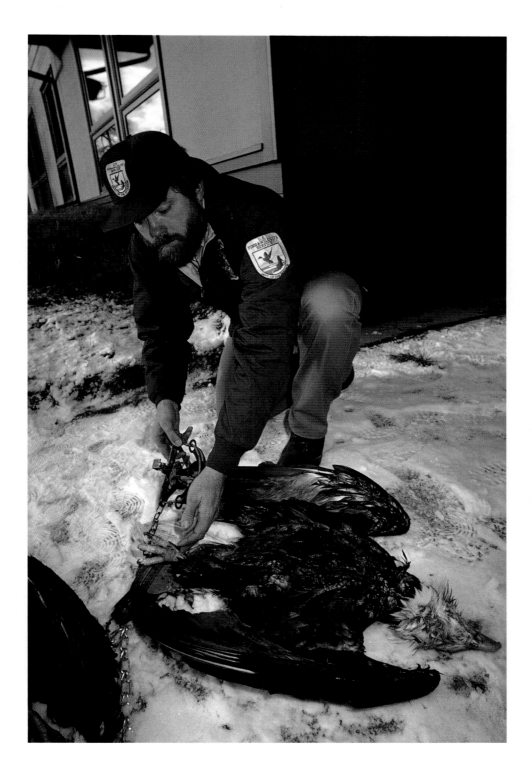

OPPOSITE AND ABOVE: *Officer Rick Johnston of the Kenai National Wildlife Refuge examines bald eagles killed in an amateur trapper's traps. If the traps had been checked in the time period of three to five days as required by law, these eagles would be alive. Sadly, the trapper did not check his for three weeks and the eagles starved to death. He was fined $100 and had to serve one hundred hours working for wildlife conservation.*

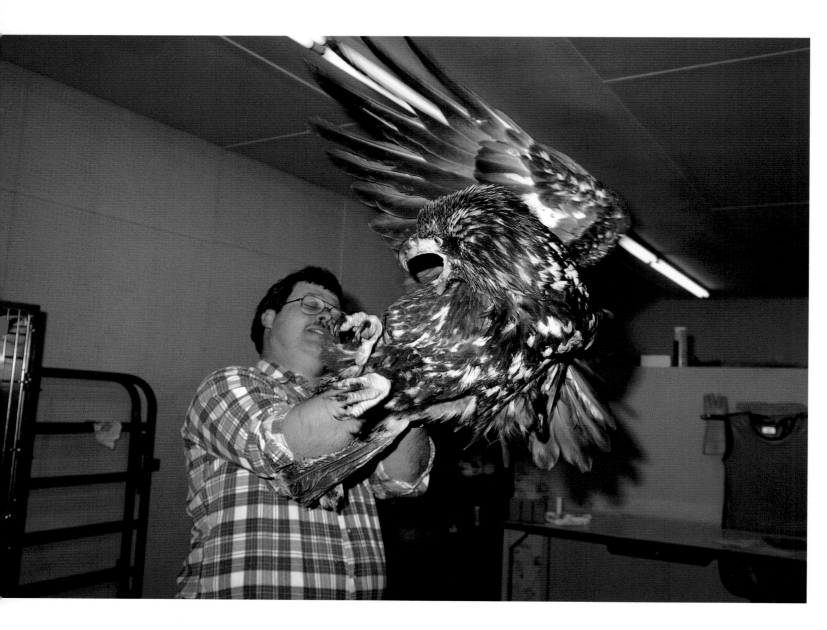

ABOVE: *Veterinarian Dr. Barth Richards struggles with a subadult bald eagle with an amputated wing. Dr. Richards has treated hundreds of eagles in his hospital in Soldotna, Alaska, and for years has been sending them to the lower forty-eight states. His program in conjunction with Dr. Theodore Bailey and the United States Fish and Wildlife Service has returned the eagle to America's skies. Those birds not capable of making it on their own (like the one pictured here) have gone to breeding centers in the lower forty-eight states.*

OPPOSITE: *An eagle cries out as a varmint trap is taken from his leg.*

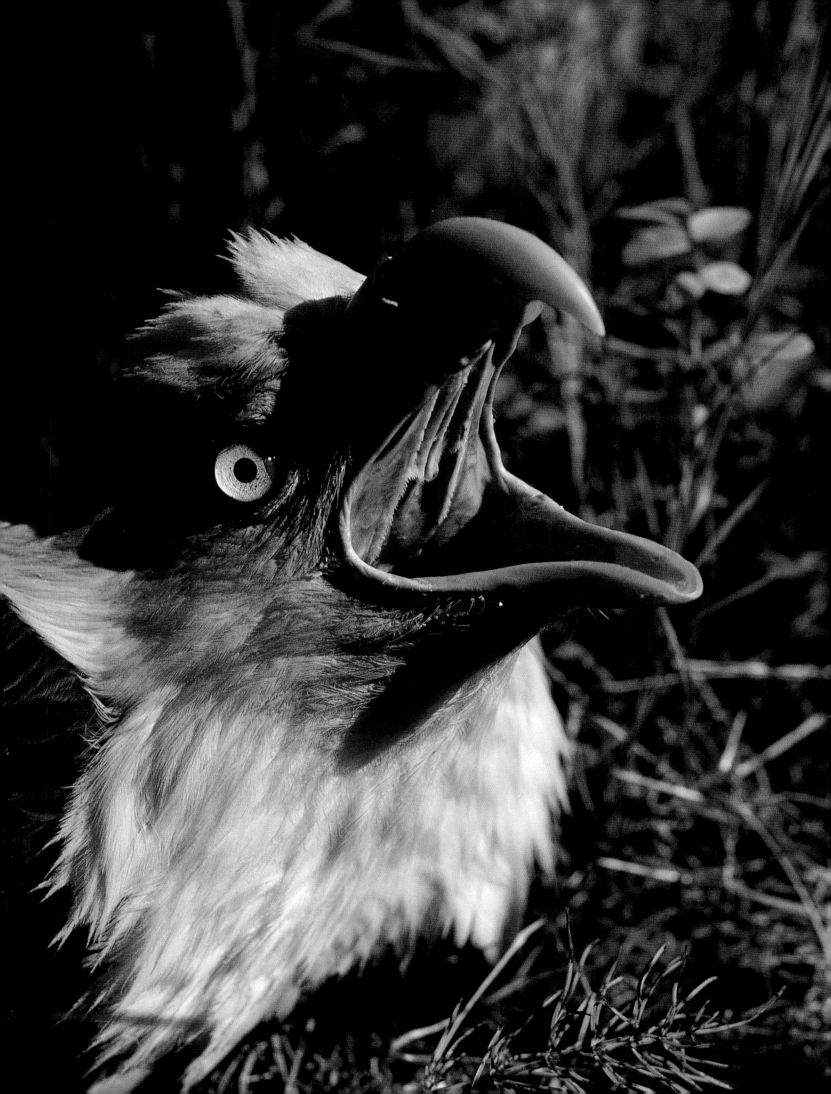

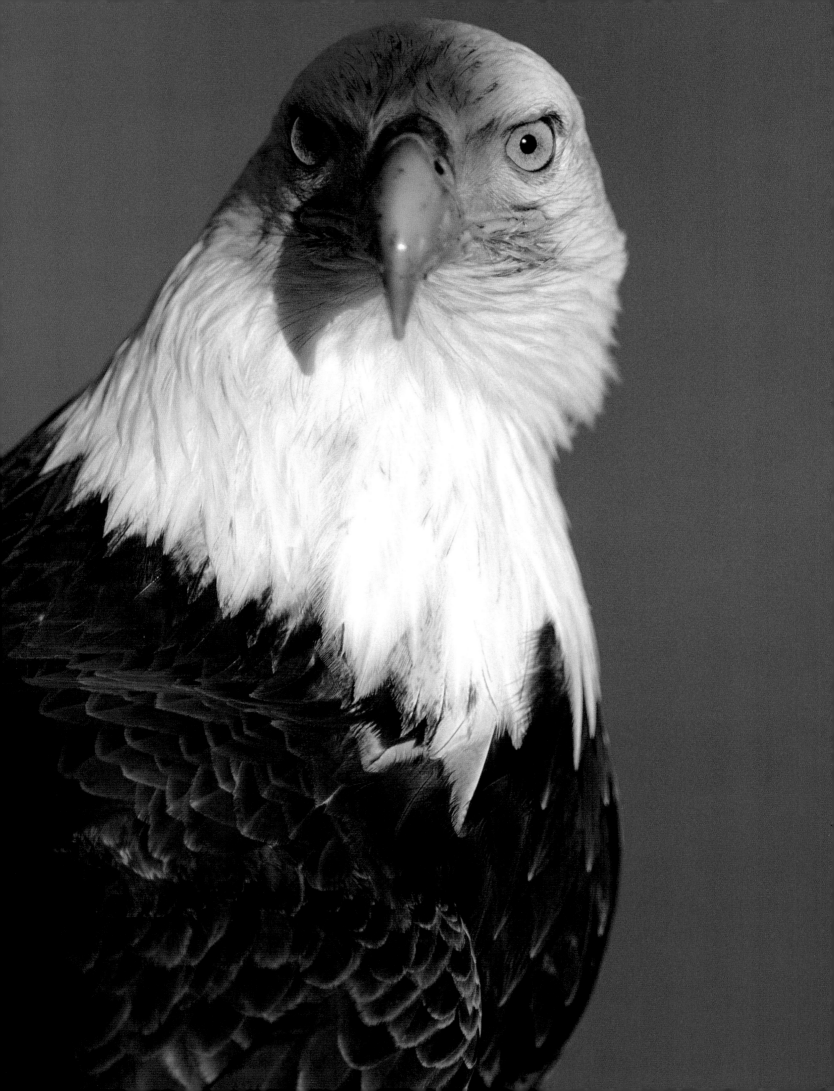

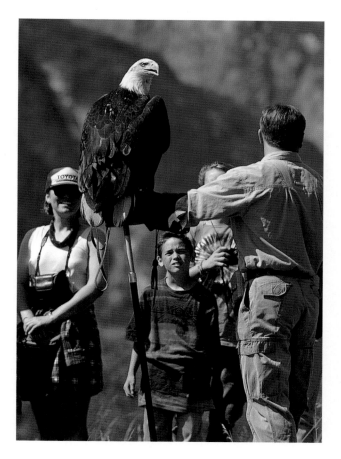

OPPOSITE: *This pristine adult male watches a team from the Massachusetts Division of Fisheries and Wildlife place an eaglet in his nest to replace the one that died. This nest was near Gill, Massachusetts. I truly appreciate the Massachusetts team for their outstanding dedication to replacing eagles in the wild.*

RIGHT: *Programs are now being launched nationwide to educate people about the difficult and fragile life cycle of our American eagle.*

BELOW: *Officer Tony Brighenti holds a four-week-old baby eagle that is going through a series of tests with a team of veterinarians, biologists, and lab technicians from the Massachusetts eagle team. The young eagle will have its eyes, ears, nose, and throat checked and have blood samples drawn before being returned to its nest by Tom French, assistant director of the Massachusetts Nongame and Endangered Species Program.*

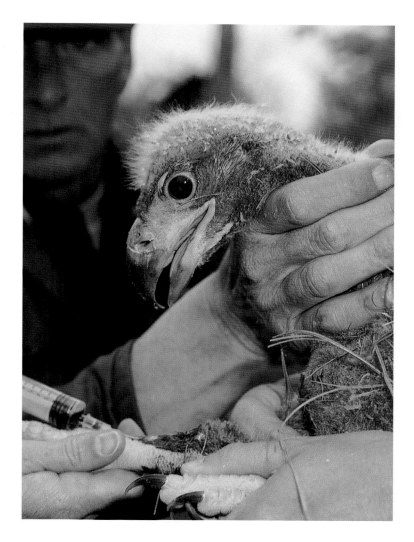

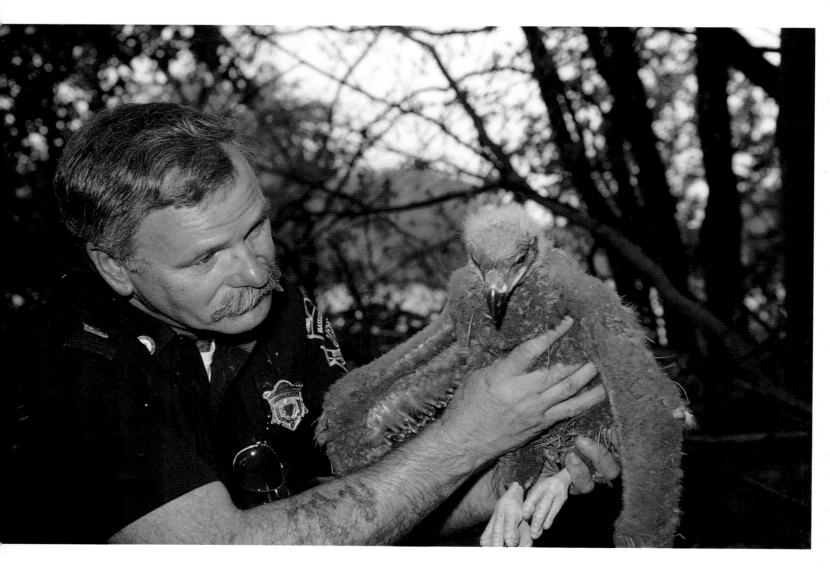

ABOVE: *Massachusetts law enforcement officer and falconer Major Tom Ricardi holds a young eagle before placing it into yet another failed nest near Holyoke, Massachusetts. Tom is personally responsible for putting hundreds of eagles back into the skies. In addition to raising eagle eggs in his aviary, he also spends his time giving lectures and helping children learn how to appreciate birds of prey.*

OPPOSITE: *A twenty-one-day-old eaglet, born and raised in captivity by Tom Ricardi, awaits its transport to a failed nest on the Connecticut River.*

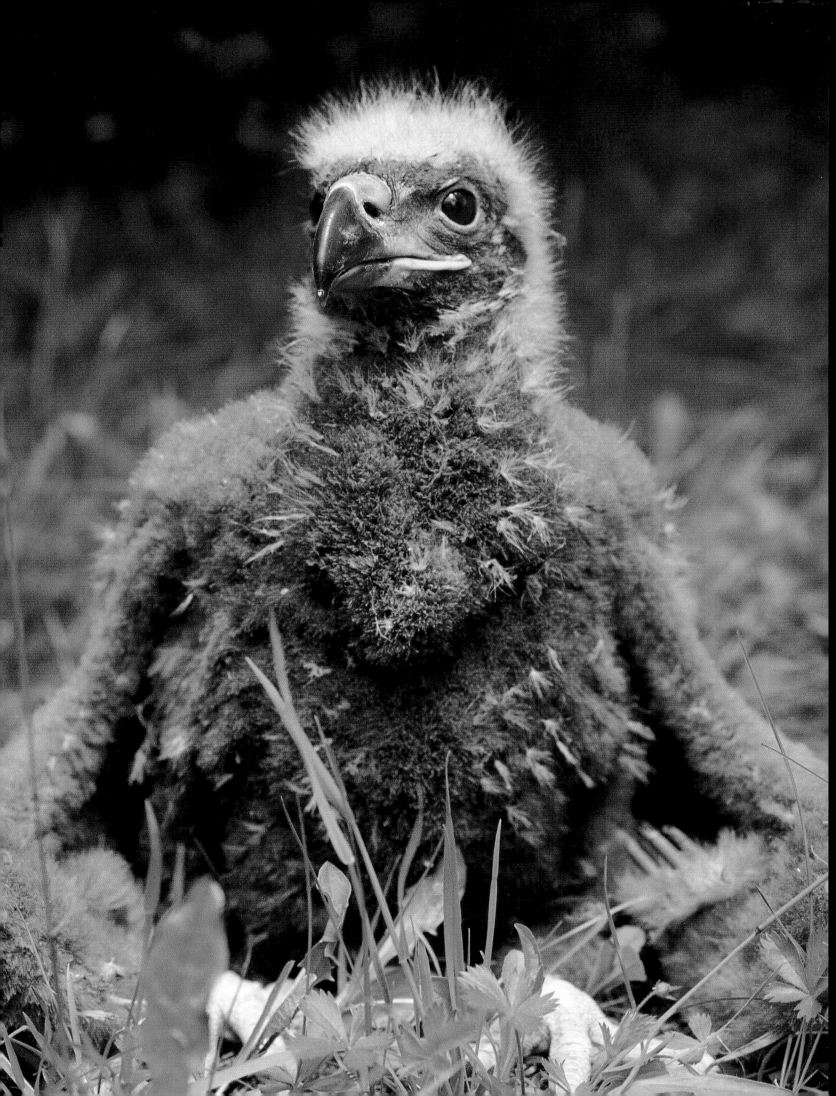

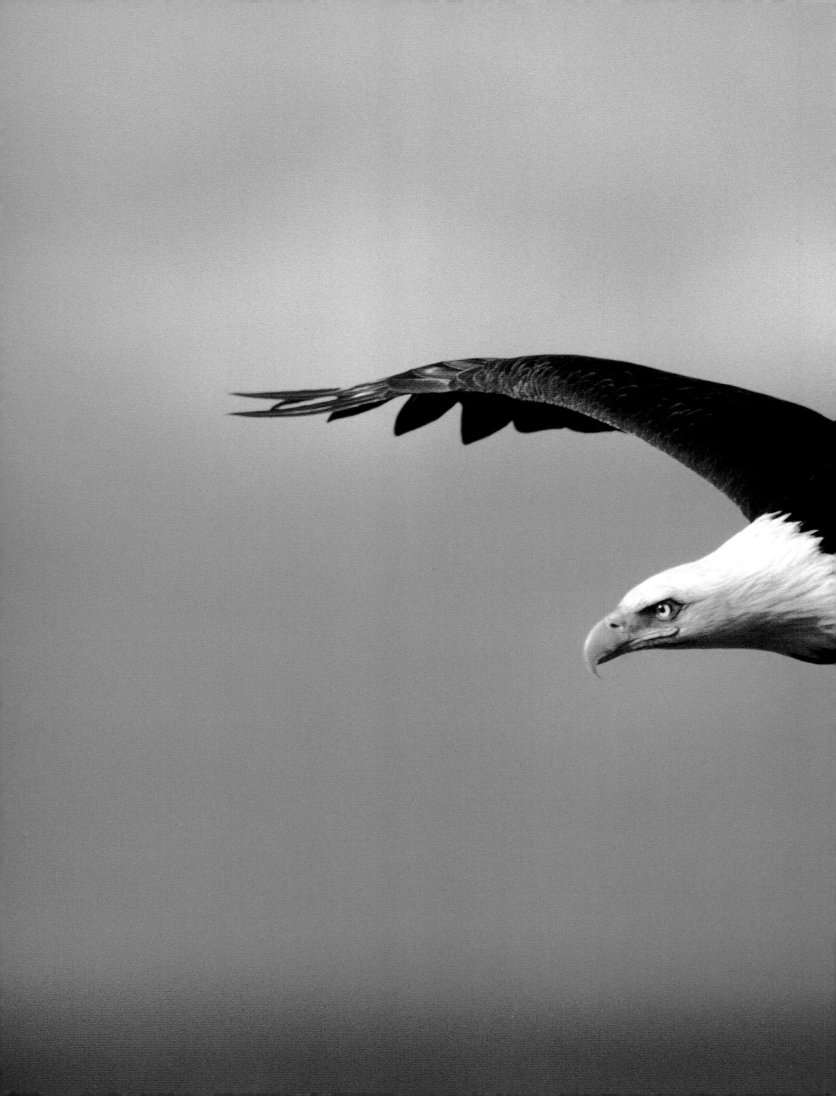

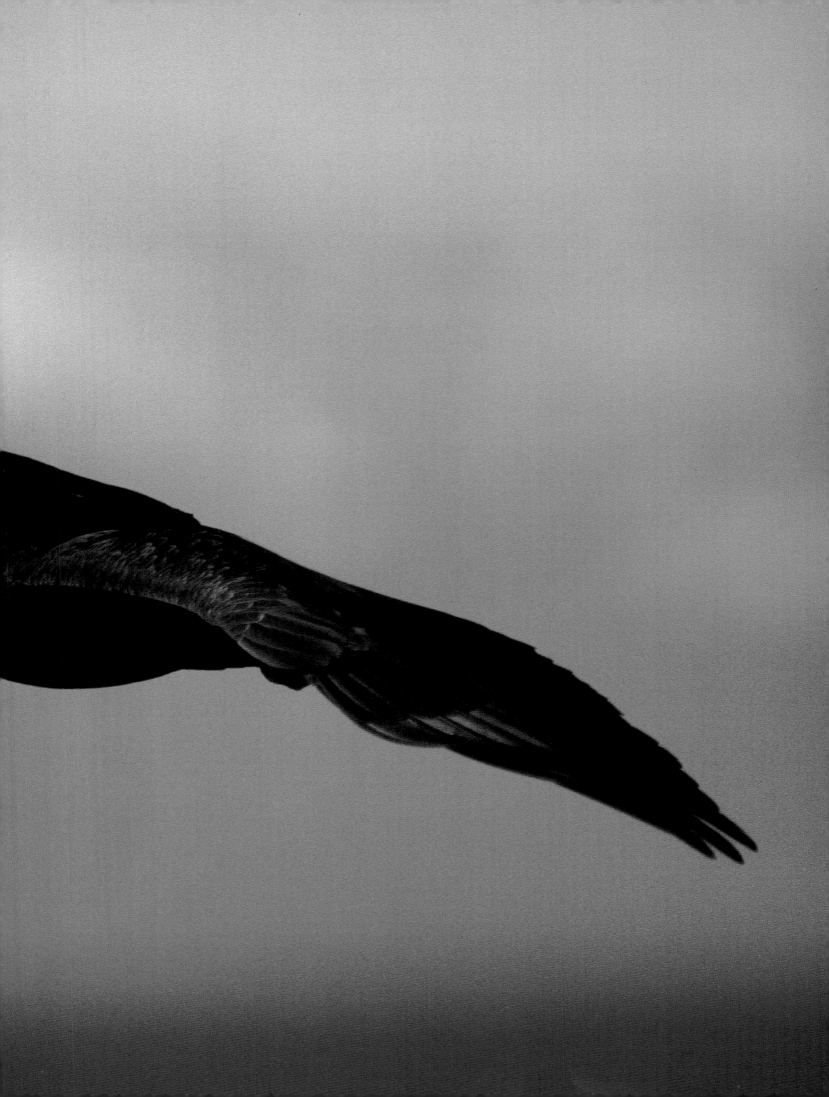

ABOVE AND FOLLOWING PAGES: *Although excellent progress has been made in returning the bald eagle to American skies, there is still a monumental amount of work to be done, not only with water and air pollution and destruction of habitat, but also with poachers. Wherever eagles gather there is almost certain to be a poacher. White tail feathers, like the one pictured above in the Everglades, are worth $1,000 each on the black market. Many eagles are also shot for their feet and talons. An intact eagle foot and talons is worth $5,000 to the right party.*

127

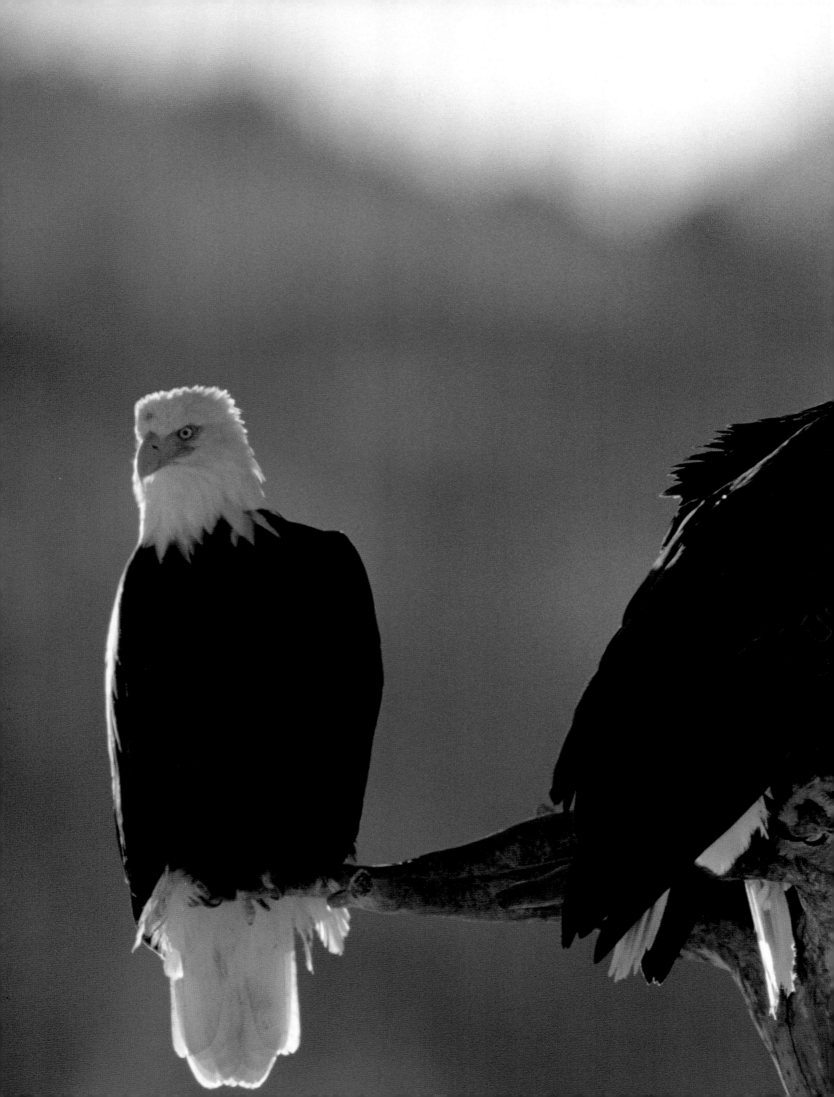

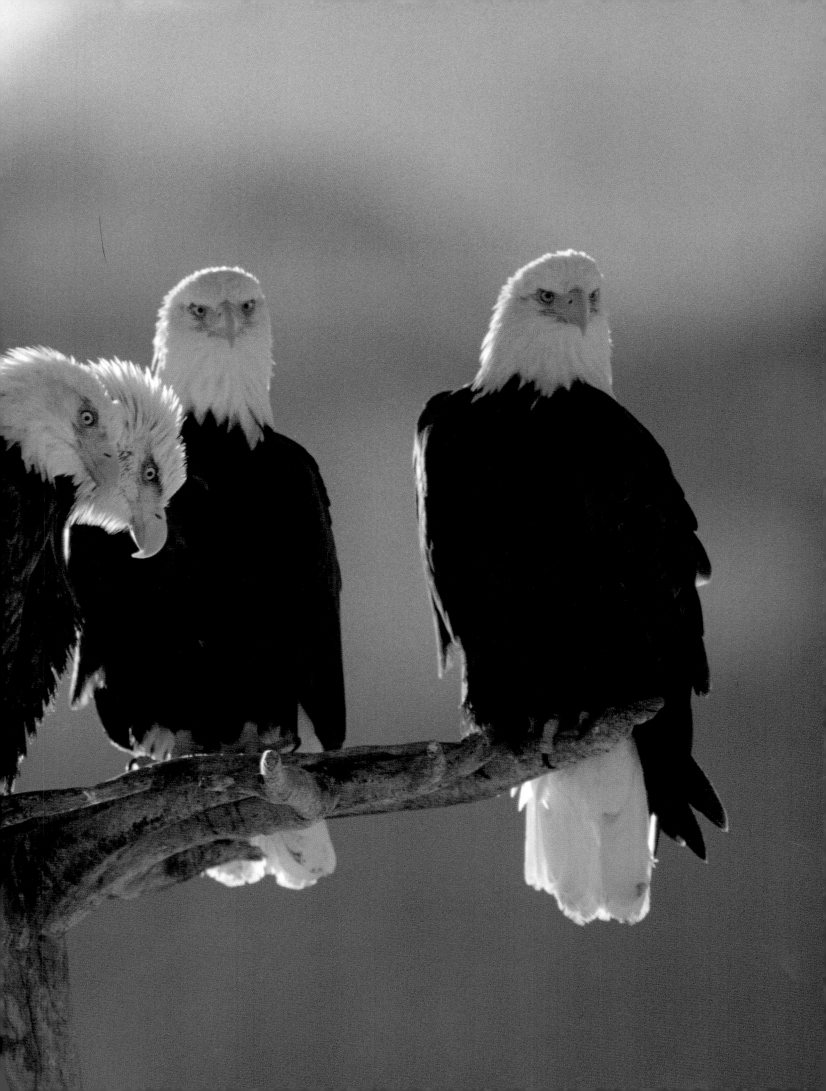

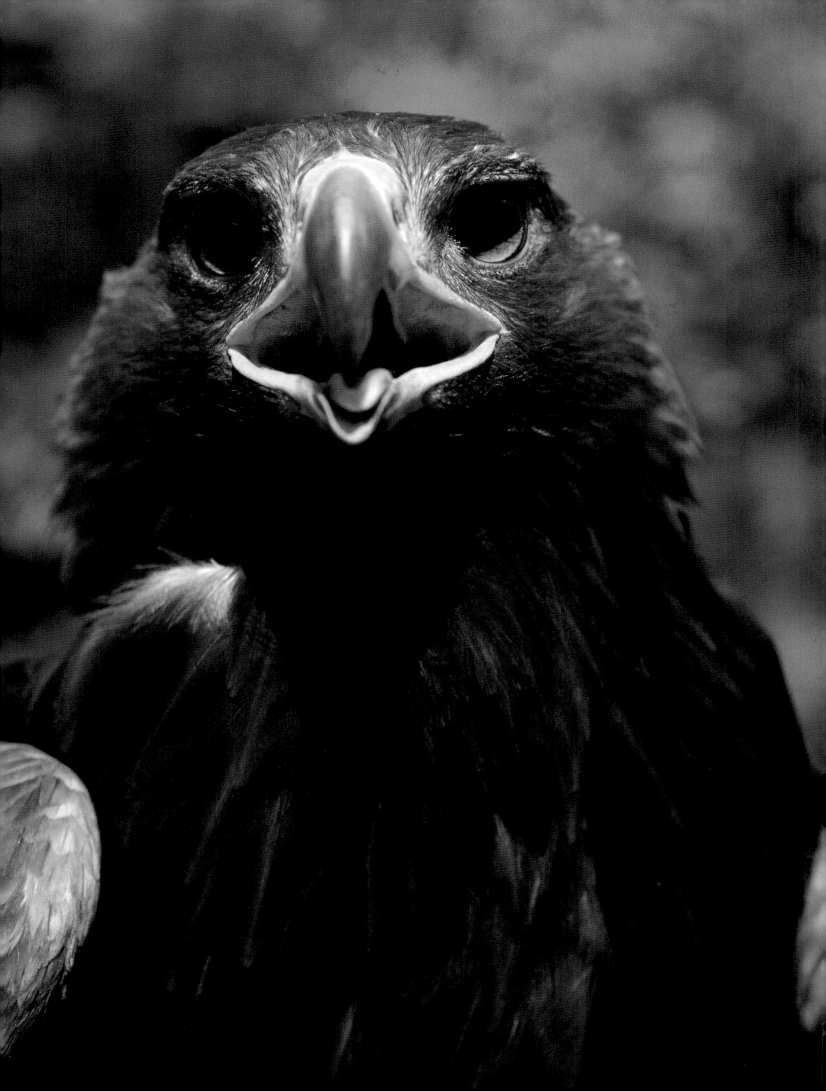

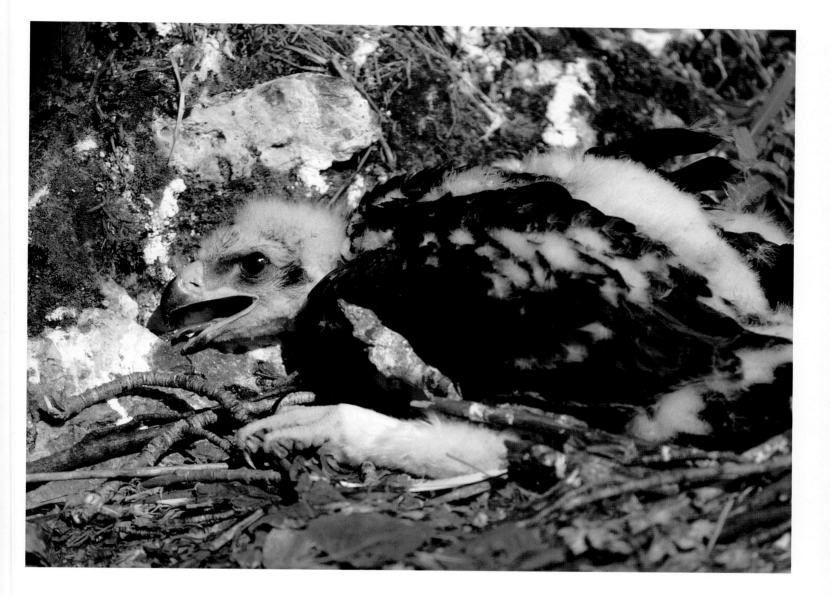

OPPOSITE: *Golden eagles also suffered the effects of DDT, but not as dramatically as bald eagles due to the varied geographic locations they inhabit. However, in days past, golden eagles suffered persecution at the hands of western ranchers and farmers who ignorantly thought that the eagles were killing their livestock. Golden eagles were killed by the dozens—even by the hundreds—on a daily basis for almost a hundred years. Hunters were employed full-time by large farms and ranches to eradicate the bird. This insane killing was only stopped a mere twenty years ago and golden eagle populations still have not recovered. Today I'm told the practice continues under a cloak of secrecy.*

ABOVE: *A five-week-old golden eaglet high atop a cliff nest in Alaska.*

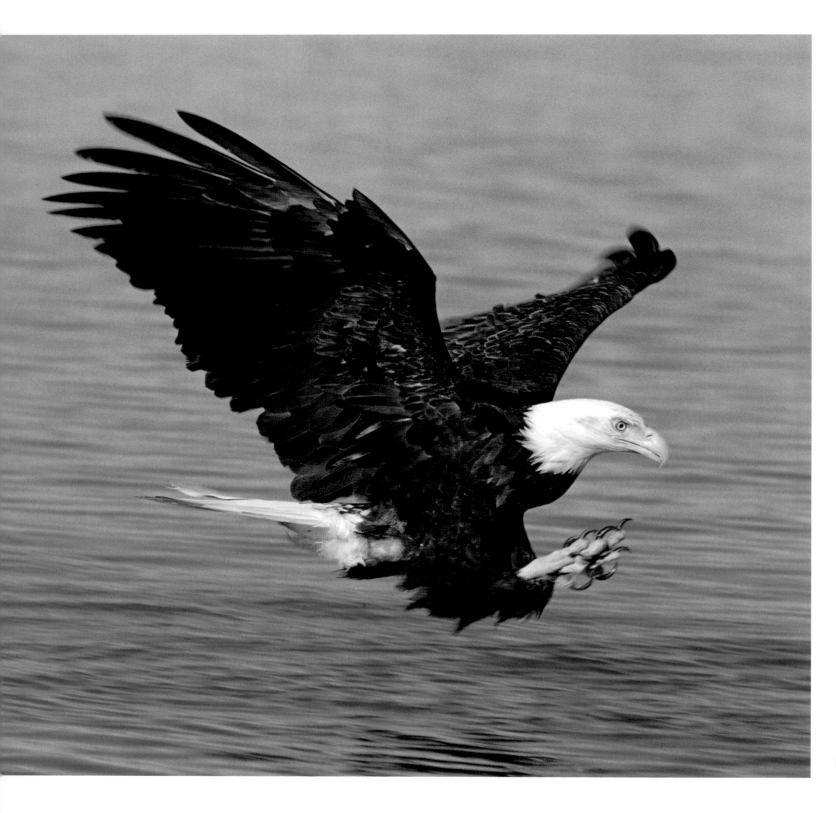

ABOVE AND FOLLOWING PAGES:
The American eagle is the greatest
fishing hawk in the world.

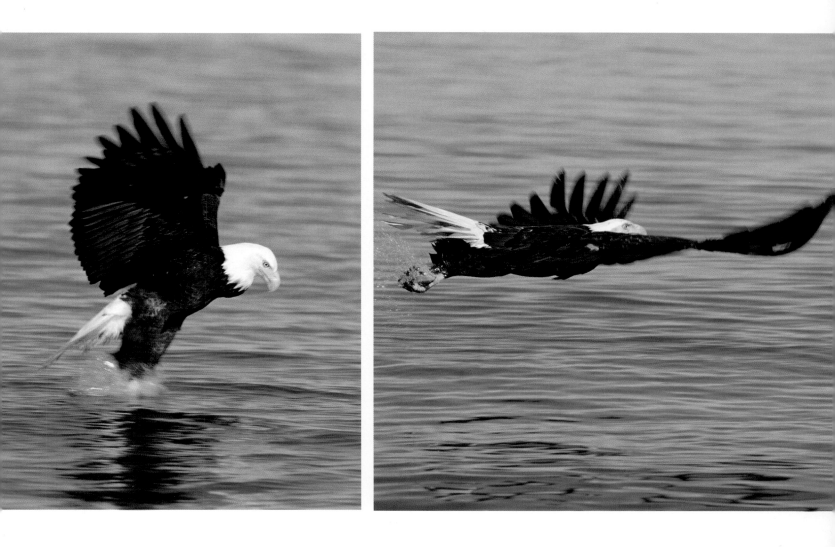

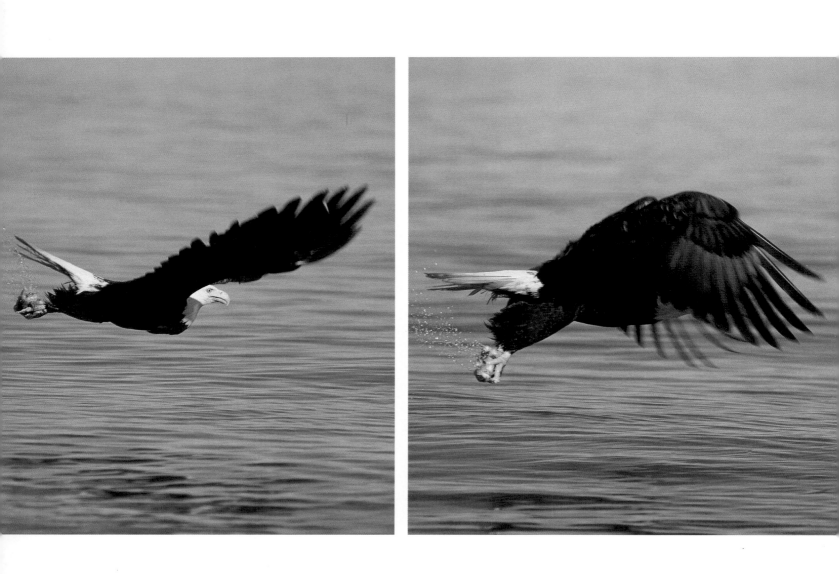

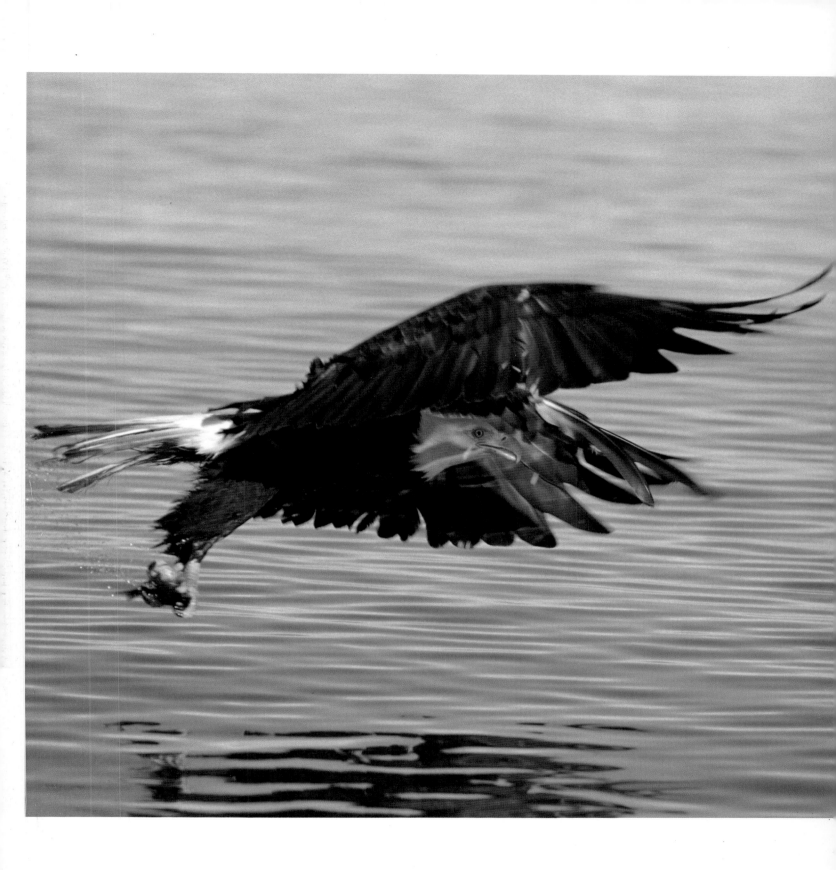

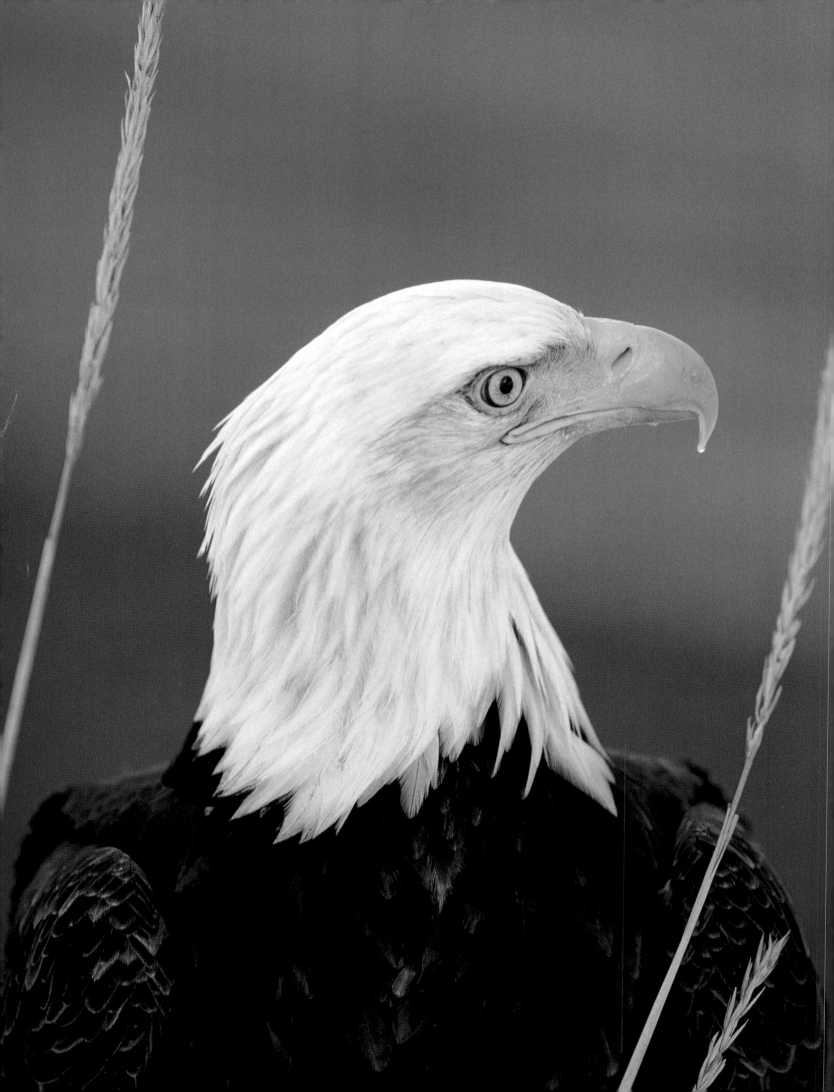